ANDY WARHOL The Last Supper

ANDY WARHOL
The Last Supper

CANTZ

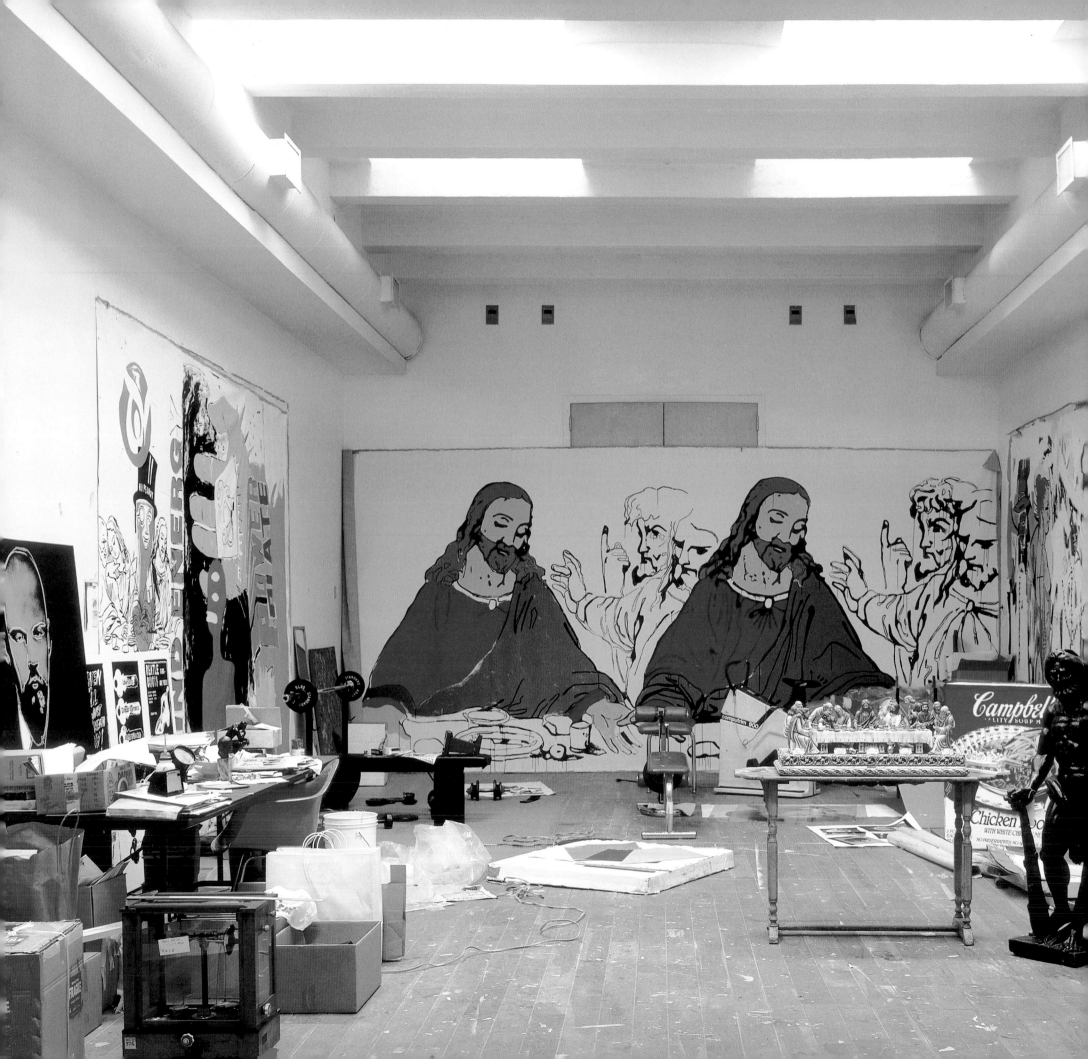

CONTENTS

7 Foreword

Carla Schulz-Hoffmann
9 **"Are You Serious or Delirious?" –**
On the Last Supper and Other Things

Corinna Thierolf
22 **All the Catholic Things**

55 **The Paintings**

Jane Daggett Dillenberger
87 **Another Andy Warhol**

Cornelia Syre
103 **Leonardo da Vinci's Last Supper**
History and Reception

107 **Drawings and Collages**

140 **Biography**

143 **Checklist of the Exhibition**

FOREWORD

For the first time in Germany, the Staatsgalerie moderner Kunst is presenting important sections of Andy Warhol's last, monumental work cycle *The Last Supper*. It takes issue with an incunabula of European art, admired and revered for centuries: Leonardo da Vinci's mural *The Last Supper* (1495–97) in the church of Santa Maria delle Grazie in Milan. This painting inspired Warhol to a tour de force in his basic artistic and ideological positions. In over 100 works – 56 of which are on show in Munich – Warhol summed up central aspects of his artistic concept.

The in various ways ambitious project, documented in the almost gigantic dimensions of nearly 11 metres in width for some of the paintings, was created for gallery rooms of a Milan bank directly opposite Santa Maria delle Grazie. The exhibition, which contained a relatively small section of the total work complex, was opened in 1987 shortly before Andy Warhol's death, with the artist present at the opening. It turned into an overwhelming media event with a claimed number of 5,000 visitors and spectacular press attendance. This led one critic to make the slightly complacent comment: "This was an Event regardless, and the art merely the pretext."

This may have been generally true for the public and the press – significantly, people hardly took up the parallel offer to visit the Refectory to see Leonardo's original – but for Andy Warhol this project was obviously of crucial importance. He devoted far more intensive effort to the theme than the commission and the space available actually demanded. Indeed, the overall extent of the work indicates an almost obsessive involvement. Significantly for the reception of Leonardo's painting as well as his own artistic approach, Warhol's reflection on one of the most frequently reproduced works in art history, is not based on the original. Instead, Warhol chose as his model cheap, easily available reproductions, similar to those he was familiar with from his Catholic-influenced childhood in Pittsburgh. He interprets these "devotional objects" excessively with an extremely wide variety of techniques, formal strategies and differentiated approaches to the subject. The work thus creates a panorama of Warhol on Warhol. But is it at the same time a serious contribution to a religiously inclined art towards the end of the 20th century, or does the theme merely remain at the level of camouflage for boundless cynicism? Is Warhol being naive to the point of being unbearable or is he displaying a shocking, cool, dissecting intelligence? Is he reviewing the smooth surface of a narcissistic consumer society without making value judgements, or is there yet another level behind? The exhibitions and the catalogue attempt to get closer to an answer to these questions, although in the end the only thing one can be sure of is uncertainty. In a perfectly staged camouflage, with this cycle of works Warhol once again undermines our hope of unambiguity and, instead, offers for every formulation its irritating counterpart. But perhaps this is precisely the key to the fascination and persuasive power of a work that doesn't come up with easy answers, but poses question upon question anew without trying to fob us off with illusory results.

With its 56 works, the exhibition may seem rather moderate in size compared to current major events. But because of the unusual formats and all the associated problems, its realisation has meant a special effort for all, and was only made possible by requisite confidence, general cooperation and willing assistance from the start on.

Thus we would like to express firs of all particular gratitude to the lenders, who showed us the trust we needed to take this risk at all: The Andy Warhol Foundation with Archibald L. Gillies, Vincent Fremont and Timothy Hunt and the Ayn Foundation with Heiner Friedrich made available the entire body of work for the exhibition in the full knowledge that because of their size, a large proportion of the pictures would have to be unstretched for transportation and then stretched again in Munich – a process that causes major problems for any conservator. From the beginning, all those involved in both institutions have also helped us competently and without red tape to cope with all the big and little complications on the technical level. Heiner Friedrich, the spiritus rector of the project as a whole, is particularly closely linked to Munich by virtue of his many years as an influential and inspired gallery owner. Without him, without his continually renewed insistence and undaunted optimism regardless of any difficulties, the project would hardly have got beyond the initial discussions. We are especially grateful to him, but also to those, who

assisted him and/or the Warhol foundation. Tad Wiley carried the main burden of organisation and management on the American side, decisively speeded up the process of dismantling and reassembly, and never gave up despite all the obstacles. We would also like to thank Sandra Amman and her colleagues who, with admirable team spirit, routinely mastered the difficult task of unstretching and stretching the canvases.

Tom Sokolowski and Mark Francis from the Andy Warhol Museum in Pittsburgh supported our project with important advice. John Smith and Matt Wrbican, who manage the archives of the artist's estate at the Museum, never got tired of going through this extensive material and finding sources important for the creation of the series. The correct assessment of these findings would probably have got stuck halfway were it not for the accurate guidance, always laced with refreshing humour, from close colleagues and friends of Warhol, especially Benjamin Liu, Jay Shriver and Christopher Makos. But also on the Munich side, the entire project was beset with major problems, which could only be successfully overcome with committed financial and technical support. The Staatsgalerie moderner Kunst, well known as a provisional place with permanent lack of space until it will move into the new building of the Pinakothek der Moderne, can only mount exhibitions of this size when large parts of its collection are put into storage. In this special case we decided on the unusual step of devoting the entire ground floor to contemporary art while the exhibition is on. This was only possible with the support of the Theo Wormland Foundation, whose collection of surrealist art – contrary to the contractual agreement – along with our own collection of Expressionist works, cannot be shown during this time. By way of compensation, from October 1998 we will be showing an overview of classical modernism in these galleries.

But it is not only because of this that we are grateful to the Theo Wormland Foundation and Hartwig Garnerus, who is responsible for its collection. As is so often the case, we also have benefited here in a variety of inspirational and financial assistance. As guest curator of this Foundation, Corinna Thierolf played a decisive role in realising the project as a whole, and without the substantial donation from Theo Wormland Männermode, the catalogue would hardly have turned out so lavish and well-produced. We also received vital financial support from Philip Morris Kunstförderung, which not only financed all the publicity, from the poster to the invitations, but also helped us a great deal with putting our needs into practice. Thanks to the mediation of Helmut Pauli, Delta Air Lines decided to take on the complicated shipping of the works from New York to Munich, along with the accompanying couriers and conservators. This considerably reduced the exhibition budget. We are very happy indeed at having achieved this cooperation!

As representative of the many co-workers involved in the practical application of all the planning in Munich we would like to mention Florian Schwemer, who was responsible for the conservatory services and technical organisation and who showed his customary care and a great deal of enthusiasm for the task in hand.

Many people were also involved in the production of the catalogue. First and foremost we would like to thank Corinna Thierolf, who decisively influenced the exhibition and its accompanying publication, and who has set new standards in the art historical debate on Andy Warhol with her carefully researched and imaginatively conceived contribution to the catalogue. Her text is complemented and supported by the excellent contribution from Jane Dagget Dillenberger, who includes a great deal of material from a theological viewpoint which helps towards a better understanding of the "Catholic" Warhol. We are grateful to Ms. Dillenberger for her permission to print an advance extract from the results of her years of research, which are due to be published soon. Within this spectrum, with its heavy concentration on contemporary art, Cornelia Syre's essay on the reception of the "Cenacolo" offers an indispensible sideways glance at the revered model of Leonardo da Vinci. Ms. Syre's contribution includes a vivid recapitulation of the outstanding significance of this work for subsequent generations.

All these contributors were supported in many different ways by Stephan Urbaschek, who was in overall charge of editing the catalogue, and steered confidently through all the difficulties involved in organisation and publicity work.

We would like to express our deepest gratitude to all these people, and to many more who have not been mentioned here. We hope that the enthusiasm and commitment which made it possible to realise the project prove their worth and contribute to a better understanding of this little-known side of Andy Warhol's work.

Johann Georg Prinz von Hohenzollern
Bayerische Staatsgemäldesammlungen

Carla Schulz-Hoffmann
Staatsgalerie moderner Kunst München

Carla Schulz-Hoffmann

"ARE YOU SERIOUS OR DELIRIOUS?"[1] – ON THE LAST SUPPER AND OTHER THINGS

Andy Warhol's last large-scale project impresses itself upon us as excessive in its dimensions and apparently heretical in its artistic and spiritual aspiration: with an acute lack of concern, or naive rashness, and from the viewpoint of the twentieth century, his *Last Supper* cycle appropriates an incunabula of European Heritage, Leonardo da Vinci's *Last Supper* in the refectory of Santa Maria delle Grazie in Milan. Although not intended as such, it has take on the character of a premonition, a provocative legacy of an artist whose life's work reflects the central issues of our modern media age with a consistency and density not to be overestimated.

Warhol's body of work, a commission in the grand style, recapitulates in a multifaceted and intelligent manner his well-nigh boundless artistic spectrum, at the same time raising as many new questions as it replies to old ones. The reactions to the work were correspondingly controversial, whereby the huge media event around the exhibition opening in Milan with its estimated 5,000 visitors exceeding all expectations and capacities[2] – to say nothing of the death of the artist several weeks later – initially distorted any analytical view of the works.

The speech made by Warhol's close friend John Richardson during the memorial service on April 1, 1987 in the New York Saint Patrick's Cathedral[3] contributed even more to the general disarray, concentrating as it did on Warhol's religiousness, which he had successfully managed to conceal from the public. Was the work a serious contribution to a religiously inclined art at the close of the twentieth century, or was it just the late work of a burnt-out artist who in his old age had become as sentimental as he was insignificant? Robert Hughes' reaction to the question as to whether Warhol's *Last Supper* might enhance his reputation was accordingly smug: "Who cares if Andy wanted to be a tick on Leonardo's ass?"[4]

Today, at a distance in time of more than eleven years and with the general acceptance of the artist into the hall of fame – a fact which has not, however, rescued his work from that boredom nurtured by familiarity – perhaps these questions can be put with less prejudice and more precision. In doing so, certain details which at first glance seem innocuous and ancil-

lary assume a degree of pertinence:
- the difference in the function of the commissioner and the location of the work and/or exhibition in the case of Leonardo da Vinci and Andy Warhol;
- the full extent of Warhol's work cycle as compared to the number of pictures shown in Milan;
- the overall number of artistic methods and techniques Warhol applied in creating the cycle in relation to those in the group selected for the Milan exhibition.

Presumabely in 1494 Leonardo da Vinci received the commission for his *Il Cenacolo* from Ludovico Sforza, one of the most influential and powerful dukes of his time, who had Santa Maria delle Grazie built as a court church and sepulchre, thus documenting the close ties between secular and church power.[5] Conceived as a mural, Leonardo carried out the work "in situ" in a specially developed technique which, unfortunately, proved to be anything but hard-wearing. As a result, admiration for one of the greatest works of western art very soon entered into a symbiosis with dejection about its critical condition, indeed, the "aesthetic of disappearance"[6] made an important contribution to the history of the work's impact. By contrast, Warhol's versions came about through the mediation of his first gallerist and long-standing friend Alexandre Iolas, and were destined for the newly-opened exhibition spaces at the Italian bank Credito Valtellinese, situated directly opposite Santa Maria delle Grazie, and therefore Leonardo's *Last Supper.*

The palace of capital, appropriately housed in a venerable palazzo, thus became strategically linked with the religious icon, while at the same time contravening it by modern means. It would seem as if Andy Warhol had become a compliant vehicle, or a cynical supplier of a suitable decoration to adorn the world of Mammon and imbue it with the greatest of solemnity. And yet the crafty "magician of the surface" evades this superficial interpretation on several counts and in a highly wilful manner. By basing his work not on Leonardo's original but on a cheap nineteenth century photographic reproduction "like you'd buy in Woolworth's",[7] Warhol neutralises the sacrilege inherent in a commission to ennoble capital through its

association with great art and deep spirituality. What is more, from the overall group of almost 100 works which he created in this context,[8] he selected not the painted works, but a total of 22 silkscreen versions for the exhibition in Milan, "even though he liked both"[9]. Why did Warhol choose the silkscreen prints for the official context of the exhibition, even though he had sufficiently representative and equally large-format paintings at his disposal which would have extended the usual repertoire? Why this obvious separation of public attitude, to which the camouflage of the silkscreen's smooth surface corresponded, and the more private gesture, which withheld the "slip" of the spontaneous, the hand-made, from the ostentatious atmosphere of public presentation? Are the two work groups, the silkscreens and the paintings, identical with two separate and divergent interpretations of the task, and do they thus correspond to the artist's understanding of himself as a dual figure, public and private? This seemingly daring thesis gains in plausibility when the two work groups are defined more precisely.

In an interview with an editor from the Italian daily *La Repubblica*, Warhol describes his procedure in transposing the theme as follows: "I used serigraphs with acrylic and then transferred them to canvas. And I painted them all (i. e., the painted works, Schulz-Hoffmann) by hand – me personally: I have now become a Sunday artist. During the week I have to earn money to live and pay my fifty employees. That is why I invested so much time. But I worked with great enthusiasm."[10] Without wanting to overinterpret this statement, which, as often happens, loses somewhat in clarity both in the translation from American to Italian, and through being taken out of the context of the whole interview, it really only makes sense if it is understood as a list of the techniques used by Warhol. That is to say, the claim "I painted them all by hand" cannot refer to the whole cycle, as obviously the serigraphs have nothing to do with painting in the traditional sense. It must refer, therefore, to the painted work complex, which alone would justify the emphasis on "by hand". From this follows a highly amusing differentiation between "earning your living" (serigraphs) and "Sunday artist" (painting), of which the latter can allow itself both enjoyment and experiment. Painting constitutes "an enjoyable leisure-time activity" and, one might even say, "service rendered to God", for both are tolerated by the prohibition to work on Sundays.

Further investigation is necessary, however, to discover why Warhol initially drew a strict dividing line between his different artistic methods, and at the same time made a definitive differentiation in terms of his art between the public and the private spheres. Doubtless the Milan exhibition fulfilled the public's customary expectations. In it, the media star presented himself through the formal and stylistic vocabulary inseparably linked with his public role: silkscreens produced mechanically after photographic models – mostly material from the tabloid press – according to a printing technique favoured by Warhol as of 1962. These silkscreens are perfectly and persuasively adapted to produce a purely surface effect which forgoes spontaneity and lends an aura of authenticity to a section of reality that has already been filtered several times. Because a newspaper photograph soberly documents a real event – like a plane crash or the murder of John F. Kennedy – its printed reproduction is assumed to have an at least equally high degree of reality.

Warhol's specific working method has been so widely and intensely discussed[11] that it should suffice here just to recapitulate on the aspects related to our particular concern. One decisive feature is its two-sidedness, or to quote Warhol: "I like that idea that you can say the opposite."[12] Accordingly, a photograph of an apparently arbitrary scene is raised in status on the one hand, by being translated into a work of art, while on the other, its binding character is levelled by the printing process and alienated, for example, by the different colours used in the individual variations. The banal undergoes an upgrading and the sublime a downgrading by basically equating the quality of everything, "high and low". The series suggests both a wealth of meaning and endless boredom, and consequently a void. The reduction to surface impact, a result both of the printing technique and of a radical isolation of the respective pictorial motif from the overall composition of the photographic model or its explanatory surroundings, leads to that incomparable symbiosis between reverence and irony, melancholy and cynicism, which no one has been able to disentangle.

This irresolvable ambiguity of the silkscreens is again underscored in the *Last Supper* work group, given that it is based on a copy of a copy. Whereas this very fact gave rise to more playful, spontaneous interpretations in the painted versions which were not exhibited in Milan (and which are oriented around an outline drawing after the original), paradoxically, the silkscreens display a greater degree of fidelity to the original, despite being based on a graphic reproduction after Leonardo's *Last Supper*. In transposing the reproduction to the pictorial carriers, to a large degree the model remains untouched. The only modifications are in the differently coloured ground, including a largely shielding camouflage (cat. 19), the series repetition of the motif, and the rotation of that motif by

180 degrees (see ill. p. 30). The overall formal style and composition, however, correspond to the copy. This even applies to the three-dimensionality, which was secondary in the surface-oriented reproductive technique of the copyist, whereas the original definitely achieves its suggestive effect through its imposing mastery of perspective which takes the whole inner space of the refectory into account.

Thus, what at first looks like a sacrilege proves on closer observation to be the exact opposite: Leonardo's *Last Supper* remains unaltered in its unique artistic and spiritual potential, prevails as an unquestionably accepted and venerated icon that forbids any manipulation. Interestingly enough, shortly before his death Warhol signed a petition against any further restoration work being done on Leonardo's masterpiece[13], emphasising with unusual sharpness: "I only know that it is a mistake to restore the *Last Supper*: it is unbelievably beautiful just as it is! The old things are always the better ones and should not be changed."[14] Whereas here he makes a demonstrative plea for the original substance and uniqueness of this outstanding work of art – an attitude which was consistent with his use of a copy – he was much less scrupulous about how his own works were treated. When asked what he thought about the complicated copyright problems with which he was constantly being confronted due to his particular artistic method, he reacted in a characteristically casual way: "I don't want to get involved. It's too much trouble. I think that you buy a magazine, you pay for it, it's yours. I don't get mad when people take my things."[15] To the astonished query whether he was really going to undertake nothing against the sale, the most he was prepared to do was to reject signed fakes: "Signing my name to it was wrong but other than that I don't care."[16]

There was apparently a difference between the works of a died-in-the-wool "commercial artist" – a category into which, in Warhol's view, all artists fell who lived from their art[17] – and those of past epochs. These have long since become separated from the conditions of their genesis, have preserved their indestructible aura and identity as sacrosanct relics, despite, or because of the alterations and countless reproductions to which they have been mercilessly subjected, as in the case of Leonardo's *Last Supper*. In the, for Warhol, characteristic guise of the American cultural philistine, he summed up his attitude more precisely when, on being confronted in Milan with *Il Cenacolo* and a not altogether intelligent question from a journalist about his relationship to Italian history and art, he replied tersely: "Spaghetti."[18] Here, a balance is struck between self-irony and reticence about the private sphere of the Other, which latter can also signify a work of art. There is

hardly a better way of describing the situation of the late twentieth century artist who has everything at his disposal but for whom nothing more is really present, as he can no longer grasp the depth: all that has survived of the *Last Supper's* spiritual wealth, its spiritual substance, are carbohydrates and that which, apart from pizza, qualifies worldwide as Italian fastfood cuisine. Warhol, the "saintly simpleton"[19] par excellence, thus marks out the terrain of the contemporary artist who conceals boundless scepticism and melancholy behind the allure of the superstar. Warhol's Milan exhibition says nothing about Leonardo's original work, but a lot about Warhol's understanding of himself; it is an unequivocal formulation of his credo. Warhol was not concerned to compete with Leonardo, rather he understood the commission as a possibility to reflect on the narrow bounds of contemporary art. In the end, the theme becomes submerged in a pool of inconsequentiality, is in fact no better or worse or earnest than a Campbell's soup can. Warhol's *Last Supper* is an easily consumed commodity and complies with the widespread desire for pictures as decoration, utility goods, and religious placebos in an "I-want-everything-right-now" society which regards works of art as a suitable and soothing backdrop against which to stage itself.

One critique of the exhibition reported pithily: "This was an Event regardless, and the art merely the pretext. To the artist, however, no doubt it meant more."[20] But just as the artist's portraits of Marilyn Monroe tell us nothing about the real Norma Jean Baker, merely reflecting her as the media art product and commodity *Marilyn* which she had become, so too the artistic and spiritual content of the *Last Supper* remains a taboo in Warhol's copy after a copy. What is more, the camouflage has been perfectly successful for the artist too, for whatever he may have associated with this commission in some secret corner of his "heart", in the exhibition funded by commerce, it remains unrecognisable.

The silkscreen technique itself, in conjunction with the model, made its own contribution towards neutralising any hint of subjectivity: here, the picture surface seems particularly porous, diffuse and thus intangible; it is capable of concealing all or nothing – who would dare to decide?

Warhol sounds out this contentual indifference in a, methodologically speaking, relatively objective and clear case – the mechanical reproduction after a copy of the *Last Supper*. In the series (cat. 15) the overall monumental motif is reduced to a postage stamp or a wallpaper pattern, scarcely any different, quantitatively, from the wide-eyed cow (ill. 1), the flowers, or the toys which often populate Warhol's exhibitions

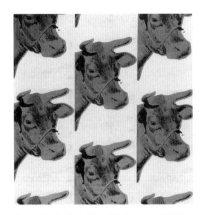

1 Andy Warhol, *Cow Wallpaper*, 1966. Silkscreen on paper. Leo Castelli Gallery, New York

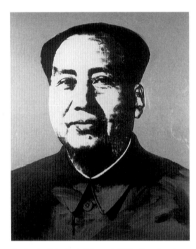

2 Andy Warhol, *Mao*, 1973. Synthetic polymer paint and silkscreen ink on canvas, 288 x 155 cm. Thomas Ammann, Zurich

walls – were it not for that irritating atmospheric disruption: the individual fields blur in the monotony of the repetition, in the relative colourlessness, or in the reduction to the contrast between black and white or one alternating colour. This quasi endless repetition of the eternally same banal or ingenious "object" subverts a basic principle of American Abstract Expressionism with its own weapons. Though theoretically the "all-over" can expand to become an all embracing, undivided cosmos, with Warhol it stays at the level of the inane uniformity of endless patterns of similarly stupid or sinister looking cows or Mao heads (ill. 2). Here too, in his *Last Supper*, the accumulation merely leads to an undifferentiated abundance that lacks a centre. With this project, Warhol even went a step further, varying the internal pictorial rhythm and combining the silkscreens (all of which have no centre and yet are differently composed) in such a way that any hint of the clarity of a central perspective is lost in the sum of the individual fragments. Or else he discredits the congruity of the scene by a superimposed camouflage pattern (cat. 19), a procedure he used in the last two years of his life for two particularly important and serious themes: his self portrait (ill. 3), and the portraits of his counterpart and friend Joseph Beuys (ill. 4), whom he greatly admired, though not without a certain exasperation. Whereas in the first example, the camouflage served primarily to intensify the cleverly devised game of concealment, in the second case it served to express uncertainty; the taboo of the private sphere shifts to being a problem of comprehension.

One eye witness reports that the first "official" meeting between Warhol and Beuys in a Düsseldorf gallery in 1979 had "all the ceremonial aura of two rival popes meeting in Avignon". Whether or not one chooses to reject this characterisation as deliberately falsifying media hype that confines the two artists within the traps of their public roles, it still hints at one essential fact: that the encounter between these two artists was also a confrontation of two intellectual positions in the world of art, which – like pope and anti-pope – shared a common root, had drifted light years apart from one another, and yet – at least from the viewpoint of the American – revolved around the opponent in yearning admiration.

Although, in a kind of obsessive acquisition, Warhol devoured portraits of the greats from the glamour worlds of the media and politics, much like the Campbell's soup cans, only to expel them again in an attitude of cool distance, in the case of his relationship with Beuys this applied only to a limited extent. One reason was that Warhol, the most impersonal and for that reason most difficult artist of his generation, created – despite all their distance – the most *personal* portraits of the

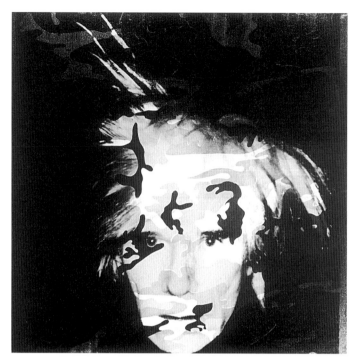

3 Andy Warhol, *Self-portrait with Camouflage*, 1986. Synthetic polymer paint and silkscreen ink on canvas. Bernd Klüser Gallery, Munich

past decades, bursting with complexity and flying in the face of their technical reproducibility, their material production. Just at that moment when the portrait was thought to be passé, along came Warhol and his Factory, his series production, his radical renunciation of a personal signature, and despite or because of all this created genuinely contemporary portraits, which are not just an expression of our mass society and the loneliness of the individual; the best of them often express something substantial about those they portray.

Another reason was that despite all the distance they maintained, in the end Beuys and Warhol aspired to a comparably romantic-idealistic grasp of their surroundings: extreme banality as regards their materials and production methods, with the aim of propagating a form of creative work which was accessible to and feasible for all.

Both factors, Warhol's extraordinary affinity to the portrait and his fundamental proximity to Beuys, allowed him to produce portraits which sum up the difference between a serious and meaningful northern European attitude and its pragmatic American counterpart with its blind faith in facts. Beuys in a camouflage outfit! What metaphor could bear more cogent witness to the admiring lack of comprehension on the part of the American for a world which he nevertheless respected with a childlike ironic distance? What could better encompass

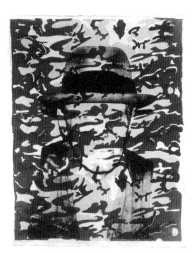

4 Andy Warhol, *Portrait of Joseph Beuys with Camouflage*, 1986. Synthetic polymer paint and silkscreen ink on canvas. Bernd Klüser Gallery, Munich

Beuys than this camouflage outfit which stands for strangeness and concealment, but which functions here so poorly as a disguise that it fails to veil the intense gaze, the open face of the artist? Beuys is a closed and open book at one and the same time, near and far, full of childlike naive trust in the individual's capacity to develop, and full of scepticism about the apparatus that supervises that same individual – all these concepts shine through in Warhol's portrait, which thereby characterises Beuys more perceptively than many theoretical writings. At the same time, they are an informative statement about Warhol himself, an artist for whom image and surface were an indispensable camouflage, protection for a vulnerable individuality. In his *Last Supper* this camouflage takes on an even greater potency: mystifying the model, its content *and* its artist creator, who once again evades us entirely.

This loss of a centred world view communicated in the silkscreens is also emphasised in the collages (cat. 31–40, 42–55) in which the colourful pieces of paper serve to interpret not the depiction but an abstract pictorial composition independent of that depiction. The opposed colour fields or the overall views of the motif (e. g. cat. 31, 40) create a more or less fragmented three-dimensionality, which in typical Warhol manner confronts the whole with tiny individual particles in keeping with the maxim: "Space is all one space and thought is all one thought, but my mind divides its spaces into spaces into spaces and thoughts into thoughts into thoughts."[21] This atomisation of once all-embracing concepts into the monotony of endless series, a feature of Warhol's work since the early silkscreens, constitutes a terse formulation of an idea which, in modified form, has influenced broad sectors of contemporary art.

One of the most original and self-willed parallels is contained in the work of "capitalist realist" Sigmar Polke, who in the 1960s, together with Gerhard Richter, stood for a "Euro Pop" oriented around the German economic miracle. A digression into Polke's contribution to the 1986 Biennale (ill. 5a/5b), some of whose presuppositions corresponded to Warhol's Milan commission, might well serve to illustrate, by comparison, what was so unique about Warhol's concept. The two projects came about at almost the same point in time. Both were oriented around undisputed superstars in the history of art and culture; the American's around a European authority, Leonardo da Vinci, the German's around Albrecht Dürer, a national identification figure of international renown. When an artist who, like Joseph Beuys, is both admired and ridiculed as an alchemist, sorcerer and manic experimenter, designs the German pavilion at the Biennale, then the spiritual

link with Albrecht Dürer, Venice lover and epitome of great German art, immediately suggests itself as an in many ways honoured and at the same time ironically reversed counterpart. Could there be a more advantageous model with which to best demonstrate the cracks and contradictions in the contemporary image of the artist in a changed world?

Polke has always ridiculed the role of the artist as a messianic renewer in a doomed society, subverting it with irresistible comedy. Irony as self-protection seems to be the motive that has influenced the basic tenor of his particular game with stylistic disguise, his scandalously non-hierarchical exploitation of kitsch and art, high and low culture, his deliberate thwarting of the significance of the artist as an ingenious creator! Polke avails himself not only of bad taste (especially in the early works) and semi-mechanical production processes as artistic means, but also of materials from the alchemist's kitchen. Changing mineral compounds, such as phosphorescent veils of colour and layers of varnish, become magic concoctions, conjuring up an aura of secrecy and incomprehensibility. Both of these inform Polke's understanding of art at a point in time when artistic work tended to be understood merely in terms of its entertainment value, or as valuable stocks and shares to be hung on the wall.

Given these circumstances, what could it mean when a contemporary artist exploits the incarnation of great German art, Albrecht Dürer, in such an impudent and banal way? Is it hubris, self-overestimation, or an ironic undermining of the stylisation of the artist as a heroic and missionary superman? Does Polke really believe in the role, or is he just cleverly plundering an available pictorial repertoire? Does he want to demonstrate that for him the values which had a normative character in Dürer's time – ratio, moderatio, providentia – can only signify blown-up verbal clichés, outsize balloons with no depth of meaning? But can they then at least be reversed to become significant form per se?

Despite these perhaps heretical assumptions, one thing is certain: Polke chose his themes very deliberately and thus, like Andy Warhol, knowingly placed himself in an existing tradition and faced up to possible comparison with Dürer. Regardless of how he judged his relationship to him, understanding it either as an ironic separation or a pathetic acquisition, what is decisive is that in his choice of worthy pictorial models and sources Polke, like Warhol, recognised no hierarchies, and he specifically fixed on this Biennale as the moment for his debate with Dürer. In his overall conception, with its alchemical-experimental basis, Polke was reacting indirectly to Dürer; in the eight ribbon paintings he was reacting directly: these are

5a Sigmar Polke, *Acht Schleifenbilder (I: Ratio)*, 1986. Graphite, silver, sepia on canvas. Staatsgalerie moderner Kunst, on loan from the Galerie Verein e.V., Munich

5b Sigmar Polke, *Acht Schleifenbilder (III: Alactritas)*, 1986. Graphite, silver, sepia on canvas. Staatsgalerie moderner Kunst, on loan from the Galerie Verein e.V., Munich

repetitions, though enlarged into isolated pictorial signs, of the ribbon ornamentations attributed to the virtues in Dürer's contribution to the triumphal procession of Emperor Maximilian I (ill. 6). With a childlike, naive delight in imitation, Polke transforms them into almost square, individual paintings which vary slightly in size. Whereas in Dürer the ornamental signs are confronted whimsically with the highly detailed depiction of the triumphal carriage, in Polke the contrast is between line drawing (=ribbon) and free painting (=picture ground), that is to say, the reverse. Thus the attendant aperçu is transformed into a largle determining and well thought-out pictorial ornament in open dialogue with the informal painting of the picture's ground, which in its method is almost surrealist. The "colours", applied spontaneously and in some areas according to the principle of "action painting", are unusual as regards their components; they become altered and transformed beyond the control of the artist. The graphite, silver oxide and other basic elements Polke utilised as colour pigment not only take into account the overall theme of that particular Biennale, namely "Environment" (in reacting to the high humidity typical of Venice), they also form part of an experimental process which includes both alchemical practices and the semi-automatic painting processes of the surrealists. Polke defined his programmatic contribution to the Biennale as a transitory event lacking in any solidity or permanence and located somewhere between experiment and calculation, a

high-wire act without a safety net and above solid ground. Ambitious and full of self irony, he thus put himself up for discussion, unveiled and veiled himself, a chameleon in a wearisome "post-modern" society, who distrusts himself as much as his counterpart, and yet still wants nothing and nobody to be put on a par with him.

In Dürer's work the ribbons are still assigned to the corresponding names of the virtues and therefore to be understood in the context of a humanist tradition, whereas in Polke's they are mere vacuous ornament. Drawing and ground congeal into the pure beauty of abstract painting, which, robbed of its enlightening humanist basis, its content, is quoted merely as a formal aesthetic abbreviation. Just as rigorously as Warhol, Polke thus rejects any normative binding character for art. His position is comparably fragile and self-ironic. Yet there is still evidence of a considerable portion of subjectivism, which Warhol's very method excluded definitively.

The difference between these two artists can be located in a tiny detail: the dot. Whereas the silkscreen printing process sets it with technical precision, in Polke's travesty it is lovingly painted by hand in keeping with the motto: "I love all dots. I am married to lots of dots. I would like all dots to be happy."[22] A dot in an anonymous mass, yes, that is acceptable enough, but then nicely individual please, and not an ugly printed dot! This is diametrically opposed to Warhol's justification for his concentration on silkscreens: "I think it would be so

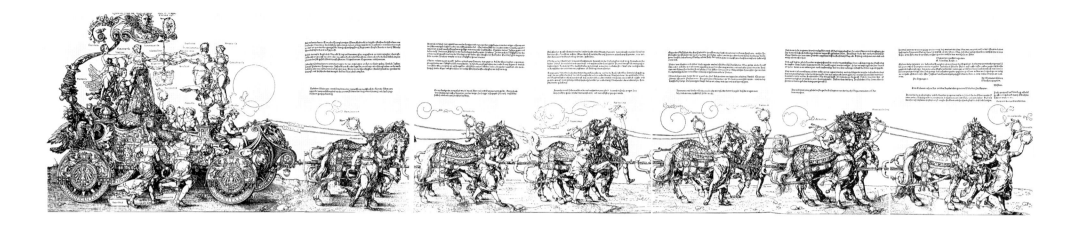

6 Albrecht Dürer, *Der Triumphwagen Kaiser Maximilians I.*, 1522. Woodcut. Staatliche Graphische Sammlung, Munich

great if more people took up silkscreens, so that nobody would know whether my picture was mine or somebody else's. ... The reason I'm painting this way is that I want to be a machine."[23] Polke still insists on a modicum of individuality in an amorphous mass, whereas Warhol pleads for absolute anonymity. And while Polke takes a minor element from an original Dürer model and raises it to the status of a freely depicted major element in his own work, his authorship remaining central, Warhol seizes merely on the surface view of the overall model, while he himself disappears shyly into the background.

From a methodical point of view, the process has much in common with structures in American literature – the series principle, the deconstruction of reality into individual particles, the supposedly objective representation based on the authenticity of a photograph. The precisely documented report, as practised by Warhol's respected model and friend Truman Capote, achieves its literary ranking thanks to criteria such as the isolation of a chain of individual observations and exactly researched details, which give the impression of being meticulously sober journalism, while narratively transforming everyday stories into events. It is no mere coincidence that the genre of the short story gained such literary significance in America, and that from east to west coast college courses are offered on the technique by highly respected authors. In a discussion with Andy Warhol, Capote differentiates quite clearly between a journalistic report, for which in principle everything, even gossip and rumour, can be a theme, and his own procedure as a writer. Warhol listens with enthusiasm to Capote's little tales about the wild groupie scene around the Rolling Stones and sees this as exciting material for later reports, whereupon Capote retorts: "Yes, it provides material, but it is nothing more than that, material. That's all. There's no echo. It's nothing more than a small series of anecdotes which all

mount to gossip, really. ... What's the point? Where's the art in it?"[24] Thus Capote returns to a classical definition of art which merely presents itself in a different methodological guise. For in the end, what is the "echo" on which he repeatedly insists if not the theme's relevance? Here Capote is also characterising Warhol's approach. As a private person he lapped up gossip insatiably but refrained from using it as the basis for his work. Instead the surface of the public image intervened, unadulterated by the voyeuristic gaze of the private. Furthermore, his selection is determined by the criterion of the "very medium" that corresponds to Capote's "echo". For although Warhol integrates any and every motif into his pictorial cosmos, from the cheapest supermarket product to the formidable symbol of European culture, he omits the whole realm of the private. In this way, an execution on the electric chair, a traffic accident, or an anonymous skull could be seen as worthy of depiction, but not the distribution of food to the poor at Easter, in which Warhol himself was actively involved[25], nor the everyday misery that exists behind and alongside events effectively presented by the media. This does not mean, however, that for Warhol Capote's "echo" can only be contained in utilisable public "commodities", yet anything with the slightest suggestion of being private is so strictly taboo that the question does not even arise.

In my view, this guiding principle also determined the Milan project, where for the purposes of the exhibition Warhol preserves the integrity of the original and does not paraphrase the given theme indiscriminately, as does Picasso, for example, in comparable cases. Instead he concentrates on the devotional image that had degenerated to the level of a mass product and which, as an endlessly modified copy, does not encroach upon the aura of the original, which only few people actually know. It also comes as no surprise that during the

15

opening of the Milan exhibition "the real *Last Supper* proved to be much less of a draw than Warhol. Only two diligent Germans ... could be found in the crepuscular gloom of the church refectory."[26] Here too, Leonardo's original, although objectively visible in the church on the opposite side of the street, remained invisible for the vernissage guests, who only had eyes for Warhol. Yet even if they had wanted to discover something about him in the exhibition, they would have been constantly confronted with just a typical Warhol image, the perfect camouflage both for Leonardo and for himself.

That element of the ephemeral inherent in the media event is subtly anticipated in the pictures and their mis-en-scène: they become blurred by a technique that levels the model and by a "colourlessness" that neutralises it, coupling sterility and artificiality with melancholy. These silkscreens are imbued with a strangely resigned sadness which seems to have to do not so much with the theme as with its disappearance – a definitive farewell to the sublime, to meaning, and to the possibility of individually determining one's position above and beyond the facade of the public domain.

If at all, then the painted works not exhibited in Milan (cat. 1–4, 11–14, 16–18), and which Warhol carried out himself by hand in his capacity as a "Sunday artist", must speak another language, especially as their technique allowed them to be more direct and thus more immediate. Here, the model was not a copy of a print, as in the case of the silkscreens, but the reproduction of an outline drawing after the original (very much in the style of the infamous Goethean "Weimar Prize Tasks"[27]), which Warhol projected onto the picture ground in different frames, proportions and relations to one another, or even as a whole, and then coloured in freehand inside the contours. Several of the coloured Christ figures are obviously based on an implacably kitschy plaster group which Warhol acquired for the purposes of this project[28] and which stood in his studio (see ill. p. 25).

However, even in the case of these "paintings", which were partially influenced by his collaboration with Clemente and in particular with Basquiat[29], what we encounter is a relatively reduced painterly process, which to a large extent leaves the pictorial ground free and thus intensifies the repressed physicality of the silkscreens by different means. The figures are reduced to outlines, have no volume, and, all in all, correspond to figures in those classical "colorbooks" so loved by Warhol, in which one page shows the clinically exact, coloured end-result, while the opposite page has just the bare outlines waiting to be filled in by the diligent but not very imaginative child or the Sunday artist. This does not require much more

than a relatively steady hand and the correct coordination of the colour fields, an adult procedure which the as yet unconditioned child rejects in its dreary boredom by painting wildly over the lines. Warhol too, allows himself some little slips of the brush: occasionally too his contours are inaccurate, seem scrawly and clumsily painted, and then again spontaneous and almost gestural by comparison. The selection, positioning and highlighting of individual details from the model, in combination with famous product logos, interpret the theme thoughtfully, by subjecting it to irony or by rendering it up-to-date.

Negatively speaking, one could say that Warhol debases the model, positively speaking, that he processes it for consumption by the average contemporary American citizen, who will identify in the silkscreens not much more than a holy picture, available on a mass scale, of unknown origins and equally unknown content. Warhol offers support both to himself and others in understanding the work, thus making a model otherwise not generally accessible either in terms of its artistic ranking or its spiritual content, at least partially digestible: in the painted works he shows a radical disregard for any kind of reverent hesitance, and by means of easily recognisable and comprehensible symbols relieves the despondent mood that may creep up on any contemporary not familiar with the theme in the face of so much holiness. Thus, for example, in "Be a Somebody with a Body" (cat. 13) he ambiguously and astutely links fitness mania and body cult with the figure of the saviour of mankind: Just who is better off here, remains unclear. Could this be an encounter between the toughened powerful "Body" of a sturdy though finite worldliness and an eternal, otherworldly spirituality? Or vice versa, shortly before his death could Christ be anticipating his future state of pure spirituality with a certain melancholy? It would seem permissible to ask the heretical question: Which is really worth it, a finite period of intense sensuality, or an infinite duration of unimaginably insubstantial and doubtless uneventful spirituality?

In another variation on the theme (see ill. p. 28), this "devout Catholic who was also a compulsive shopper"[30] links enlightenment, signified in the corporate emblem of General Electric and the purity of the popular soap "Dove", with a price reduction label on which is written, against a red background, something that in the American idiom can mean "selling out to the devil", "apparently referring to Judas as well as our contemporary society".[31] And, one might add, it would be hypocritical to start acting the missionary, because even the highest religious values have degenerated to the status of bargain offers in the lower basement, or else just survive pathetically

as yet one more remake or substitute. Or is Warhol perhaps contravening a widespread "fun culture" by presenting the fetish of eternal youthfulness and fitness, to which he himself fell victim[32], in all its wistful futility on the one hand, and on the other, by defining it for what it actually is: a squeaky clean and shiny advertising image which has nothing to do with reality and only presents the surface, that is, the beautifully styled product itself?

Looking at the overall project once again from this viewpoint, some associated elements emerge which signify a further differentiation in content. The above mentioned large-scale renunciation of colourfulness – especially evident in the silkscreens but with a correspondence in the paintings' black-grey outline drawing on white ground – plus the extreme dimensions and often reduced artistic technique make the cycle intractable and not easily accessible. Here, an artist whose work was normally predestined for use as an effective poster evades any such use by the media: the formats are too unwieldy, the colours too unfavourable, and the details too untypical to be suitable for a striking poster. The individual motifs often seem boring and, looked at individually, are more reminiscent of an invitation to a bible class. But obviously it was not so much his reticence about Leonardo as about the religious aspiration which dictated his artistic approach and determined the final result, which instead of media effectiveness radiates a serene atmosphere much less suited to quick wear and tear. Of course, the constrained sadness of the classical farewell theme is paired with a basic mood of melancholy which always accompanies Warhol's work, despite its often bold and simple colourfulness and superficial sobriety. His *Last Supper* cycle is of a much more transitory character than his *Disaster, Electric Chairs, Skulls* or *Marilyn* pictures (see ill. p. 32) which since 1962 had described the fleetingness of reality so emotionlessly. This aspect of transience inherent in the theme refuses to be understood against the background of an accompanying promise of eternal life. Instead, the hope of permanence fades in a very worldly reticence and resigned pathos. One is reminded of Warhol's comments in 1968 when recovering from the murderous attack on him during which he was critically injured by a psychologically disturbed former employee: "I always wished I had died, and I still wish that, because I could have gotten the whole thing over with ... I never understood why when you died, you didn't just vanish ... I always thought I'd like my own tombstone to be blank. No epitaph, and no name. Well, actually, I'd like it to say 'figment'".[33] To judge by this statement, with its reference to a totally worldly reality, officially, at least, Warhol

wanted nothing to do with transcendence, preferring to dissolve into nothingness as the "figment" as which he saw himself in life. His vision of death corresponds to the "nothingness of a blank after-image", as Trevor Fairbrother fittingly remarks[34], whereby the extent to which this undescribed state of being might have been able to take on contours is still an open question! This nothingness of the blank after-image ate its way into the *Last Supper* works, which have a strikingly conceptual quality and achieve abstraction with the means of figurative painting. In Warhol's extreme enlargement, the relationship between outline drawing and ground, legitimate in the model for the painted works, composed as it was for close viewing, cannot be taken in at a glance as a meaningful space for action. "Empty spaces" become the determining feature of the paintings, and these, plus the childlike brush stroke, intensify the impression of inaccessibility, fragmentation, incompletion. The paintings seem to belong to some intermediate realm; they are neither a real, sensually graspable event, nor an unambiguous projection onto an "other-worldly" state of pure spirituality. In the silkscreens, this unstable balance between proximity and distance, abundance and emptiness, precisely defined objectivity and the relativisation of all spatial coordinates, contrasts with a schematic overall structure primarily influenced by the mechanical reproduction process and the colour restriction. In both cases, however, reticence and restraint determined the strategy of an artist whose unusual media impact must undoubtedly be attributed to other attributes.

Warhol reacted unusually abruptly, therefore, when one interviewer drew a parallel between the relationship between Jesus and his disciples and Warhol's function in the Factory, inferring from this his dedication to the theme of the *Last Supper*: "That's negative. To me it's negative. I don't want to talk about negative things."[35] It is an open question whether this defensive reaction was an expression of deep religious feeling or the result of a superstitious fear of being punished by the Lord for his pride. Yet it is perfectly clear that he distanced himself from the thesis. It is quite unthinkable that Warhol would have savoured the disrespectful PR campaigns by the textile and car industries which used the *Last Supper* shamelessly and tastelessly as an advertising carrier for their products![36] By contrast, in both the public and the private spheres, to the extent that the latter is known to us at all, Warhol's own interpretation is guided by distance, prudence and reticence, a strategy that was appropriate both to his great model and the religious theme, and to his own safety.

The permanence of the fictive, the "figment" as Warhol

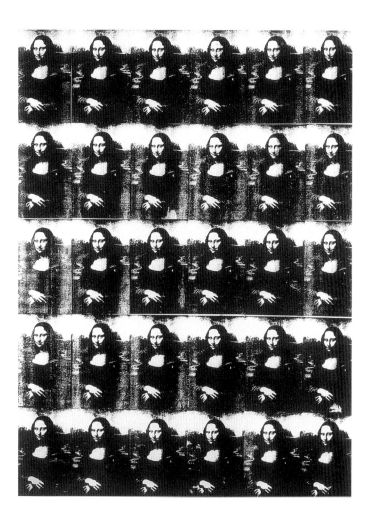

7 Andy Warhol, *Thirty are Better than One*, 1963. Synthetic polymer paint and silkscreen ink on canvas, 279 x 240 cm. Private collection

Yet this "eternally same" does not depict a tangible reality, but at most the reproduction of stylised superstars in glossy pictures, or, as in the *Last Suppers*, merely the incomplete reproduction of a copy that is in no way linked with the aureate radiance of the original. For Warhol the sceptic, that ethereal remnant of the sublime takes effect not in the profane or the significant object, but in its variously filtered reflection.

It has become almost traditional for modernism to see abstract art as the last refuge of transcendence and spirituality. From Wilhelm Worringer's trail-breaking work *Abstraktion und Einfühlung*, published in 1908, to Robert Rosenblum's exemplary thesis in *Modern Painting and the Northern Romantic Tradition*[39], the notion of transcendence has been associated with non-figurative art. Some important impulses for this emanated from the theological and philosophical principles manifest both in Protestantism[40] and in Jewish belief, while Catholicism, with its delight in images, has always had difficulties with abstraction. Thus Mark Rothko's and Barnett Newman's all-embracing meditation spaces, open in principle to everyone and condensing time into an undifferentiated duration, are inconceivable in their consistency without the philosophical background of Jewish mysticism. Its impelling force revolutionised art and created counter-worlds in which, according to Barnett Newman, "abstract thoughts and generally valid truths" could express themselves, and not a "sentimental or artificial beauty". The artist is no longer a copyist of given realities or a "maker of candy" but a "creator" and "searcher"[41]. The pictorial works mediate a synthesis between undifferentiated time and mythical form. Their spiritual content is identical with the object, exists in and for itself (ill. 8). In an essay on Newman, Jean-François Lyotard writes about a visit the artist made in 1949 to the grave mounds of the Miami Indians in southwest Ohio and the Indian forts in Newark, quoting Newman: "As I stood upright in front of the grave mounds in Miamisburg ... I was bewildered by the absolute character of the emotion, by the simplicity, which was so self evident ... You look at the place and you think: Here I am, here ... and back there, down there (beyond the boundaries of the place) is chaos, nature, the river banks, the landscapes ... But here you understand the meaning of your own being ... I got the idea of making the observer present, the idea that man is present."[42] It is hardly possible to formulate the unity of time and myth more clearly; time as the eternally valid everlasting "moment" is identical with the essence of the pictures, their primeval ground. For this reason, a work of art cannot be a description of something, and also cannot demand an interpretative explanation. It contains no message and illustrates

referred to himself, is already expressed in the uniformity of the early series or repetitions – for example, the variation on Leonardo's *Mona Lisa* in *Thirty are better than One* (ill. 7) – and permeates the whole work like a leitmotif up to and including the umpteenth instalment of the *Last Supper* (cat. 15). The central, non-hierarchical organisation plus the lack of differentiation in a surface divided into uniform fields are influenced both by the everyday reality of the media, and by eastern European icon painting. Warhol was familiar with the latter from his childhood in Pittsburgh and family visits to the church; his family were active members of the local Byzantine-Catholic community. The eternal repetition of the same excludes the idea of finitude and tries instead to awaken the impression of timelessness. "Like the Byzantine Catholic belief that man can be elevated to the divine, to transcend the worldly through the mysticism of repetitious chanting, Warhol elevates the profane to the level of the spiritual through the mantra-like repetition of images and the unreality of his colors."[37]

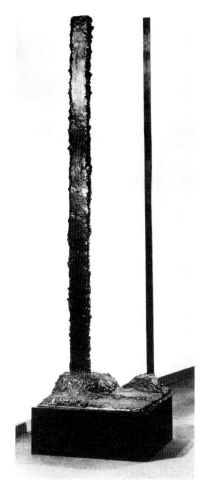

8 Barnett Newman, *Here I (To Marcia)*, 1950. Bronze. Collection Annalee Newman, New York

no idea; it exists in and for itself: "The work comes about in the course of the moment, but the gaze of the moment discharges itself on it like a minimal command: Be!"[43] In Newman's sense, this is the only possible reply to the question of the crucified Christ, and thus mankind's existential basis: "Why hast thou forsaken me?" Work titles such as "Be" and "Here" refer clearly to this concept of human existence as a simple "so being", which has no explanation and whose fundamental form always remains the same. Ideally, therefore, the essence of the individual work would be that it "takes place" and thus participates in the eternal order of the world. As a moral category the spiritual dimension is contained in each respective work as a command, not however in the sense of a maxim for action, but in the sense of a state of being, an eternally constant postulate.

The permanence of the respective work as a space of meditation is in Warhol being confronted with the thin ice of a surface reflection in which transience is manifestly perpetuated in the objective world. The beautiful appearance that shows itself to the fleeting glance, and makes Warhol's work seem so easily accessible, is a modern correspondence to the baroque allegory of transience which conceals something unknown behind the opulence of the surface and seems to suggest to the observer that there is cheer and abundance where in fact there is a gaping chasm. The fear of what might be concealed behind the passing scenes of reality, and that seizes on the wealth of images as a protection against the incomprehensible, has always been a determining moment in an art influenced by Catholicism. As long as this protective mechanism functions, potentially, all possibilities remain open to that concealed incomprehensible "beyond".

To this extent the secret behind the *Last Supper*, like that of its creator who so perfectly staged the camouflage, must remain essentially concealed. In the perpetually repeated formula that the surface of his pictures conceal nothing, Warhol would seem to be beseeching us to protect their secret, in the same way as in the thirteenth century Saint Stephen, founder of the Order of Grandmont, also beseeched his brothers: Saint Stephen is said to have "placed the casket in a secret and secure place and forbidden anyone to go near it during his lifetime. The brothers all felt the desire to know what was inside the casket. The saint himself hoped that all the brothers would hold it in the same great veneration as he did. After his death, they could no longer contain themselves and broke it open, only to find a piece of paper on which was written: 'Brother Stephen, founder of the Order of Grandmont, greets his brothers and requests them fervently to beware of the worldly

people. For just as you venerated the casket as long as you did not know what was in it, so too will they treat you!'"[44]

Could it be that Warhol so stubbornly insisted on the inviolability of the surface and its aspiration to exclusiveness, because in the depths of his heart he hoped it concealed a secret?

1 To the question as to whether the exhibition of Andy Warhols "monster-sized last supper silk screen" 1994/95 at the New York Dia Center for the Arts was worth the trip to Chelsea, Robert Hughes of *Time* magazine replied: "Are you serious or are you delirious?" Under the motto "Ask two Hugheses" the same question was put to Fred Hughes, the executor of the artist's last will and testament, who gave a positive reply and emphasised Warhol's interest in religious iconography. Both quotations are to be found in the press documents at the Dia Center in New York, together with portrait photographs and a reproduction of one of the paintings.

2 On this point, and for further details on the work's genesis, reception and historical categorisation, see Corinna Thierolf's contribution to this catalogue.

3 John Richardson, "Eulogy for Andy Warhol", in: Andy Warhol, *Heaven and Hell are Just One Breath Away! Late Paintings and Related Works. 1984–1986* (New York: 1992), pp. 140–141.

4 See note 1

5 See Ludwig Heydenreich, *Leonardo, The Last Supper* (London: 1974).

6 With reference to Paul Virilio's study of the same name (French "Estétique de la dispartion"), (Berlin: 1986).

7 Rupert Smith, quoted from the Sotheby's auction catalogue, April 1988, text to item number *927.

8 The Master's Thesis by Susanna Szanto, *Recovering Context and Meaning: Andy Warhol's 'Last Supper' in Milan*, University of Pittsburgh 1997 (unpublished) and research carried out by Corinna Thierolf (see her contribution to this catalogue) come to the conclusion that at least 24 silkscreens, 27 paintings, and 47 works on paper were created for this project.

9 See David Bourdon, *Warhol* (New York: 1989), p. 406.

10 As the quote for the article in *La Republicca* was translated from American into Italian, there is some doubt about how correct the translation is. It only makes sense in the form suggested here, which contains a list of the processes used by Warhol, as the silkscreens were not painted by hand. For the exact wording in the Italian quotation see Corinna Thierolf, note 45, p. 49.

11 For an introduction to Warhol's method see important exhibition catalogues such as Erika Billeter (ed.), *Andy Warhol: Ein Buch zur Ausstellung, 1978,* in Kunsthaus Zürich (Zurich: 1978), Kinaston McShine (ed.) *Andy Warhol – A Retrospective* (New York, Chicago, London, Cologne, Paris: 1989/90), *Andy Warhol. Paintings 1960–1986* (Lucerne: 1995).

12 Warhol, in: Paul Taylor, "The Last Interview. Andy Warhol", in: *Flash Art* (International Edition), no. 33, April 1987, pp. 40–44, p. 44.

13 The petition signed by important American artists was published in *The New York Times* of March 6, 1987. Reference in Susanna Szanto, (see note 8), p. 32.

14 Warhol, quoted in German translation from Alessandra Farkas, "Incontro con Andy Warhol alla Vigilia del Suo Amico a Milano Dove Presente una 'Copia' di Leonardo", in: *Corriere della Sera*, no date, press folder distributed by the Credito Valtellinese.

15 Taylor, 1987 (see note 12), pp. 43–44.

16 Ibid.

17 Ibid., p. 42.

18 Quoted from John O'Connor and Benjamin Lui, *Unseen Warhol*, New York 1996, p. 128 (speaking to Daniela Morera, a European editor of *Interview*, who accompanied Warhol during his stay in Milan for the opening of the exhibition on January 22, 1987).

19 Richardson, 1992 (see note 3), p. 141.

20 Martin Filler in *Art in America*, May 1987, p. 143. In my view, the author's conclusion that the choice of the theme of the Last Supper documents

Warhol's return to his Catholic faith in the last years of his life is in need of revision. Warhol was indeed more preoccupied with religious subjects, but the respective "sediment" had always exercised an infuence on his work. It could be that subliminarlly, Warhol, who was not free of sentimentality, superstition, or "premonitions", regarded paintings on this theme as apothopaic weapons.

21 Andy Warhol, in: *The Philosophy of Andy Warhol. From A to B and Back Again* (New York: 1975), p. 143.

22 Sigmar Polke quoted from the exhib. cat. *Sigmar Polke* (Tübingen, Düsseldorf, Eindhoven: 1976), p. 76.

23 Andy Warhol, in: Gene R. Swenson, "What is Pop Art? Answers from 8 painters", in: *Artnews*, vol. 62, November 1963, p. 26.

24 Andy Warhol, Truman Capote, "Sunday with Mr. C.: An Audiodocumentary by Andy Warhol Starring Truman Capote", *Rolling Stone Magazine* (New York: 1973).

25 See corresponding references in: *The Andy Warhol Diaries*, Pat Hackett (ed.), London: 1989, p. 722 (entry dated March 30, 1986).

26 Martin Filler, 1987 (see note 20). The two Germans were Inge Feltrinelli and Gabriele Henkel.

27 In 1799 Johann Wolfgang von Goethe and Heinrich Meyer instituted the so-called "Weimarer Preisaufgaben" aimed at influencing the fine arts of the time. The thematic selection was based on poems by Homer, of which individual episodes were to be illustrated according to strict guidelines. The project was discontinued in 1805 because of its minimal success and the poor quality of the contributions. See Johnann Wolfgang von Goethe, *Schriften zur Kunst*, Part I (Munich: 1962), p. 290 (first printed in the *Jenaische Allgemeine Literaturzeitung*, 1805).

28 See contribution to this catalogue by Corinna Thierolf.

29 See Tilman Osterwold (ed.) exhib. cat. *Collaborationes, Warhol, Basquiat, Clemente* (Kassel/Munich: 1996, and Thierolf, see note 27), p. 49.

30 Zan Schuweiler Daab, "For Heaven's Sake: Warhol's Art as Religious Allegory", in: *Religion and the Arts, A Journal from Boston College*, vol. 1, no. 1, autumn 1996, pp. 15ff., p. 26.

31 Osterwold, 1996 (see note 29), p. 27/28.

32 Warhol's mania for staying fit and keeping more or less up with young people is documented in many personal statements. For example, in his last interview he commented with a hint of resignation to praise at being able to lift 105 pounds. "No it's light. You're stronger than me. And fitter and handsomer and younger. And you wear better clothes." (see not 12), p. 48.

33 Andy Warhol, *America* (New York: 1985), pp. 126–129.

34 Trevor Fairbrother, "Vanitas: Skulls and Self-Portraits by Andy Warhol", in: exhib. cat. for the exhibition of the same name (London: 1996), n. p.

35 Taylor 1987 (see note 12), p. 41.

36 On the Otto Kern and VW advertisements, see Corinna Thierolf in this catalogue, p. 33.

37 Schuweiler Daab, 1996 (see note 30), p. 24.

38 Wilhelm Worringer, *Abstraktion und Einfühlung, Ein Beitrag zur Stilpsychologie* (Munich: 1908), new edition Munich 1981.

39 Robert Rosenblum, *Modern Painting and the Northern Romantic Tradition, Friedrich to Rothko* (London: 1975).

40 See the landmark publication by Werner Hofmann (ed.), *Luther und die Folgen für die Kunst* (Munich: 1983).

41 "... art is an expression of thought, of important truths, not of a sentimental and artificial 'beauty'. It established the artist as a creator and a searcher rather than as a copyist or a maker of candy." Barnett Newman, "On Modern Art: Inquiry and Confirmation", in: Barnett Newman, *Selected Writings and Interviews* (Berkeley: 1992), p. 67.

42 Jean-Francois Lyotard, "Der Augenblick, Newman", in: Jean-Francois Lyotard, *Philosophie und Malerei im Zeitalter ihres Experimentierens* (Berlin: 1986), p. 19.

43 Ibid., p. 23.

44 From a medieval source quoted in *Franziskanische Quellenschriften*, the Deutsche Franziskaner (eds.), volume 6, "Nach Deutschland und England, Die Chroniken der Minderbrüder Jordan von Giano und Thomas von Eccleston" (Werl: 1957, p. 199. I am very grateful to Annette Kehnel for this reference.

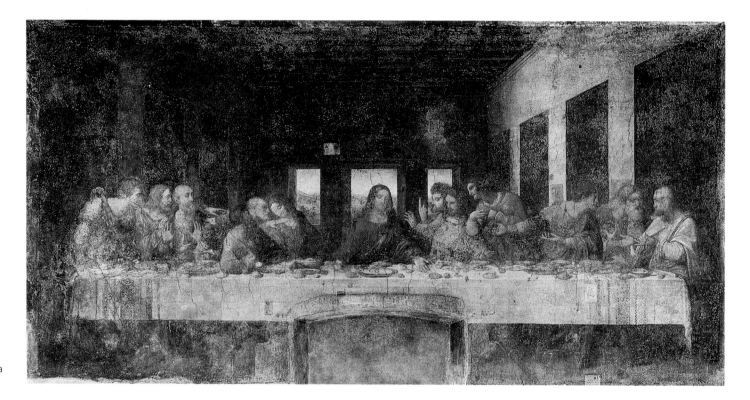

1 Leonardo da Vinci, *The Last Supper,*
1495–97. Mural in the refectory of Santa
Maria delle Grazie, Milan, 420 x 910 cm

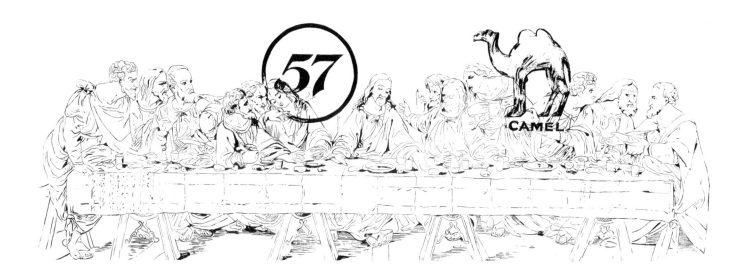

2 Andy Warhol, *The Last Supper (Camel)*,
1986. Synthetic polymer paint on canvas,
300 x 884 cm

Corinna Thierolf

"ALL THE CATHOLIC THINGS"[1]

"If you want to know all about Andy Warhol, just look at the surface: of my paintings and films and me, and there I am. There's nothing behind it."[2]

LOOK FOR THE DIFFERENCE

There is nothing as inscrutable as the surface of Warhol's pictures, and there is hardly a greater challenge to those seriously interested in his works than the task of exploring the meaning of the incredibly succinct formulas he offers by way of interpretation. "Art from art" is the ostensibly quite simple concept that has characterised Warhol's works from the very beginning. In examining them, one is confronted again and again with the question of whether the silkscreen prints done after photographs of Marilyn and Mao, dollar bills (ill. 3) and soup cans, and ultimately the works based upon classics of art history, (ill. 5 and 36) done for the most part during the eighties bear some meaning deriving from a virtually unidentifiable interaction between the original, the artist's model and Warhol's pictures. Does an examination of the banalising reproduction techniques and easily readable motifs uncover a truly rigorous and earnest analysis of media and consumer society, a probing critical study that casts an unexpected light on the people in that society? Or is there nothing but a "surface reason"[3] that does no more than demonstrate in a ratio of 1:1 what is already the subject of considerable discussion anyway – that "authentic" experience, is replaced by substantively neutral images intended merely for visual consumption?

The correlation between the question of meaningful high art and the succinct answer becomes all the more complicated, the greater the degree of tradition the popular subjects possess. While *Marilyn* was still a movie idol typical of her times and the empty, wooden *Brillo Boxes* (ill. 4) were amusing cuckoo's eggs whose real sisters promising laundry as white as the powder they contained could be found in every American supermarket, the *Last Supper* pictures confront us with a religious theme, which, because this genre plays no apparent role in 20th-century art, cries out for comparison with the more sublime contents of earlier works passed down by tradition. And this is particularly true in view of the fact that Leonardo's Milan *Last Supper* (ill. 1), undeniably the most famous work on this theme, was the point of departure for Warhol's pictures (ill. 2)

Leonardo's painting gained world-wide fame through oral and written accounts and above all through the distribution of reproductions, from among which Warhol selected his models. His approach to the visual processing of these "objets trouvés" was one he employed frequently in his creative work, and thus they have become "hallmarks" of his art. This approach involved the manipulation of found objects (modifications in size, serial repetition and a summary rendering of motifs; schematic coloration) as well as the integration of trademarks and labels for ketchup, potato chips, etc. Not only does this rough-and-tumble process guarantee a "genuine Warhol" in each and every end-product, it also serves to neutralise the sacred theme by turning it into a normal, everyday product, giving rise to the question of whether it makes any sense at all under such circumstances to look for a more profound level of meaning at all. There is, at any rate, no trace of any particular concern with issues of content to be found in the first entry in Warhol's diary, in which the artist remarks as follows with respect to the *Last Supper*:

"I'm doing the Last Supper for Iolas. For Lucio Amelio I'm doing the Volcanoes. So I guess I'm a commercial artist. I guess that's the score."[4]

THE COMMISSION

In about 1984 Alexander Iolas, Warhol's first gallerist and a friend of long standing,[5] visited the Palazzo Stelline in Milan, where he found a situation one might certainly regard – in Warhol's sense – as "very media".[6] The palace, originally a monastery and later used as home for the poor and finally as an orphanage, housed a bank at the time (and still does today) – the Credito Valtellinese.[7] The bank wanted to use the former refectory as an exhibition hall. Iolas responded with a concept for the first exhibition based on a perfect assessment of the circumstances: Opposite the Palazzo stands the Dominican cloister Santa Maria delle Grazie, in the refectory of which Leonardo painted his *Last Supper* between 1495 and 1497.

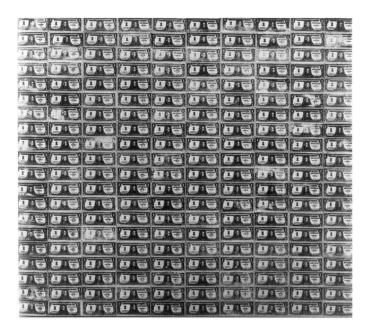

3 Andy Warhol, *200 One Dollar Bills*, 1962. Silkscreen ink on canvas, 205 x 220 cm. Private collection

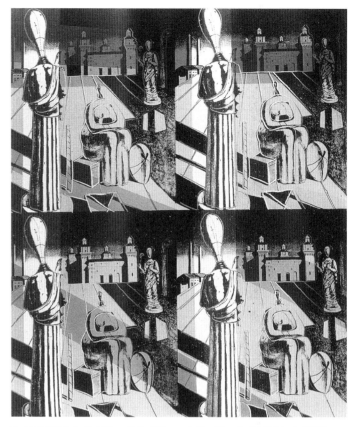

5 Andy Warhol, *The Disquieting Muses* (after Giorgio de Chirico), 1982. Synthetic polymer paint and silkscreen ink on canvas, 127 x 116 cm

4 Andy Warhol between his Brillo Boxes, 1964. Boxes. Silkscreen print on wood, each 43 x 43 x 35 cm. Photo by Fred McDarrah

Iolas wanted to couple the powerful aura of the painting, one of the most famous in the history of art, with that of contemporary responses, which viewers could see and compare for themselves. As Warhol remembered it, he asked three or four artists whether they would be interested in doing a *Last Supper*.[8] As it appears, Warhol, who had devoted the largest part of his work to popular phenomena and celebrities, was the only one sufficiently attracted to the idea to take the commission.[9]

The works relate to the paraphrases of the *Mona Lisa* (see ill. p. 18), a theme he had dealt with as early as 1963,[10] and to the extensive series of pictures begun during the mid-eighties based on masterpieces by Botticelli, Raphael (ill. 36), Munch, de Chirico (ill. 5) and others and gathered under the heading of "Art from Art".[11] Yet there were precedents not only for the pictures but for the exhibition concept as well, for works by Warhol had already been presented alongside paintings by Chirico, to which they were directly related, in a Rome gallery in 1982.[12]

The preparations made by Iolas and Warhol resulted in the exhibition entitled "Warhol – Il Cenacolo" (January 22nd, 1987 – March 21st, 1987), featuring 22 of the works completed in 1985 and 1986.[13] It was to be the last project presented during the lifetimes of the artist and the gallerist. Warhol died following a gall-bladder operation on February 22nd, 1987 and Iolas succumbed to AIDS. The exhibition was a farewell, a good-bye as shocking as it was wonderful, from which this *Last Supper* series subsequently derived a quality of mysterious

enchantment. The theme immediately calls to mind Christ prophesying his own death at the last meal in the company of his disciples. This parallel challenged a number of fans and interpreters of Warhol's art to attempt to uncover a hitherto secret hiding place in the soul of the artist,[14] who, although known to have come from a very religious family, appeared to have defined his life's goal in terms of the dictum "I want to be a machine"[15] – a purpose that stands in clear contradiction to the transubstantiation believed to have taken place at the Last Supper.

THE WORK

In the course of preparations for the project "Warhol – Il Cenacolo", for which at least 24 silkscreen prints and 27 paintings on canvas as well as 47 works on paper were completed and supplemented with a pair of sneakers bearing the painted image of Christ's face and a total of three *Collaborations* on the theme produced by Warhol and Jean-Michel Basquiat,[16] Warhol put together a diverse collection of reproductions of Leonardo's *Last Supper*. He had collected a number of sober,

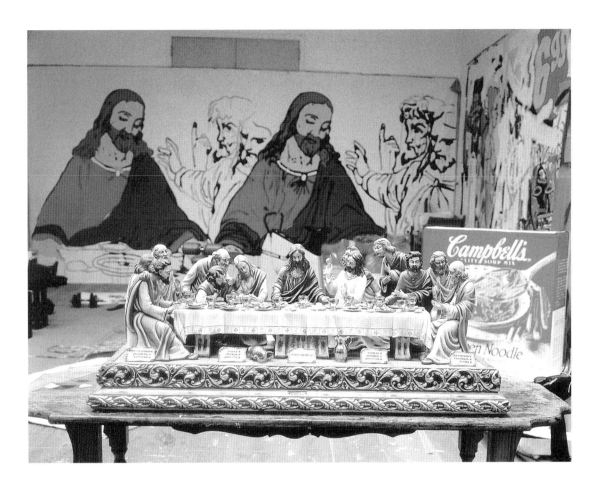

7 Refectory at Santa Maria delle Grazie after bombing on August 16th, 1943. In the background, supported by scaffolding and veiled with a cloth, is the north wall with Leonardo's *Last Supper* mural

6 Andy Warhol's studio with an enamelled porcelain sculpture based on Leonardo's *Last Supper*, 1987. Photo by Evelyn Hofer

objective imitations (ill. 10, 12) and curious transformations of the masterpiece (ill. 6), of which some have survived in his estate. In spite of this abundance of sources, it has not been possible to determine why and precisely when Warhol decided to use specific models and visual adaptations, since several documents are (still) missing[17] and because Warhol explored a wide range of possibilities while working on the project between the spring of 1985 and the spring of 1986. His approach during this phase is virtually impossible to reconstruct in retrospect.[18] If he had originally planned to paint copies of the *Last Supper* by hand, he abandoned that undertaking at least temporarily,[19] as his aim was to achieve as close an imitation of the original in his pictures as possible. For this purpose, a reproduction technique based on photographs seemed best suited. In 1987, Rupert Smith, who produced the silk-screen prints for the artist, recollected the difficult and time-consuming search for an appropriate photographic model.[20] The reproductions available at the time were too dark for Warhol's purposes – a consequence of the progressive deterioration of the original of which observers have been aware since the 16th century. Leonardo had not done the wall

painting in fresco technique but had painted it instead in oil and tempera on stucco. This allowed him to work more slowly, to render the figures more precisely and vividly and to devote his full attention to the prevailing conditions of light and shadow in the painted room. Unfortunately, the bond between the paint and the stucco undersurface was unstable, and considerable damage was already noted not long after the work's completion.[21] To make matters worse, the *Last Supper* was overpainted four times, and the dining hall itself was substantially reconstructed and later damaged during World War II bombing raids (ill. 7); the influences of heavy traffic and the effects of masses of viewers on the air in the room – no less severe than those caused by earlier flooding – had taken their toll as well.[22] Altogether, the work has been restored seven times to date. The last restoration was begun during the seventies and is not expected to be completed before the year 2000.[23] These operations – as Warhol himself was convinced[24] – have not significantly improved the painting's general condition. All of this simply goes to show that Leonardo's authentic creation is unreproducible and that, as a result, ideas about how the world's most often copied work looks are influenced by "copies" that reflect the condition of the painting at various different historical stages or paraphrase it in a number of more or less subjective or eclectic renditions (ill. 8 and 9). The current restoration will not change this situation fundamentally. Although previous overpaintings and retouching operations are being removed, giving us a more accurate idea of the original than has been possible heretofore, the

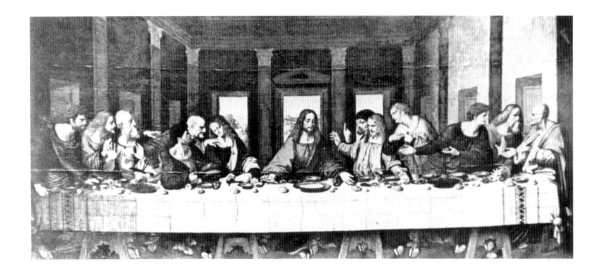

8 Marco D'Oggiono, *The Last Supper* (after Leonardo), circa 1500. Paris, Louvre

10 Outline drawing based on Leonardo's Last Supper, model for Andy Warhol's painted *Last Supper* pictures. The Andy Warhol Museum/ Archives, Pittsburgh. Photo by Matt Wrbican

missing segments are also being repainted at the same time, meaning that viewers will be confronted with the work in a condition of wholeness and freshness that could only be achieved through external intervention. In Warhol's view the only available model suitable for production of his silkscreen prints on canvas and paper turned out to be a photograph based upon a 19th-century copy of Leonardo's *Last Supper* (ill. 12, left below) found by Smith in a Korean-owned shop selling devotional articles located near the Factory.[25] For one group of these works, for example, the white sized canvas was covered with paint before the *Last Supper* motif (ill. 24) in black and, in some cases, the camouflage pattern was printed. Even the technically more complicated-looking collages combined with silk-screen prints (cat. 31–40, 42–55) are based upon a relatively simple principle: Prior to the one-step

printing process, coloured paper sections were fixed to the pictorial surface.[26]

Warhol also found an outline drawing in the "Cyclopedia of Painters and Paintings", published in 1913,[27] in which the composition and the figures of Leonardo's *Last Supper* are reproduced quite clearly (ill. 10). Thanks to this source, he eventually recognised the possibility of painting Leonardo's picture by hand, a method he had initially rejected, as mentioned above (cat. 1, 3–8, 11–14, 16–18, 20). Warhol fastened the drawing to the glass of an overhead projector[28] and transferred the projected lines in acrylic paint to the white sized canvas. By changing the distance between the projector and the picture, he was able to influence the size of his figures. Shifting the position of the drawing enabled him – as can be seen in cat. 18 – to turn the figures easily, even in large-format works.

One particular detail of the outline drawing, the head of Christ, was also used as a model for the so-called *Reversals* (cat. 9–10). For these, the work sequence was reversed in order to print the figures' surroundings, instead of the motifs themselves, on the canvas. The outlines of the 112 heads on each picture are actually gaps in this layer of paint, through which the white or yellow undercoat is visible.

Warhol also experimented with three-dimensional models, including a small white plastic maquette found by Rupert Smith at a filling station in New Jersey and a similar but larger and colourfully enamelled sculpture (ill. 6) Warhol had run

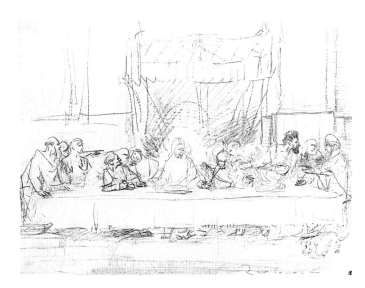

9 Rembrandt, *The Last Supper* (after Leonardo, done from a 16th-century engraving by Antonio da Monza), circa 1633. Red chalk drawing, 36.5 x 47.5 cm. Metropolitan Museum, Lehman Collection, New York

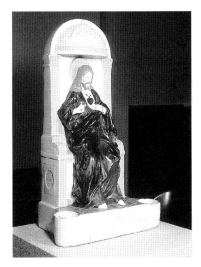

11 Domestic altar, between 1938 and 1941, painted by Andy Warhol, 42.5 x 25 x 15 cm. The Andy Warhol Museum/Archives, Pittsburgh. Photo by Matt Wrbican

13 *Wise Potato Chips Bag*, 25 x 14 cm, photocopy of a Wise potato chips bag, 25.5 x 13 cm. Models for *Last Supper* pictures by Andy Warhol. The Andy Warhol Museum/Archives, Pittsburgh. Photo by Matt Wrbican

across near Times Square.[29] From the latter piece in particular – a sculpture entirely worthy of comparison with works by Jeff Koons, which, beyond that, also shows a marked similarity to a household altar (ill. 11) Warhol has painted as a child, regularly furnished with candles and prayed at[30] – Warhol and his assistants took a number of Polaroid photos (ill. 12),[31] from which he did several drawings.[32] According to Liu, Warhol had begun the project with the desire to find a "new perspective" on Leonardo's fresco in order to make it "exciting" again.[33] This is presumably one of the reasons for his decision to begin with photographs from a bird's-eye view. Although he did not pursue this approach further,[34] the summarily applied luminous colour characteristic of several of Warhol's pictures, which differed from the nuanced internal coloration of the model (cat. 18 and 20), and the depiction of a fish on a plate seen from above in cat. 18 can be related to the second of these sculptures and the corresponding photographs. It is possible that Warhol's decision to leave the painted figures white in many cases was based not only on the source drawing but also on the plastic maquette, the white figures of which were – audaciously – meant to suggest marble.[35]

Also worthy of mention in the context of the various sources and models are the large, flat trademarks or logos by means of which Warhol parried Leonardo's achievement in central perspective in some of his painted pictures. The stylised owl's head (cat. 16) that partially conceals the figure of Andrew (!) and completely covers those of Judas, Peter and John is the fitting signet of the "Wise" Company, a maker of potato chips (ill. 13), which purposefully placed the owl, a

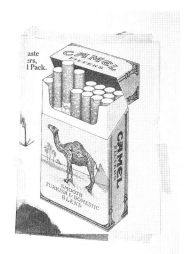

14 Ad for "Camel" cigarettes from the *New York Times*, May 5th, 1983, model for the *Last Supper (Camel)*. The Andy Warhol Museum/Archives, Pittsburgh. Photo by Matt Wrbican

symbol of wisdom, on its packaging. The circled number "57" in cat. 12 alludes to the "Heinz" Company of Warhol's native city of Pittsburgh, which boasts on every label that it supplies the world with "57 varieties" of sauces, including its famous ketchup (ill. 20). This wonderfully integrated signet, which serves John as a kind of halo, is opposed on the right-hand side of the picture by an animal labelled as a "camel". Unlike the corresponding newspaper clipping with the cigarette brand symbol (ill. 14) from Warhol's collection of models, the painted camel has two humps instead of one, and the printing is slightly modified. The invention of the second hump, according to Warhol's chief assistant Jay Shriver, would not have been in keeping with the artist's approach.[36] In view of the fact

12 Andy Warhol, Polaroids of the enamelled porcelain statue, 1985. In the background is the model for the silk-screens (left below) and for the painted pictures in the *Last Supper* series (right below). The Andy Warhol Museum/Archives, Pittsburgh. Photo by Matt Wrbican

15 Andy Warhol/Jean-Michel Basquiat, *Mind Energy*, 1985. Synthetic polymer paint on canvas, 297 x 409 cm. Private collection

27

16 Andy Warhol, *The Last Supper (Mr. Peanut)*, circa 1985/86. Silkscreen ink and synthetic polymer paint on canvas, 255 x 295 cm

17 Ad for "General Electric" from the *New York Times*, Sept. 20th, 1984, model for Warhol's *The Last Supper (Mr. Peanut)*, circa. 1985/86. The Andy Warhol Museum/ Archives, Pittsburgh. Photo by Matt Wrbican

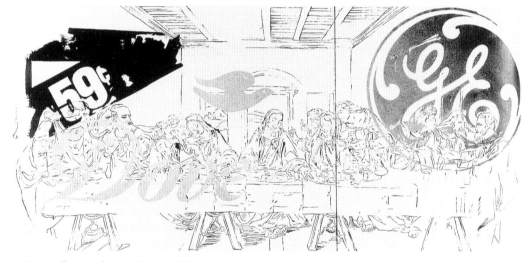

18 Andy Warhol, *The Last Supper (Dove)*, 1986. Synthetic polymer paint on canvas, 290 x 658 cm

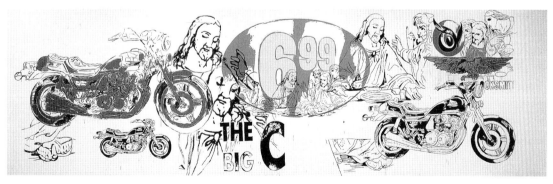

19 Andy Warhol, *The Last Supper (The Big C)*, 1986. Synthetic polymer paint on canvas, 295 x 988 cm. The Andy Warhol Museum, Pittsburgh

that Warhol appropriated other trademarks without manipulating them, this statement appears plausible, and it remains unclear where Warhol found his source or why he transformed the "Camel" camel into a two-humped animal.[37]

Other trademarks appear in some of the pictures not exhibited in Munich. They should – keeping in mind the entire complex of the *Last Supper* series – be mentioned in passing, at least. In the painting *Mind Energy*, executed jointly by Basquiat and Warhol (ill. 15), the advertising figure known as "Mr. Peanut" is incorporated in front of the group around Christ and John.[38] Above it – as an additional contribution by Warhol – is the above-mentioned Wise trademark and to the right a hand in front of a plate bearing a geometrical drawing, a motif Warhol undoubtedly discovered in the course of his interest into esoteric healing arts.[39] "Mr. Peanut" appears again in a painting done by Warhol alone (ill. 16), next to the "GE" logo representing General Electric (ill. 17), a symbol he appropriated for his purposes while working with Basquiat.[40] In *Last Supper (Dove)* (ill. 18), the price notation "59 c" is also included, along with the printing and symbol for the simple and popular "Dove Soap".[4] In the complexly structured, large *Last Supper (The Big C)* (ill. 19), the Wise symbol is accompanied by motorcycles, an eagle, the print fragment "ocksmit" and the oval-outlined numerals "6 99", the latter also a price label that overlaps the central group of figures. Below it are the words "The Big C", an expression which not only refers (presumably) to Christ but, in the U.S. at least, is a discreet yet popular reference to the disease of cancer (ill. 20).

Finally, mention should be made as well of the *Be a Somebody with a Body* pictures, represented here by several examples (cat. 1, 2 and 13), which may be regarded as a distinct series within the larger series of painted versions of the *Last Supper*, since the combination of lettering with the image of a bodybuilder adorned with a "halo" appears either as an independent painting or is set on an equal footing opposite the figure of Christ, shown without symbolic props, or overlapped by it. It has not been possible to determine from which of the many newspapers obtained and examined by Warhol and his assistants the source was taken nor to identify the context in which it appeared. Only a photograph of such an ad (ill. 21) is found in the archives of the Andy Warhol Museum in Pittsburgh. This may have served Warhol as a working model, and it shows once again how accurately the artist integrated available motifs into his pictures.

According to the information evaluated here, the *Last Supper* series was produced between the spring of 1985 and the spring of 1986. Entries in Warhol's diary indicate that he

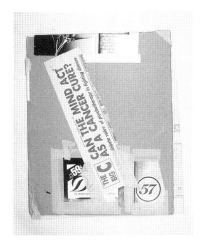

20 *"The Big C"*, newspaper clipping from the *New York Post*, July 25th, 1985, photocopy of a label from "Dove" soap and a sauce label from the Heinz company, models for *Last Supper* pictures by Warhol. The Andy Warhol Museum/Archives, Pittsburgh. Photo by Matt Wrbican

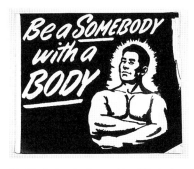

21 Photograph of an unidentified ad page, 30 x 36 cm, model for Warhol's *Be a Somebody with a Body*. The Andy Warhol Museum/Archives, Pittsburgh. Photo by Matt Wrbican

22 Former refectory at the Palazzo delle Stelline, Milan. Preparation for the exhibition "Andy Warhol. Il Cenacolo", January 1987

23 Andy Warhol, *The Last Supper*, 1986. Synthetic polymer paint and silk-screen ink on canvas, 102 x 102 cm

was already searching for a sculptural version of the Last Supper before April 25th, 1985. Of the three large sculptures under consideration, Warhol originally planned to use the largest, a piece measuring about 50 cm, for his work, but the middle-sized version was purchased on July 9th, 1985.[42] The time frame for the entire process is determined on the basis of Benjamin Liu's statement that the photographic experiments with this sculpture marked the beginning of work on the theme and on Rupert Smith's remark to the effect that Warhol was involved in the project for a year.[43] No reliable evidence has yet been found in support of repeated statements by both Jay Shriver and Benjamin Liu that Warhol had been concerned with Leonardo's *Last Supper* prior to receiving Iolas' commission.[44] According to the artist's own comments, the painted pictures were done on Sundays only: "I painted them all by hand – I myself; so now I've become a Sunday painter. During the week I have to earn money to live and to pay my fifty employees. That is why the project took so long. But I worked with a passion."[45]

DOUBLING THE LAST SUPPER – LEONARDO AND WARHOL IN MILAN[46]

As Iolas' commission was the stimulus for the *Last Supper* series, the selection and manner of installation in Milan deserves particular attention.[47] And we must keep in mind that

neither the gallerist nor the artist was present during the preparations. Iolas was seriously ill and had gone to Greece, eventually entering the hospital in Treviglio for treatment. He communicated his ideas to Philippe Daverio, who assisted on his behalf during preparations for the exhibition.[48] Warhol, who had sold his works to the gallerist prior to the opening and thus fulfilled his commitment,[49] nevertheless requested Daniela Morera's support in the realisation of the original ideas.[50] There were certainly agreements made regarding the selection and installation of the pictures, yet despite the likely existence of a clear conception, knowledge about the original planning for this widely acclaimed but ultimately improvised event remains sketchy (ill. 22).

Iolas want to erect semi-circular walls on both sides of the extremely elongated 600-square metre room and painting them, along with the parquet floor, white. The gallerist's intention here may have been to create a spatial effect reminiscent of earlier installations of the artist's work.[51] Warhol planned to show only silkscreen prints and collages in this ambience, and no paintings at all.[52] Positioned along the broad sides of the exhibition hall were six smaller silkscreen prints, in which Leonardo's *Last Supper* appeared in a dual top-and-bottom presentation (ill. 23),[53] and twelve collages with the face of Christ (see cat. 39 and cat. 41–52). These were "framed" by four large works hung on the curving walls. In three of the silkscreen prints, the *Last Supper* appears twice in a side-by-

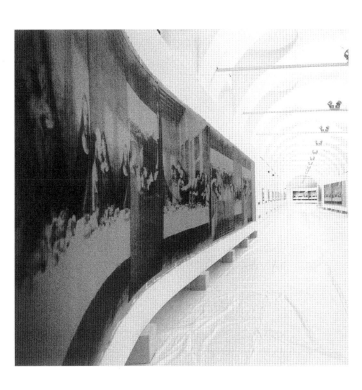

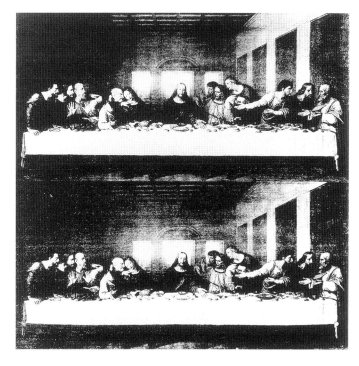

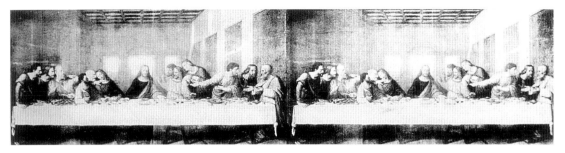

24 Andy Warhol, *The Last Supper (Pink)*, 1986. Synthetic polymer paint and silkscreen ink on canvas, 195 x 765 cm. The Andy Warhol Museum, Pittsburgh

Christ's death on the cross in the betrayal during the Eucharistic celebration[57] – is reinterpreted by Warhol. Visitors entering the refectory in the Palazzo Stelline found themselves confronted by a large number of different sized compositions in a central perspective arranged side by side and one above the other as well as more than a hundred "cloned" disciples and 34 Christ figures.[58] The artist chose not to depict a Crucifixion scene (although that theme was an important focus in his later work).[59] Although the length of the large prints corresponded approximately to the original, they were only half as high, so that the figures appear smaller than life size. In addition, the works were fixed at a relatively low position on the wall – certainly a function of the architecture of the Palazzo – which explains why the tension deliberately created by Leonardo between the "lower world" of the monks and the Last Supper scene presented above it, but in a frontal view, in Warhol's work no longer has the theological ambivalence of the original. At the same time, access to the community (or communities) portrayed is not made easier, for despite the changes in size on Warhol's canvases, the monumentality of the figures inherent in Leonardo's painting, and thus the explicit distancing of the viewer from the pictorial image, is maintained. Warhol's pictures were created with the aid of a copy in which, despite all of the obvious differences that distinguish it from the original (the figures are painted more primitively, and the apostle Thaddeus, in particular, is portrayed as considerably younger), the proportions of space and size in Leonardo's work are virtually unchanged. That Warhol chose this particular copy is all the more remarkable in view of the fact that the specific characteristics cited above are manipulated in many of the copies and paraphrases done by other artists (ill. 8 and 9).[60] Exemplary evidence of this can be found in a print based upon Leonardo's *Last Supper* with which Warhol was very familiar, a picture his mother had inserted between the pages of her old Slavic prayer book

side arrangement (ill. 24); the fourth presents details featuring groups of up to six figures from Leonardo's composition, both "right-side-up" and upside down (ill. 25). If we consider at this point the relationship between the refectory and the fresco developed by Leonardo in Santa Maria delle Grazie (ill. 26) – a comparison that was certainly intended to be a "component" of Warhol's exhibition[54] – we recognise several major differences, differences of which Warhol must also have been aware, since he had viewed the original for the first time during the eighties.[55] Leonardo had painted his work, which measured 4.20 x 9.10 metres, in the upper portion of the north wall of the refectory. In spite of the illusionism meant to suggest the real nature of the events, the figures, themselves larger than life, were also monumentalised within the room in which they were shown. These criteria are essential to an understanding of the work. While the subject was undoubtedly chosen for the dining hall in order to integrate the monks into the communal meal celebrated by Christ and his disciples, the position of the painting the handling of perspective and the proportional relationships foster an attitude of reverence on the part of the faithful towards the death of Christ, whose sacrifice meant the redemption of humankind, as symbolised in the Eucharist. These real and symbolic references to monastic life,[56] which are further augmented by a Crucifixion scene on the opposite wall – an allusion to the origin of

25 Andy Warhol, *The Last Supper (Red)*, 1986. Synthetic polymer paint and silkscreen ink on canvas, 198 x 1000 cm. Galerie Bruno Bischofberger, Zurich

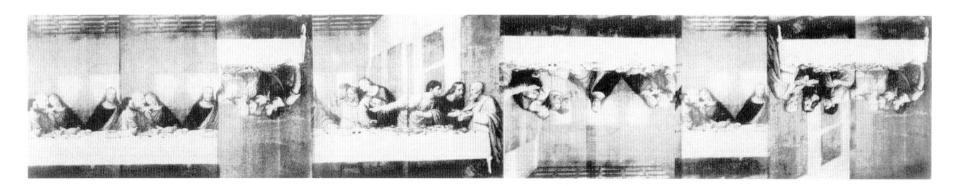

(ill. 27). In this version, the head of Christ does not rise so high in front of the window as it does in the original. The subtle language Leonardo developed in the enlargement of his figures in order to express their elevated status apparently struck the copier as unsuitable for a picture meant for popular use. Much simpler to comprehend of course, especially in a print incapable of communicating a complete spatial experience, is the halo introduced instead – a "foreign body" which, by the way, despite the other substantial differences that distinguish the work from Warhol's, is remarkably similar to the circled "57" in cat. 12.

A completely different view is gained through comparison with the *Last Suppers* featuring versions arranged one above the other, in which Warhol may have referred to the dual reality of Leonardo's work – the illusionistic extension of the monastery refectory into the picture[61] and the action depicted in the scene – while emphasising at the same time the distinction between the authentic *Last Supper* and its painted representation. Such a conclusion is both supported and led *ad absurdum* by the pictures, for how indeed could the difference between "above" and "below" be expressed by placing identical images one above the other?

Warhol's bold mixture of elements of pictorial design appropriated from Leonardo (including the proportional relationship between the figures and the room) and those he altered (hanging the pictures lower, varying their size, repeating the

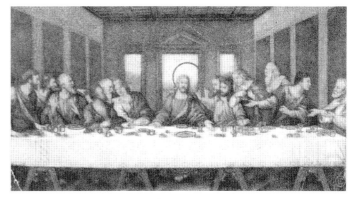

27 Mass card showing the *Last Supper* placed by Julia Warhola in her prayer book, 5 x 9 cm. Anna und Paul Warhola Collection, Smock, Pennsylvania

scene or focusing on details, "cutting the composition apart" and reassembling it, or – in the collages – using a "torn" background with complete detail printed on it, dispensing with local or natural colours in favour of a two-colour scheme) set a confusing perceptual game in motion, the effect of which is further heightened by the unusual, curving space, which prevents the viewer from establishing any kind of fixed orientation. Christ became present not only once but many times in numerous Last Supper scenes, and Leonardo's composition based upon a central perspective from the standpoint of the viewer was opposed by multiple versions by Warhol. As a result, an important aspect of traditional theological interpretation is rendered useless with respect to the Renaissance painting, for the perceived visual unity of the image, which can be interpreted as a reference to the unity of Church and doctrine, is no longer there. Appropriately, the exhibition hall had no fixed spatial boundaries, which, as in the opposing refectory, might have determined the dimensions of a composition. Moreover, the pictures themselves had no fixed borders, a circumstance which is unfortunately no longer recognisable due to the decision taken after Warhol's death to mount the canvases on stretchers. Warhol had left behind all of his *Last Suppers*, including the works not shown at the Palazzo Stelline, in unmounted condition, as painted cloths. The large silkscreen prints exhibited in Milan were fastened directly to the wall. Thus the question arises whether the white margins around the motifs and the slightly oblique placement of the prints on the canvas are deliberate aspects of Warhol's response to Leonardo or merely "errors" resulting from the printing process, which were capable of subsequent correction through stretching on frames that established clear pictorial boundaries. Warhol himself left the question open.[62]

26 Refectory at Santa Maria delle Grazie, Milan

29 The Turin Shroud (detail)

30 Andy Warhol signing catalogues during the openings of the Milan exhibition. Photo by Maria Mulas

31 Title page of the New York weekly *The Village Voice* of May 5th, 1987

28 Andy Warhol, *Gold Marilyn*, 1962. Synthetic polymer paint, silkscreen ink and oil on canvas, 211 x 145 cm. The Museum of Modern Art, New York, gift from Philip Johnson

service of the original and thus interpreted Leonardo's painting as the creation of a divine artist.[64] In doing so, he identified as the motor that powered his activity an impulse to which St. Veronica and the icon painters after her had responded. His intent, namely, was to "make a copy of the original, so that ultimately everyone could take it home and hang it in their living rooms".[65] In his works, just as in the "true images" of legend, of which the Turin Shroud (ill. 29) is an example, the depicted image appears only in rudimentary form on the canvas.

Warhol, of course, did not make a copy of the original but instead a copy of a copy, which he also manipulated in accordance with the same "universal" principle he employed in his work on other pictorial themes. It is also true that his moveable pictures, in contrast to Leonardo's work, belong to a grey area between art (with religious themes) and the art market; in other words, they were not painted for use as religious articles and are thus emphatically "open" to other purposes. A purchaser, therefore, buys both a "painting by Leonardo" and a picture by Warhol, and will find information in the work which reflects additionally on the discourse regarding uniqueness, repetition and original creation.

The contrast between Leonardo's *Last Supper* and Warhol's *Last Suppers* was made clear at the opening of the exhibition by the visitors, many of whom had travelled great distances. In attendance were between 3,000 and 5,000 persons[66] who, according to accounts, were more interested in the pop star himself (ill. 30) than in his pictures and who, on the other hand, gave more attention to these than to Leonardo's work, which they had been encouraged to view first.[67] There was no simple, quiet meal between the Last Supper and the Crucifixion but instead a party amongst numerous bright-coloured pictures, a happening at which not Christ but the God of Pop, who died shortly afterwards, was the dynamic "centre" (ill. 31). Asked whether the followers of Christ could be compared with those of Warhol, Benjamin Liu answered, "I would say absolutely but that would be totally wrong".[68] Warhol responded to a similar suggestion by saying: "That's negative, to me it's negative. I don't want to talk about negative things."[69]

THE "REAL" LAST SUPPER

There is no doubt that Leonardo's work has been "held consistently in great admiration by the people of Milan and by foreigners as well".[70] Nevertheless, or perhaps for that very reason, some travellers to Milan have surely wondered where the "real *Last Supper*" is, and more than a few visitors are likely to have departed in the belief that they had seen the original,

It has been suggested that Warhol intended to recall Leonardo's direct application of his painted *Last Supper* to stucco by having his pictures fastened directly to the wall.[63] It also appears conceivable that he meant to allude to Leonardo's work at another level. His printed cloths possess a quality that can be associated with the Vera Icon tradition. According to legend, Christ responded to St. Veronica's wish to have a picture of her Lord with her at all times by pressing his face into a linen cloth, in which his features were miraculously preserved. A possible reference to this "true image", not created by a human hand, can be recognised in Warhol's technically produced prints, which provide copies of the greatly admired original. In much the same way that icon painters oriented themselves as nearly as possible to original images (or to replicas that corresponded closely to them) in order to preserve their aura in the reproduction, Warhol, to whom an interest in "religious posters" was by no means alien (ill. 28), placed himself in the

32 Copies of Leonardo's *Last Supper* in the refectory at Santa Maria delle Grazie, circa 1900

33 Jeans ad for Otto Kern company, 1993. Photo by Horst Wackerbart, Düsseldorf

Alps, the painting presumably commissioned by the French king Francis I is probably the best known. It is said to have done after the king's wish to take the original "back home to his kingdom"[72] was denied. Three-dimensional versions were also in existence as early as 1500.[73] The first enamelled replica – Warhol worked with a late successor of this genre – is dated circa 1550. Important artists, including Raphael and later Rubens and Rembrandt, did works based upon the original.[75] Prints made with varying degrees of accurate replication of the original or of existing copies[76] have contributed significantly to the popularisation of the motif.

A photograph of the Santa Maria delle Grazie refectory in 1900 (ill. 32), taken after its conversion into a museum, can be interpreted as a kind of devotional image dealing with the flood of reproductions that spread over the entire globe in the 18th and 19th centuries. The arrangement of chairs is not to be understood as evidence of a painting class that has just left the room but as a precise aid in locating the masterpiece, about the original substance of which, as painted by Leonardo, only scholars are in disagreement. Without the seating arrangement, some visitors would have been disoriented in the room, in which numerous copies of varying ages mounted on easels or hung on the walls competed with the "real" *Last Supper*, as they were familiar only with reproductions of the work in which the spatial context, obviously regarded as unimportant or "distracting", is not presented. The silent choreography of the chairs allowed members of the newly arisen class of "middle-class intellectuals", for whom a visit to Milan was a duty, the dignity of a purposeful entry into this actually quite confusing "installation", which – it should be emphasised – bears a remarkable resemblance to Warhol's exhibition at the Palazzo Stelline. Once the monks had left the refectory, the visitors were able to learn what the room's new purpose was: the communication of knowledge about the "beautiful, true and good" original through the didactic medium of the comparative view. In retrospect, the liveliness of the scene – which is in reality quite museumlike – suggested by the easels can be regarded as a discreet indication of the unfettered hustle and bustle that took place *ante le mura*, where commercial painters, craftsmen and printing shops produced the *Last Supper* for a steadily growing circle of customers. The no longer quite so new "product" – naturally no more than an imitation of the original, which even a king had not been allowed to move from the spot – was made increasingly available, independent of its religious architecture, for private, secular use; now, however it could offer, once again, room for devotion. Warhol himself recalled being inspired by the religious content

although what they had admired was merely a work intended to resemble it. Today, at least 33 copies made only 40 years after the completion of Leonardo's work have been identified. The most astonishing fact about them is that they include four frescoes and three paintings on wood or canvas which once belonged to churches, monasteries or hospitals in Milan.[71] Other replicas have been discovered in Rome and northern Italy, in particular. Among the copies distributed beyond the

of the work,[77] reporting even that he had often passed by a reproduction hung in his parents' home and made the sign of the cross.[78] Yet the spiritual value of the image, which is preserved even in reproductions, is slowly being diluted. In 1993 the Kaiserslautern jeans supplier Otto Kern initiated an ad campaign featuring a photograph by Horst Wackerbart in which twelve bare-breasted female disciples in jeans are seen gathered around a trousered "guy" at the table of the Lord (ill. 33).[79] This bold commercial revelation immediately generated a publicity-rich scandal – a liturgy that obviously encourages repetition, as in the case of VW's most recent efforts to promote the new "Golf".[80] These are only two of many examples which show that the original is now so widely disseminated and used for so many different purposes as a glossy, high-class product and a cheap imitation that ultimately, if any thought is put on the matter at all, there can be no agreement as to where the picture actually belongs and what it shows. It would seem to have been covered over by the "sludge of habit",[81] which even the most rigorous restoration process cannot remove. Accordingly, when asked in an interview one month before the Milan exhibition whether Leonardo's Last Supper had a special meaning for him, he answered: "It's a good picture ... It's something you see all the time. You don't think about it."[82]

"I LIKE THAT IDEA THAT YOU CAN SAY THE OPPOSITE"[83]
THE EXHIBITION CONTEXT
AND THE INDIVIDUAL PICTURE

One of the principle features of Warhol's art is presentation of the same motif in a series of individual pictures. In addition – and herein lies the significant innovation – he often repeated the same motif within the same work. These two different strategies for generating serial images were incorporated into an exhibition concept that is characteristic for Warhol, in which each picture can be understood both as an autonomous work or as part of a larger context. Thus in Milan, for example, the integrity of content and composition in a simple Last Supper is both negated and confirmed. This irreconcilable contradiction is sustained in the Double Last Suppers, a series in its own right. Here, each separate picture contains a comparable, but not identical, portion of the information that a simple Last Supper can only communicate within the context of the installation.

Since Warhol repeatedly emphasised the bond that links similarly structured groups of works – with regard to his Shadows series exhibited at the Galerie Heiner Friedrichs in 1979,

for example, he commented: "Really, it's one painting in 83 parts"[84] – it is worthwhile considering whether this applies to the Last Supper series as well.[85]

Since the sixties, the artist typically sent pictures selected for exhibition – if he did not install them himself – to gallerists without precise instructions. In 1962 Warhol delivered his 32 Campbell's Soup Cans to the Ferus Gallery in Los Angeles and gave the director, Irving Blum carte blanche with regard to the mode of presentation and the sale of the works. It wasn't until Blum told the artist that he had decided to keep the pictures together[86] that Warhol answered: "Irving, I am thrilled, because they were conceived as a group, a series. If you could keep them together it would make me very happy."[87]

Perhaps encouraged by these positive experiences (or suggestions?), Warhol permitted the gallerist considerably greater freedom only a few years later. He sent his pictures of Elvis Presley, printed on canvases and composed of as many as eight (partially overlapping) repetitions of the same motif, to the gallerist, leaving it to the latter to decide where to cut the "individual" prints – in other words, to determine how the serial images within each picture were to be serialised outside the picture (ill. 34). This flexibility made it possible to "adjust" the pictures to fit precisely with the conditions prevailing in the exhibition space and to interpret them as an indivisible "environment".[88] When pictures are meant to be sold, how-

34 Andy Warhol, Double Elvis, 1964. Synthetic polymer paint and silkscreen ink on canvas, 205 x 205 cm. Private collection

ever, which, apart from the ideal value associated with the presentation of art, is the primary goal of such undertakings, the problem of designing a new environment arises. Can it be enough for a purchaser who buys a single picture, as is often the case, to be familiar with the original installation in order to "imagine" his lone work in that context, or does it become necessary to convert the gallery – as Heiner Friedrich did in comparable cases – from a showroom for purchasers into a permanent, publicly accessible and possibly sponsor-funded institution?[89] Quite apart from the fact that the first of these two alternatives involves the difficulty of acquainting the constantly changing owner population again and again with the "origins", it should be remembered that these very origins were not clearly specified by the artist. On the contrary, Warhol – true to his principle that "everything" could be seen on the surface of his pictures – tosses, so to speak, the ball of differing, contradictory and often totally confusing possibilities to the viewer and then stands by to observe what happens. The fact that he frequently expressed no specific wishes yet clearly favoured the handling of his pictures as parts of an interrelated whole can be explained on the basis of the bipolar character of each individual work. The aspect of the autonomous picture is emphasised, on the one hand, as each work is an independent (and saleable) unit in which only one of the formal, colour and size variations explored in the series is valid. On the other hand, the serial nature of the pictures is underscored, since a comparable vocabulary of forms is varied in all of the works, the size of various different backgrounds and the use of specific techniques recurs throughout and the meaning of each separate picture is confirmed, extended or varied within the serial context.

The question arises at this point whether a works complex can be subdivided into smaller units. In the case of his extensive series of *Campbell's Soup Cans*, the artist himself indirectly emphasised the independence of the 32 soup cans exhibited in Los Angeles from the numerous other pictures done during the same year. With regard to the *Flowers* series (1964), however, a group comprised of several hundred works which one could divide into subgroups on the basis of differences in size and minor variations in composition, Warhol stated that the entire context of the series should be not only ideally imaginable but visually perceptible as well. Accordingly, the artist dictated the following remarks for his diary on December 15th, 1986[90]: "Then we went up to the … Metropolitan Museum … They had two big Flower paintings of mine … The museum should get *all* of them – I mean, that's how they're supposed to be – *all together*."[91]

Given an understanding of the difficulties faced by a museum or collector, such as the procurement of funds, the availability of exhibition space and the decision to present a group of works by a single artist in such an exhaustive manner, one might presume that an appreciation of these problems was another reason for Warhol's reserve or his periodic indecisiveness. It can also be assumed, however, that the artist tended to distinguish between private and institutional presentations of his works. Accordingly, museums would be expected to apply different criteria in purchasing and presentation than a private collector, whose possibilities are ordinarily exhausted with the purchase of a single picture or a relatively small group of works. Thus, within the widely distributed network of smaller collections, the "vehicle character" (a definition coined by Joseph Beuys)[92] of the work of art would take priority, in which via motif, mode of depiction and technique the structure of ideas underlying Andy Warhol's Pop Art is represented by example in a single, complete module. Warhol, therefore, would have been interested in something more than releasing his pictures originating in large contexts into new, unforeseeable constellations, for he also developed a concept which, with pictures distributed over walls in a pattern without perceptible focal hierarchies – to cite only one example – reflects the specifically American "indifferent surface power of pure expansion",[93] an aspect that is recognisable only in the presence of work complexes that are as complete as possible. Each of these poles – individual picture and series – is equally important; both are nodes within the artist's oeuvre, connected with one another by a network of links and overlappings but capable of complete separation as well. For those uncertain about which alternative to choose, the artist offers a solution in the form of the following statement, which one could imagine as an endless loop: "I like the idea that you can say the opposite."

"I JUST CAN'T TELL THE DIFFERENCE"[94]

The fact that one can always say the opposite contains not only the germ of a human dilemma but also points to the possibility of making a clear choice of "this" or "that". Warhol demonstrates both aspects at very different levels in his *Last Supper* series, probing with his polarities at the same time for gaps and potential links. His serial method brings about a substantive devaluation of the motifs selected through randomly accessible reproductions. In making neutrality his primary theme, however, he also proclaims his interest in the unique. His method of copying famous works continues to

prompt associations with cheap plagiarism, yet it shows as well that every single copy can assume the status of an original by virtue of the stylistic means employed by the artist. Because he reproduces a recognised masterpiece in serial form, the idea of a mystical union with both the treasured original and the content it represents is engendered. As Warhol's "reproductions" are based upon commercially available copies, however, the desired connection is aimed not only at the sublime but also at the simple, the popular, the pragmatically real. Moreover, his pictures and groups of works have a certain unfinished character (originally not mounted, the painted works not painted completely, the relationship between series and individual picture not exhaustively defined) but are also "final products" at the same time. After all, though Warhol described himself as a commercial artist, he met the essential criteria associated with status as an independent creative artist. The way in which these various different aspects define the radius of Warhol's fundamental approaches to art and life, which encompasses both a mere "pleasantly touching feeling" (ill. 35;

text on top of the collage) and the existential tension between opposing poles, the resolution of which is exemplified in the *Last Supper* – that is, in belief in the transformation of bread and wine to flesh and blood – is to be the subject of the following discussion.

If we take the artist's written and oral statements at face value, the *Last Supper* series is a commercial work. Remarks relevant to this issue support the conclusion, accepted by many, that the "valid" works are those which were exhibited in Milan.[95]

We know that Warhol repeatedly made "false" and contradictory statements about his work and its origins. Aside from the fact that this behaviour helped create an image which contributed both to his fame and to the saleability of his works, his responses lured his questioners onto unexpected paths, stimulating them and himself to imagine a fundamentally different existence achieved through the possibility of an unexpected solution. In doing so, he was also probing the limits of credibility and exploring the diversity of levels to which a statement

could be construed to refer. This is exemplified in his inventive claim to have painted the *Last Supper* series on Sundays only. The statement cannot be interpreted as a description of the actual work process, for there is sufficient evidence to show that his work on these and other pictures completed during the period in question occupied him both during the week and on weekends.[96] Thus what we have here is a witty remark intended to confront the viewer, who, in view of the overall situation, would hardly assume the presence of religious content in the pictures (but seeks it nevertheless), with the aspect of Warhol's work as a kind of religious service, although the artist would actually have had to rest on Sundays in accordance with Christian conventions. In addition, the statement also shows that the extremely busy artist, who – in his own words – earned a large portion of the money with which he "stuffed many people's mouths"[97] by doing commercial art, through work for his journal *Interview* and his TV series, *30 Minutes with Andy Warhol*, was forced to make time for his concern with major pictorial themes by working during his so-called "spare time". We recognise here both the self-declared commercial artist and the independent creative artist as well, of whom passionate involvement in his work on Sunday, and not pragmatism, is to be expected. The ironic twist in the statement, of course, is Warhol's analogy to the "Sunday painter", whose amateur, in most cases honorary artistic fervour Warhol also appropriates for himself, contrasting it with the two forms of professional work in art. This confrontation appear all the more drastic in view of the fact that Warhol regarded business success as the "most fascinating form of art",[98] and that according to available information he was also well paid for the *Last Supper* project.[99] Warhol thus presents himself above all as a good American, a homo oeconomicus for whom admiration increases, the busier and richer he becomes, and who seeks his salvation in success.

Fully commensurate with such a self-definition that exploits all possible contrasts is the fact that Warhol not only fulfilled his commission for Iolas' exhibition with his *Last Supper* pictures but also produced more pictures than could ever have been shown in Milan. Some 80 works, or four-fifths of the entire complex, were not exhibited at the Palazzo Stelline. Warhol claimed that about 40 pictures were "preparatory" pieces,[100] and Iolas even stated that these earlier pictures had been thrown away.[101] As these preparatory works have not been identified[102] and since Iolas' description of the allegedly destroyed works matches some of the surviving painted and occasionally exhibited *Last Supper* pictures,[103] two possibilities come to mind:

It is conceivable that the artist and the gallerist decided in Milan to offer the silk-screen prints as the final solution in the artist's struggle to find the images he was looking for, in order to heighten interest on the part of viewers and potential buyers in what was being presented to them at the time. In addition, the descriptions may be interpreted as deliberately disclosed contradictions to the principles that underlie Warhol's work; for what, precisely, would one expect to see in preparatory studies by an artist whose entire oeuvre is dedicated to the elimination of priorities and the negation of differences between the study and the "finished work", between the single picture and the series, and artist who was so intent upon not "wasting" anything[104] that he considered preserving even "The Worst of Warhol,"[105] thus making it available to purchasers and rendering it "valid" at the same time? As difficult as it is to evaluate the written and oral sources in Warhol's case, the artist's "Sundays statement" appears to provide particularly compelling evidence for this theory. In that statement he mentions that he was passionately engaged in painting (!) pictures on Sundays. Although the remark is an indication of how important the painted pictures were to him, it has little relevance to the Milan exhibition, since the exhibition there showed only silk-screen prints produced in Rupert Smith's workshop during the week.

In summary, it is possible to conclude that Warhol was striving to respond to the situation in Milan as appropriately as possible by emphasising at that particular location the uniqueness of a copy-plagued original and the aspect of the juxtaposition or the competition between Warhol and Leonardo in the doubling scheme used in his silkscreen prints.[106] The *Reversals* (cat. 10 and 11), the *60 Last Suppers* (cat. 15) and the paintings, on the other hand, none of which were exhibited at the Palazzo Stelline, are based, as will be demonstrated below, on a scheme which goes beyond the stringent concept underlying the simple and double *Last Suppers* shown in Milan and which also make it possible to isolate these works from the entire series and – for those who wished to do so – to regard them at autonomous.[107] Consequently, it is clear that the whole series, did not serve, as was presumed,[108] the purposes of the Milan exhibition alone, and that the supposedly rejected pictures were just as much a part of the artist's concept, according to which everything is equally valid. Nor can the contention that the painted pictures were completed before the silk-screen prints stand up to scrutiny.[109] Any attempt to assign the artist to a specific category, to comprehend his serial creative approach on the basis of a generally valid principle, is futile.[110] Differences resolve themselves,

37 Andy Warhol, *Strong Arms and Broads*, 1960. Synthetic polymer paint on canvas. The Andy Warhol Estate

38 Andy Warhol, *Are you "different?"* (Negative), 1985. Silkscreen ink and synthetic polymer paint on canvas, 50 x 40 cm

39 Andy Warhol, *Are you "different?"*, 1985. Silkscreen ink and synthetic polymer paint on canvas, 50 x 40 cm

since everything is equally significant. Thus we can join with Warhol, the independent commercial artist and Sunday painter, who with this definition questions both the aspect of art's character as merchandise and the criterion of creative inspiration at the same time, in concluding: "I just can't tell the difference."[111]

"ARE YOU 'DIFFERENT?'"[112]

Of the works not shown in Milan, I wish to introduce first the painted pictures for which Warhol returned to a technique he had employed until 1962, before he began doing silk-screen prints. This method is the copying process mentioned at the outset, which he did not take up again until 1983, during his work with Basquiat and Clemente, after a 20-year painting hiatus. Although Warhol himself referred to the pictures as

40 Photocopy of a page from the *National Enquirer*, circa 1985, 21 x 27.5 cm. Model for Warhol's *Are you "different?"*. The Andy Warhol Museum/Archives, Pittsburgh. Photo by Matt Wrbican

"hand-painted", they hardly fulfil the criteria ordinarily associated with painting by hand. Instead, the artist remains within the calculable bandwidth of his plagiarist scheme with respect to the painted works as well; and as in the case of his silk-screen prints, none of his painted pictures was done without a model.[113] Yet the "hand job"[114] permitted a more rapid, spontaneous working procedure that was free of interruptions caused by intermediate technical steps, a process that was particularly appropriate for the dialogue-oriented *Collaborations*. The aspect of dialogue also appears to have played a part in the *Last Supper* pictures. As if searching for a process of interaction between the Renaissance original and his own ideas, he treated motifs from the source, which he would only have had to copy completely, as abstract props removed from their context, combining them occasionally with advertising motifs.

Even in his early work Warhol had processed ads promising more beautiful bodies, offers for remedies for baldness, for instance, or ways to put muscle on weak bodies (ill. 37). By transferring these trivial motifs onto the less ephemeral medium of the painting, he gave them a provocatively high status and in doing so made it clear to everyone that the images depicted related to matters of concern to more people than just Andy Warhol. Some works from the late phase of his œuvre are based upon the same principle (cat. 2), although these – and this is the essential innovation – are contrasted with pictures in which the Christ figure from Leonardo's *Last Supper* is confronted with a bodybuilder (cat. 13) or overlaps such an image in the manner of a ghost figure (cat. 1). The annoying struggle with the human body (which the ageing artist attempted to combat through daily exercise periods and subcutaneous injections of collagens),[115] contrasted with the "medicine of immortality" offered by Christ at the Last Supper and the redundant appeal to "Be a Somebody with a Body" takes on a dual meaning. It points to the difference between belief in the mere corporeality of the human being and belief in the spiritual substance of the body of Christ, whom the faithful regard as God and man in one. As if Warhol wanted to investigate the problem of doubt with respect to faith in this principle and in salvation through God, two of his pictures from the same period contain the words "Are you 'different?'" (ill. 38 and 39; see ill. 40), a question the enlightened protagonist appears to have answered for himself already. This cannot be said of "Rambo" hero Sylvester Stallone, whom Warhol gave a *Be a Somebody with a Body* in 1986, a gift "he [Stallone] liked it a lot".[117] As we hear, Stallone, who refers to himself as the "Alpha Animal"[118] and who married the mammarian wonder

Brigitte Nielsen back then in an effort to strengthen his animalistic component, still claims that "My body is my pride and joy".[119] However, the double-entendre of the "statuesque shell"[120] was not set in opposition to the Christ figure on the gift and was therefore not comprehensible to everybody. And thus we may now look on in admiration as Rambo, since converted to being simply an average guy, celebrates his "rebirth as an actor"[121] as a totally "normal American male face"[122] showing the telltale signs of "hamburgers and French-fries".[123] That is quite far removed from Christ, who pronounced following his sermon on bread and flesh: "It is the spirit that quickeneth; the flesh profiteth nothing." (John 6:63)

"TO CONCEIVE SUCH HEAVENLY BEAUTY"[124]

One can only marvel at the uncanny aptness of a poster ad for the Sportsman's Club placed at the streetcar stop directly outside the Santa Maria delle Grazie (ill. 41). A "stimulant"[125] seems to have set the figures in motion and is intended to captivate the viewer as well, who in most cases will have to achieve the perfect beauty embodied by the models on the poster. It was a also a kind of "stimulant"[126] emanating from the "Master" that shook the apostles at the "quietly consecrated supper table"[127] inside the refectory. At the Last

Supper, Christ called upon the apostles and the community of the faithful to undergo a transformation, to become the one body of Christ – yet his announcement of the impending betrayal[128] during the Last Supper also revealed the difference between Him and His followers. It was undoubtedly a significant challenge for Leonardo to make this disparity visible. Like the apostles, Christ is not given a halo and is portrayed as a human being; while the apostles are depicted in attitudes of irritated restlessness, however, His existential form, expressed in his quiet bearing and the ideal symmetry of His facial features rises above them. A bridge is formed by the figure of John, "whom Jesus loved" (John 13:23). He casts his eyes downward, as does Christ himself, yet he does not rest against His chest, as described in the gospel (John 13:23), but instead leans his head against Peter. Thus all of the apostles are affected by the mood of shock. This characterisation represents the decisive alteration undertaken by Leonardo with regard to earlier compositions (ills. 42 and 43). What he created was not a "mere" sacred scene; his focus upon the dramatic turn of events reveals the depths of the human soul in the examples provided by his "identification figures", which undoubtedly contributed heavily to the extraordinary fame his fresco achieved.

According to Vasari's account, the Last Supper theme and, in particular, the glorified figure of Christ[129] posed a challenge Leonardo considered himself ill-equipped to meet. We may conclude on the basis of the sheer extent of the *Last Supper* series that Warhol, who dealt with the figure of Christ in a number of pictures, must have experienced a similar response. Both artists approached a clearly conceived

41 Ad poster at a streetcar stop in front of Santa Maria delle Grazie, Milan, January 1998

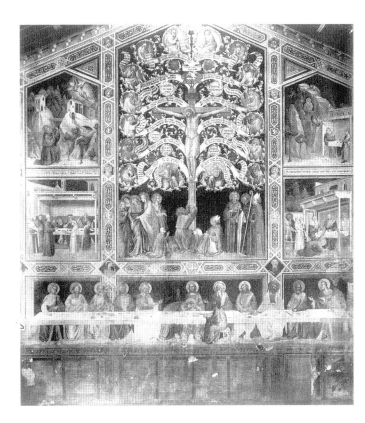

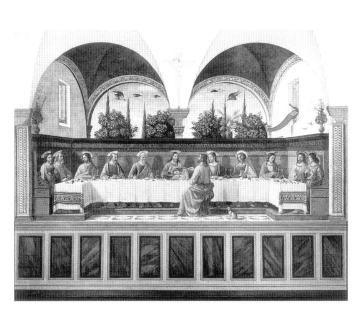

42 Taddeo Gaddi, *The Last Supper*, circa 1345–50. Fresco in the refectory at St. Croce, Florence

43 Domenico Ghirlandaio, *The Last Supper*, circa, 1480–81. Fresco in the refectory at San Marco, Florence

commission with a degree of intensity that can only be understood as a deep personal involvement in the content that manifested itself in the course of the work process. According to Vasari, the prior of Santa Maria delle Grazie repeatedly pressured Leonardo to bring his work, finally, to a conclusion, for "he found it strange to observe Leonardo standing for as much as half a day lost in study; he would have preferred that the artist never let his brush rest, like workers digging in a garden".[130] Leonardo was finally compelled to explain to the concerned Duke, who had received the prior's report, "that a man of superior mind sometimes accomplished the most when working the least, because he invents within himself and forms those perfected images which the hands, once these images have been conceived by the intellect, bring to expression and recreate".[131] The head of Judas, as Vasari recounts, caused him particular difficulties, for he was in search of a form in which "to express the face [of Judas], who was so foolish that he resolved, having benefited from so many acts of charity, to betray his Lord and the Creator of the world."[132] As Leonardo added, to the Duke's amusement, he could, of course, if nothing better occurred to him, "still use the head of that bothersome, meddlesome prior".[133] The greatest problems were posed by the head of Christ, however, "for which he did not wish to search on earth",[134] but which would be difficult to find elsewhere, for, as Vasari recalls, his thoughts "did not carry him so high that he believed himself capable of conceiving in his imagination such heavenly beauty as the incarnate divinity must have possessed".[135] Vasari's account of the painting of the Last Supper ends with the remark: "The head of Christ [...] remained unfinished"[136] – a statement that suggests certain points of comparison with Warhol, especially with regard to the matter of obstacles to completion of the

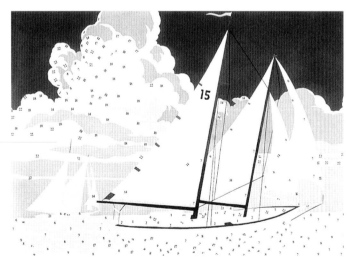

44 Andy Warhol, *Do-It-Yourself (Sailboat)*, 1962. Synthetic polymer paint on canvas, 183 x 254 cm. Private collection, Berlin

work. Paradoxically, Warhol's "copies" do not show the "finished product"; instead, they look unfinished, since none of them is painted completely. Early on Warhol had declared the process character of work in art as the end product of his painting, and he was thus able to make pictorial content out of the creative pause that had once aroused the suspicions of the prior of Santa Maria delle Grazie. He had transformed his *Do it yourself* pictures (ill. 44), based upon mass-produced paint-by-the-numbers patterns for diligent children and adults, into "originals" by transferring the pictures onto larger canvases and then, disregarding the orderly numbering system, used different colours to paint them[137] and deliberately left portions of the surface unpainted. The garden, to recall the analogy suggested by the erstwhile prior of Santa Maria delle Grazie, was not dug in the expected manner – the colour fields were not painted in correspondence to the patterns. The gaps left on the canvas represent holes in the thoroughly preconceived intact world of the originals. Breaks, uncertainties and "incorrectly" painted spots become symbols of real life, which is represented, yet at the same time vigorously questioned, in the pictures, since the transgressions against the preordained system, themselves signs of a certain vital impulse, are part of the artist's original concept. A more advanced stage of this approach can be seen in the *Last Supper* pictures, in which a shift in the distribution of power is evident, however. It appears that Warhol, the "machine", collides in spite of the plagiarist system with the content of the subject, as if the theme were not as "accessible" as the large number of reproductions would suggest. In contrast to the silk-screen prints, the focus is not placed upon the repetition and manipulation of the given; instead, all of the components are analysed individually and in context. In this process the artist's attention is concentrated less on the meaningful spatial ambience, which is not even depicted at all in some pictures, or on coloration, which is "absent" in substantial portions, but focused more intently upon figures. Since a model was available for every figure, all figures could be painted with the same speed – a methodological approach fully in keeping with Warhol's principle of economy,[138] to which, however, his concern with the theme was not sacrificed. Both aspects, speed and passion, become evident in the tracks of dripping paint that call to mind both "sloppy" work and blood.

The quest for the "right" composition is illustrated with particular clarity in a work (cat. 18) in which props from Leonardo's *Last Supper* are presented as if from differing distances. In this work, the balanced scene in the Milan painting is transformed into a disparate pastiche which demands, for

45 Jiri Georg Dokoupil, *Double Jesus,* 1986. Synthetic polymer paint and enamel on canvas, 198 x 345 cm

46 Andy Warhol/Jean-Michel Basquiat, *Ten Punching Bags*, circa 1985–86. Synthetic polymer paint on punching bags, each 112 x 36 cm. The Andy Warhol Museum, Pittsburgh

that very reason, continuous re-assessment and the discovery of one's own point(s) of view. As can be shown in an examination of the following works, Warhol's involvement with the theme incorporates both challenging approaches to taboos and fundamental doubts about the amenability of the subject to depiction. By focusing on certain segments of the picture (or, alternatively, dispensing with their depiction) in his long *Last Supper* paintings, he brings various different and often neglected aspects of Leonardo's fresco – or of the outline drawing from which he worked – to the foreground. Thus in cat. 17, in which only the figures at the table are shown, the presentation of the feet takes on an importance that receives little attention in the more complex compositions. They are shown in remarkably graceful, almost coquettish attitudes, a posture often assumed by homosexuals as a sign of identification and which in this context can be seen as a discreet link joining Christ, the disciples, Leonardo and Warhol, whose homosexuality has been a frequent subject of discussion or denial. This aspect is all the more noteworthy in light of the fact that this specific section of the original is difficult to make out, and copiers have traditionally brought their own ideas into play in rendering it (ill. 8 and 9).

Yet another taboo is the multiple representation of Jesus in a single picture, a form of repetition that commonly appears in Christian iconography only in connection with the description of historical sequences. Here (cat. 14 and 18), however – as is also the case in a work by Jiri Georg Dokoupil (ill. 45) exhibited at the Sonnabend Gallery in New York in early 1987 – the uniqueness and corporeal integrity of Christ is put to question. In response to the suggestion that such doublings were odd, Warhol simply commented that they were "The European Pope and the American Pope".[139] Yet as it is hardly possible to separate Warhol's and Leonardo's contributions in the pictures or to relate them to a single common core, Warhol felt no need to sort out the "who is who" of the two identical figures. Reminded of Dokoupil, who spoke of the transgressive character of the two crucifixes presented side by side, Warhol responded by saying: "He took the words out of my mouth."[140] This statement is qualified in the course of the interview, however, when Warhol refuses to talk about "negative things".[141]

A set of 10 punching bags (ill. 46) is surely one of the most provocative works done by Warhol – in cooperation with Basquiat – during the period of his concern with the Last Supper theme. The idea of painting an item of sports equipment was originally Basquiat's, who inscribed the name of his gallerist Mary Boone beneath a stylised crown on a punching bag after the two had had a falling out. Warhol expressed his admiration for the outcome, and the two artists soon did a *Collaboration*, in which Warhol applied the face of Christ in a slightly modified size on the white plastic material and Basquiat added additional graffiti. Different letters – "J" and "G" evoke direct associations with the words "Jesus" and "God" – and doodles, including images of houses, a crown, an amorphous "shadow form" vaguely resembling a human body and a leafless twig or branch of thorns can be seen next to the word "Judge". The word reappears several times in an equally desperate and insistent staccato and is complemented by the terms "shit", "Abo", "Lead" and "Asbestos". The stark colour contrast, confined to black, red, blue and white, and the suspension mounting – certainly practical for athletic purposes but brutal and suggestive of sado-masochist instruments of torture in this context – contribute further to imbuing the work with an almost unbearable tension, which evokes thoughts of the Passion of Christ while reminding us – on punching bags, of all things – of Jesus' command to "love thy neighbour". The concept of Christ's martyrdom also calls to mind suffering artists, who – struggling for recognition in the art market – continually felt misunderstood or exploited. Countless examples could be added on the basis of Warhol's *Diary* alone, and

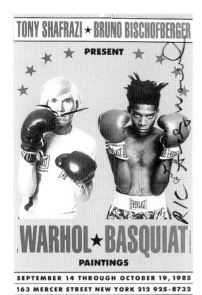

47 Poster for the *Collaboration* pictures by Andy Warhol and Jean-Michel Basquiat in the Tony Shafrazi Gallery, New York, September 14th – October 19th, 1985, 47.5 x 30 cm, with a drawing and signature by Andy Warhol. Photo by Michael Halsband. The Andy Warhol Museum/Archives, Pittsburgh

with regard to his joint endeavour with Basquiat, it is quite likely that the contention, expressed by some people at the time, that the younger artist was merely the "mascot"[142] of the older man was painful to both of them. In any event, neither of the two simply turned the other cheek, patiently and willingly, as Christ had preached in the Sermon on the Mount, for they had their likenesses printed on the poster in the pose of boxers, whose untamed wildness is expressed in their hair (ill. 47).

Installations like the *10 Punching Bags*, in which fingers are laid into wounds, are opposed in Warhol's oeuvre by pictures in which he approaches the question of the depictability of Christ with extreme caution. Among these works, all of which were done in 1986 and thus towards the end of his work on the *Last Supper* project, are two pieces on which only the outline of a head of Christ (cat. 3 and cat. 4, p. 58) and a white field (cat. 3 and cat. 4, p. 59) are visible. Jesus is "reincarnated" only under black light – skin, hair and clothing take on colour and emerge like a "secret writing". A similar approach is found only in Warhol's early work, in one example of which he "concealed" two bare-breasted female torsos with the same kind of paint (ill. 48). The picture was done as a commercial project for *Playboy* magazine, which naturally did not pass up the opportunity to "undress"[143] the figures, using an appropriate photographic technique[144] – after all, the journal, already in print for 13 years at the time and flourishing in puritanical America, of all places, was one of the few safe havens for closet voyeurs at that time. Although Warhol explains his use of the "camouflage" technique by claiming that he wanted to keep the police at bay,[145] the statement makes little sense in view of the other pictures published in the magazine. Indeed, he was actually playing deliberately on the idea of the "indecency" of his "pornographic" pieces, which revealed themselves as such only in some dark, private place, and thus underscoring the principles on which *Playboy*'s success is based.

To return to the comparison between Warhol's and Leonardo's approaches to representation of the Last Supper, Leonardo, painting in the early years of the Renaissance, was able to visualise the diverse aspects of Christian doctrine comprised within the table scene (the rivalry between body and spirit, the ambivalent positions of finite and eternal life, obedience to Christ's commandments and their sinful transgression) in a painting as a challenge to his contemporaries by juxtaposing the ideal figure of Christ and the character portraits of the disciples and by exploiting the opposition between the sense perspective and the central perspective. The latter is "missing" both in Warhol's serially reproduced silkscreens and the paintings, in which components of a larger context are isolated and linked within new relationships. There is no fixed vantage point from which to approach the works in a customary way; instead, viewers are called upon to "co-operate" on the pictures, to attempt to come to grips with the content and the mode in which it is presented.[146] Since Warhol's pictures were created with a secular rather than a religious context, it is possible to interpret his process as a "substitute" for the context that existed in Milan in the relationship between the dining monks and the *Last Supper*. Aspects of urban life are also reflected in Warhol's works by virtue of the incorporation of themes such as the cult of the body that is characteristic of our time and the quest for a new definition of sexuality. Virtually excluded from monastic life, neither of these issues was of particular importance to Leonardo. The contents represent an attempt to come to grips with various currents regarded as unacceptable in broad segments of society; they call to mind the disease of AIDS, which has repeatedly been stamped as "God's punishment". If we reflect upon the gaping holes this wholesale death, truly a rider of the apocalypse, tore in Warhol's circle of friends alone during the eighties,[147] we recognise the roots of this thematic concern immediately. It also becomes easier to understand why Warhol does not

48 Andy Warhol, *Double Torso*, 1987. Synthetic polymer paint and silkscreen ink on canvas (illuminated with black-light), 111 x 203 cm. Playboy Enterprises, Inc. Collection

49 Andy Warhol, *Gold Marilyn*, 1962. Galerie Bruno Bischofberger, Zurich

50 Andy Warhol, *Heaven and Hell Are Just One Breath Away!*, circa 1984/85. Synthetic polymer paint on paper, 79 x 59 cm

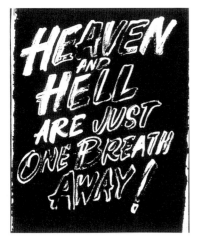

51 Andy Warhol, *Heaven and Hell Are Just One Breath Away!* (Negative), 1985. Synthetic polymer paint and silkscreen ink on canvas, 50 x 40 cm

separate taboo and purity, kitsch and the sublime or the unique and the reproducible but instead integrates the into the Last Supper theme, developing in the process a vocabulary for the diversity and inscrutability of the present, which has fixed upon "market value" as the greatest common denominator.

The size of the series alone suggests a market-oriented work ethic reminiscent of the overflowing souvenir shops in the Vatican, whose devotion to profit is obvious even within the "Holy District" in Rome. On the other hand, Warhol (like the monks of old) fulfils the promise of the renewal of the Last Supper with each and every repetition. A similar comparison can also be made with respect to the black light variations (cat. 3 and cat. 4, p. 58), with their undercurrent of vital eroticism and their concern with the eternal life and Christ's physical disappearance. Whereas Warhol found comparatively "classical" solutions in other paintings dealing with human death through the juxtaposition of fullness and emptiness (ill. 49), he makes no effort to avoid highly effective transformations in visualising Jesus' wondrous proclamation of eternal life and thus brings the now virtually irresolvable tension between the devastating experiences of death during the eighties and Christ's optimistic-sounding offer to a climax. It is a tight-rope walk with which he forges a link between the naive immediacy of popular imagery[148] and the undepictable, asking at the same time whether one simply "vanishes"[149] after death or enters an afterlife whose shimmer, provided they are not illuminated under black light, is heralded in the pictures. Just as heaven and hell are only a breath away, complementing one another like positive and negative images (ill. 50 and 51), "heavenly beauty" and disaster, the sacred and the profane, can be contained together in one and the same composition in a heightened relationship of dialectical tension.

BABYLON – BETWEEN HEAVEN AND EARTH

Warhol's serial compositions can be related to the environment in which they originated – the city. An examination of the map of Manhattan or other cities carved out of the expansive continent of North America reveals a gridwork matrix comparable to the system used for the *60 Last Suppers* (cat. 15) and the two *Reversals* (cat. 9 and cat. 10) – three silkscreen prints also not shown in Milan. In the same way that the meaning of the individual motif is both affirmed and neutralised through 60-fold or 112-fold repetition, the individual is courted, on the one hand, while the gridwork pattern, on the other, is designed in such a way as to homogenise the social characteristics of individuals in the same way that it evens out the geographic features of the landscape. The various units in the gridwork matrix of the silk-screens are characterised by a kind of "equality" that is ostensibly aimed for in the cities but not achieved. Whether a field appears above, below, on the left or on the right is not important – directions, which are certainly capable of bearing meaning, are interchangeable. The pictures are conceived like the patterns of streets set at right angles in large American cities, streets that end at "open" boundaries and can be extended in a systematic way whenever population growth requires. Just as there is no midpoint in Warhol's series, there is no centre in the network of the cities – neither within the horizontal geometry of the streets nor in the vertical structure of the high-rise buildings. More often frequented areas are referred to as "nodes",[150] a word that denotes non-hierarchical intersections and interconnections among various things, intentions or objectives. Identified only by numbers, the individual sections, or blocks, streets and avenues – comparable to Warhol's separate pictures – represent "abstract units for buying and selling",[151] each unit offering buyers the same opportunity; altogether they are instruments admitted to competition within the democratic orchestra of America. The individual's success is reflected in the number of sections or units he owns. European formulas are ill suited for this pragmatic vision, indeed for the democratic perspective in general. The church as a spiritual centre in the middle of a village where all roads intersect – an idea which people in the New World still stubbornly associate with Europe – is opposed in America by houses of God situated more or less randomly at various points in the continuous matrix of streets. Whereas Romanesque and Neo-Gothic churches still have the appearance of "fortresses", which, built of stone, shield their insides against the noise and the bustle of the secular city, modern church structures are difficult to distinguish from the outside from buildings in which people live and work. Once the highest edifices in the city, churches today, to the extent that they are not parts of higher office or residential buildings, occasionally have the honour of being the lowest – and the only ones not equipped with elevators gliding, weightlessly it would seem, "towards the heavens".

The absence of a centre gains particular importance in the Last Supper pictures, as they deal with a Christian pictorial theme for which artists sought well beyond the end of the genre's period of flower in the 18th century to find means of expression through which to emphasise that very centre or midpoint. Thus both figural compositions and the structure of

52 Andy Warhol, *Philip's Scull*.
Synthetic polymer paint and silkscreen
ink on canvas, 101.5 x 101.5 cm.
Private collection

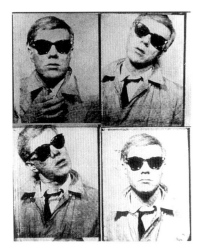

53 Andy Warhol, *Self-Portrait,* 1964.
Synthetic polymer paint and silkscreen
ink on canvas, four panels, each
50 x 40 cm. Collection of Mr. und Mrs.
Brooks Barron, Michigan

the traditional altarpiece, the triptych, are oriented towards formal and substantive focus.

This objective is also served by abstract images, including above all the central symbol of Christianity, the cross. It is interesting to note that, in the course of his work with the grid-work matrix, Warhol reputedly positioned four motifs so close together that a cross pattern was formed along their inside edges (ills. 52 and 53). Remarkably, the *Last Supper* series, in which he was clearly involved with a religious theme, contain no such works. While we may be justified in asking, in the case of thc skulls or the self-portraits, whether the cross has symbolic value – a question which, as it turns out, is all the more appropriate in view of the fact that Warhol appears wearing sunglasses[152] – such an approach seems irrelevant to the proliferating repetitive sequences in the *Last Supper* series. Here, the elementary form is swallowed up by the uniform pattern. Equally fruitless is the attempt to explain the numbers of rows on the basis of Christian number symbolism. Though one might have expected rows in the *60 Last Suppers* group to consist of 12 *Last Supper* images, Warhol actually constructed his pattern on the basis of 10 repetitions, making use of a number that has been employed by various American artists, including Donald Judd in particular, since the sixties to distance themselves from European compositional schemes (ill. 54). Indeed, in the sphere of Christian cultures – although no direct influence can be proven – precursors for such indefinite repetitions can be found, at best, within the field of ethnography, in items such as the so-called "swallowing pictures" or edible "notes" (ill. 55) produced like merchandise for trade and consumption. Evidence of the serial sequencing of painted and later printed motifs, reminiscent of stamp production, is available from as long ago as the Middle Ages, when it was customary to consume, one after the other, images on small pieces of paper sold in great numbers at shrine markets in order to bring about cures for illnesses through the intercession of the figures depicted on them.[153]

Another revealing parallel may be found in the serial depictions of Buddha and Bodhisattwa figures that are widely disseminated in the Asian region (ill. 56).[154] It is impossible to determine at present, however, whether the compositorial and thematic affinities between these articles and Warhol's repetitions are merely coincidental or actually the product of a direct interest on the part of the artist in Asian art and religion.[155] The image shown here is from a work by the artist Hiroshi Sugimoto, a native of Tokyo who has lived in the U.S. since the seventies. He devoted himself in an extensive photo series to a study of the 1,000 statues of Kwannon, works which origi-

nated in the 13th century. The statues are positioned side by side in rows in the Sanjusangen-do, a long hall subdivided by 33 pillars that forms part of the Myoho-in Temple in Kyoto. Kwannon, a god of mercy, assumed human form in 33 variations, all associated by the faithful with each of the 1,000 figures; thus the presence of the figures in the hall is magnified even further.[156] Just as one recognises various different phases in the life of the divinity in the virtually identical sculptures, which nevertheless evoke different effects in different locations and under changing light conditions, it is also possible to see the omnipresence of Christ represented in Warhol's recurring *Last Supper* or *Jesus* images – an abundance and sense of presence that is intensified in the viewer's eyes for the very reason that Warhol dispenses entirely with symbolic forms that can be "easily" decoded (the meanings of numbers, the triptych, etc.) and instead allows the size of his pictures to unfold an immediate physical effect. The protective space comprised by sanctuaries, in which religious art has traditionally been housed even in our century (see Mark Rothko's chapel in Houston)[157] has permeated the monumental pictures themselves. Their size affords them their only protection.

The question has remained open among students of Warhol's works as to whether the world of religious images correlates with a fundamental attitude on the part of the artist and whether his strong Catholic family background had a lasting impact upon his life and a lasting influence upon his work.

In general, Warhol's statements about his art do not suggest the presence of a particularly strong religious motivation. This is evident, for example, in a comment on his portraits of Marilyn Monroe, which he began producing immediately after her suicide and which, despite their lively coloration, clearly deal with the subject of the movie idol's death. " There was no profound reason for doing a death series, no 'victims of their time'; there was no reason for doing it at all, just a surface reason."[158]

Such statements prompted many to wonder whether Warhol's work wasn't motivated exclusively by the appeal of the visible, by his interest in popular phenomena, to which category both movie stars and First Ladies can be assigned, as can Jesus and soup cans as well. This position was not seriously shaken until the art historian John Richardson, speaking at the memorial service for Andy Warhol at New York's St. Patrick's Cathedral, declared to a large audience for the first time that the artist had been a deeply religious person, mentioning at the same time that Warhol had kept this aspect of his character a secret.[159]

54 Donald Judd, *Untitled (Stack)*, 1968, ten-part object. Steel, Plexiglas, each part 15 x 68 x 61 cm. Staatsgalerie moderner Kunst, Munich

55 Sheet of "edible papers" with the image of mercy from Altötting, circa 1910. Bayerisches Nationalmuseum, Munich, Sammlung Kriss

As aptly as these personal secrets complement the artist's public image, adding the component Warhol had elevated to the status of an essential ingredient of his "I like … the opposite" concept of art, voices critical of these revelations can still be heard today. Jay Shriver, for instance, who assisted Warhol on the *Last Supper* series and worked with him almost daily, is somewhat reserved and sceptical with respect to the contention that religion played a major role in Andy Warhol's life. Shriver states that he never discussed religion with the artist and never witnessed any kind of religious activity on his part.[160] Indeed, the references to biblical texts Warhol occasionally made in commenting about his work – he saw an analogy, for example, between the increase in creativity that may result when several artists work together and the miraculous multiplication of the loaves by Christ[161] – do not provide sufficient reason to postulate profound religious content in the *Last Supper* series. Thus it would be logical for us to place the *Last Supper* series within the whole of Warhol's œuvre on the basis of the simple argument that Leonardo's *Last Supper* had stimulated his interest because it is as famous as Campbell's soup cans and because Jesus, like Marilyn Monroe, is a popular phenomenon. Accordingly, Warhol would have assigned equal significance to different contents without the least hesitation about violating anything sacred.

It is obvious that Andy Warhol was by no means certain about the meaning of religion in his life. Asked whether he believed in God, he answered in 1977: "I guess I do."[162] And on the subject of churches he once said: "I just sneak in at funny hours … I like church. It's empty when I go. I walk around. There are so many beautiful Catholic churches in New York. I used to go to some Episcopal churches, too."[163] As far as anyone knows, however, he no longer attended mass from start to finish, staying "always for five minutes" and never taking communion.[164] And as if he did not feel completely safe and secure inside the church, he usually remained hidden behind a column, where he would be difficult to recognise.[165] As casual as these statements of Warhol's appear, they nevertheless offer evidence of a continuing search for the remaining traces of culture that have not been devoured by industrial mass-reproduction and which surpass the power of mere surface in an era of complete devotion to the visual. It is conceivable, therefore, that Warhol was interested in investigating both the disappearance of the church and religion from view and their continued quiet existence. What appears blasphemous at first glance – the incorporation of potato chips and light-bulb labels into the *Last Supper* series, for instance – could then be regarded not only as a reference to realties of

western life near the end of the 20th century but as a search for evidence of Christian substance in bread and spirit in the most refined of products.

Warhol obviously saw the sneaker as an object in which the themes of religion and western civilisation are joined in an especially mysterious way. He appeared in sneakers at the opening of his first exhibition in Milan (ill. 57). He printed an image of Jesus on sneakers (ill. 58), and as if this weren't enough, he used the verb "to sneak in" to characterise his visits to church, a phrase that refers not only to a kind of surreptitious entry but to a style of canvas shoes that one would rather expect to see on the feet of sightseeing tourists than on those of faithful churchgoers.

For the sneakers he elevated to the status of an art object Warhol did not use Leonardo's version of the face of Christ but instead took an image from an ad for a "night light" (ill. 59) meant to encourage readers to purchase a lamp that looked "like ivory" for $9.98. The combination of sneaker and Jesus suggests that Warhol intended to use this choice of "canvas", casual sneakers for every social stratus, to emphasise the inflationary process to which the unique and the sublime are subjected. If so, then Warhol was pulling this Jesus, formerly placed in a somewhat "enlightened" context by the words "lights your way", down into the dirt through which a sneakers-wearer must inevitably tread for good.

In fact, however, Warhol's treatment of the sneaker is much more complex than this, for he not only reproduced the face of Jesus and the price of the lamp on the shoe but also

56 Hiroshi Sugimoto, *The Hall of Thirty-Three Bays*, 1995, series of 48 photographs in an edition of 25 copies, 50 x 60 cm. Ileana Sonnabend Gallery

45

added the letters "TMEAT". Decoded, the play on words generates "meat", "eat" and "teat". In addition, the reverse bears the word "Sin" in large letters, and the word "Accepted" is printed on the tongue. Which of these terms refers to the shoe, which to Jesus and which to the Jesus Night Light, meant to illuminate the way that is truly so difficult to find, can only be determined and placed in a sensible context when the slogan "Converse All Star" printed on the brand-new shoe is also taken into account. The meanings of converse are multiple and include "reverse" or "opposite" and "small-talk"; to be "conversant in" is "to know", and the word also suggests a "turnabout". Thus this commercial item of merchandise was predestined to unite within itself the whole spectrum of rich contrasts that Warhol displayed with such apparent casualness on the shoes.

A conversion from the temptations of the flesh and the unholy pursuits of the leisure society to Christian religion – poles that supposedly cannot be harmonised – no longer appears necessary, since the one flows easily into the other. This revelation comes to anyone who undertakes a pilgrimage to the consumer temple erected by the Nike company, redesigned in 1997 and since then one of the main attractions in New York City. The flagship store is aptly named "Niketown", for the believer not only receives all-round service (horizontal and vertical shopping!)[166] but actually becomes a part of the extensive whole that is expressed in the universal credo chiselled in stone above the entrance: "Courage, Victory, Teamwork and Honor".

Spiritual instruction is given to the employees, who gather each morning, arms interlocking, to form a circle and hear about the new shoe models and the day's sales goal. Spiritual instruction on the logic of the merchandise is given to consumers as well, when the trend-setting shoes are presented like relics in shrines devoted to saints (ill. 60). "Just do it" is the message Nike sends out into the world on every shoe-box.

59 Photocopy of a page from an unidentified magazine, circa 1984–1985, 21.5 x 27.5 cm. Model for the Jesus image on the sneakers. The Andy Warhol Museum/Archives, Pittsburgh. Photo by Matt Wrbican

That sounds quite similar to the "Why not?" with which Andy Warhol justified his artistic activities[167] – although he, as one is prompted to infer from the words "Sin" and "Accepted" printed on his sneakers, had not settled the question of the justification for such an approach in his own mind.

The frontier-bashing slogan "Just do it" – the motto for "edutainment", a concept in which education and entertainment for the "fun generation"[168] are profitably merged – expresses not only the goal orientation of the market, characterised by the familiar cry of "total commitment" most often heard today from the mouths of athletes,[169] but to an increasing degree that of the church as well. This is exemplified in a structure that was not Warhol's favourite church but nevertheless a building he regarded as one of New York's most fabulous – "it's great".[170]

Since the 19th century, nearly a third of the block of Lexington Avenue between 53rd and 54th Streets belonged to St. Peter's parish. What is now the Citibank Corporation[171] endeavoured in 1970 to acquire the land. Hoping to build Citibank's new future-oriented showcase headquarters build-

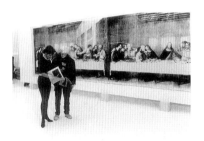

57 Andy Warhol with Daniela Morera shortly before the opening of the Milan exhibition. Photo by Maria Mulas

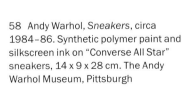

58 Andy Warhol, *Sneakers*, circa 1984–86. Synthetic polymer paint and silkscreen ink on "Converse All Star" sneakers, 14 x 9 x 28 cm. The Andy Warhol Museum, Pittsburgh

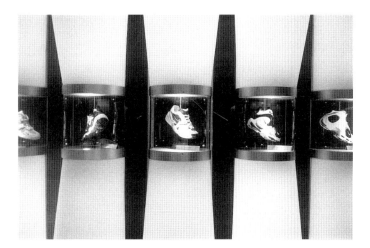

ing there, it was proposed tearing down the old church. The representatives of St. Peter's agreed on the condition that a new church would be erected at the same spot. They also demanded that "nothing but open sky"[172] be allowed to rise above the structure – a bold ambition in New York for anyone also concerned with "keeping their feet on the ground" at the same time. They received support from Hugh Stubbins, the architect responsible for the entire complex. He also shared their view that the construction of a building with nothing but offices would not be beneficial to people living in that part of the city. The final agreement called for the lower storeys of the administration building to provide space for shops, restaurants and entertainment operations, along with a plaza where pedestrians could stop and rest.[173]

Viewed from the outside, the church appears to be an independent architectural structure. While the nearly 920-foot-high sky scraper next door seems to touch the sky, the direct line to heaven in this relatively tiny building is emphasised by a band of glass that runs upward from the side walls over the roof area. This opening permits not only a view of the heavens, however, but also allows people inside the hallowed building to gaze at the temple of the financial world (ill. 61): "Citicorp", the abbreviation used to designate both the complex and the bank – penetrates as an unmistakable advertisement into the interior of the church, where one might interpret it – provided one wanted to establish a positive link between utterly disparate poles – as an allusion to the Corpus Christi, the body of Christ, whose religion is to be spread throughout the world just like the power of the bank. While it is true that those responsible for the construction project incorporated humanitarian objectives into their plan in order to avoid to sacrificing the needs of the faithful and the community to the dictates of pure functionality, it is equally true that St. Peter's has become a church which demonstrates in unmistakable fashion the value placed on religion in western cities. Open to the world, the building is much less a place for meditation and devotion than a setting for visual encounter. The gazes of businesspeople hurrying by on the streets can meet those of churchgoers through the clear glass window panes; whatever sense of purpose either may have had is thus easily disturbed. Without entering the street at all, worshippers can enter the shopping centre and the (usually empty) plaza through the church foyer. Conversely, the less devout may be motivated in these halls characterised by "visual contiguity" to stop in for a "quick dose of religion".

"When people stop going to church, we have to take the church to the people" was the explanation offered by the Archbishop of Canterbury for a program initiated by the Anglican Church, which broadcast a short devotional service in the 216 branch stores of the ASDA supermarket chain on the Sundays of Advent in 1997.[174] In the one case, the high priests of capital gained entry into the hallowed space of the church with their neon "Citicorp" logo; in the other, the prophet entered the great consumer temple. It is enough to take a few strides ("converse") with sneakers worn by "everyone" on the streets of America; it is sufficient to shift people's gaze in a different direction or to interrupt the Musak for just a few minutes – and lo and behold, profit and prayer are all of a sudden united.

As much as Andy Warhol admired the Citicorp complex and St. Peter's Church, it was not the church he visited regularly. He preferred a more traditional house of worship, the name of which he discreetly forgot when asked about it in an interview.[175] It is the Church of St. Vincent Ferrer, a Gothic Revival church shrouded in mystical shadow a few blocks farther north. After being picked up from the church on Sunday, February 8th, just a few days before his death, and taken to a much more worldly setting – the flea market – he commented in his Diary: "... and it was embarrassing to walk from the church steps into a big black limo."[176]

> "All art is at once surface and symbol.
> Those who go beneath the surface do
> so at their peril."[177]

1 Andy Warhol, cited from Bob Colacello, *Holy Terror. Andy Warhol Close Up* (New York: 1991), p. 119.
2 Andy Warhol in conversation with Gretchen Berg, "Nothing to Lose", in *Cahiers du Cinema*, No. 10, May 1967, pp. 38–43, p. 40.
3 See *ibid.*, p. 12 and p. 41. Warhol used the term in reference to his pictures of Marilyn Monroe. The complete quotation reads: "The Monroe picture was part of a death series I was doing of people who had died by different ways.

There was no profound reason for doing a death series, no 'victims of their time'; there was no reason for doing it at all, just a surface reason."

4 Pat Hackett (ed.), *The Andy Warhol Diaries* (London, Sidney, NewYork: 1989), p. 645 (entry of April 25th, 1985).

5 Alexander Iolas (* 1901 in Alexandria), who began as a ballet dancer in George Ballanchine's group, gained fame as an extravagant art dealer and collector specialising in Surrealist art with a widely distributed international network of galleries, paved the way for Warhol's first exhibition, featuring drawings inspired by the writings of Truman Capote.

6 This term was used by Gerard Malanga, one of Warhol's assistants, to describe an important criterion employed by the artist in selecting originals for adaptation. For more detail see Michael Lüthy, Andy Warhol. *Thirty are better than one* (Frankfurt and Leipzig: 1995), p. 109.

7 The Benedictine monastery Santa Maria della Stella was established in 1494 but converted less than 100 years later into a poorhouse and soon afterwards into an orphanage, which survived into the 1970s. The building was then taken over by the municipal government, which rents out space in it to a variety of institutions. The Credito Valtellinese bank endeavours to present contemporary art, which received little institutional support in Milan at the time, in its non-profit gallery. Because the word "stelline" (Italian: diminutive form for "stella" , meaning "star") is also used to designate orphans, the name has survived to this day. See Gruppo Bancario Credito Valtellinese (eds.), *Le Stelline. Storia e Vita die un Palazzo* (Milan: 1995), pp. 98, 103 (note 1) and 153.

8 The only evidence that Iolas approached several different artists is a remark by Warhol. When asked why he had done the *Last Supper*, he responded: "Because Iolas asked me to do the *Last Supper*. He got a gallery in front of the other *Last Supper*, and he asked three or four people to do *Last Suppers*." Cited from Paul Taylor, "The Last Interview. Andy Warhol", in *Flash Art* (International Edition), No. 33, April 1987, pp. 40–44, p. 41.

9 Sylvia de Cuevas, Iolas' niece and assistant was unable to determine on the basis of available documentary materials who the other artists commissioned by her uncle were or why they did not carry out the commission. Verbal communication from Sylvia de Cuevas, October 31st, 1997.

10 See Lüthy, 1995 (see note 6), pp. 13–24, including a brilliant analysis of the historical background. Warhol returned to the motif in a series of pictures completed since 1978.

11 See Jörg Schellmann (ed.), *Andy Warhol. Art from Art* (Cologne, New York: 1994). The works in question are Leonardo's Florentine *Annunciation*, Piero della Francesca's *Madonna of the Duke of Montefeltro*, Raphael's *Sistine Madonna*, Uccello's *St. George and the Dragon*, Botticelli's *Birth of Venus*, Tischbein's *Goethe in the Campagna*, Munch's *The Scream*, de Chirico's *The Disturbing Muses* and *Italian Square with Ariadne* and several works based upon "typical" paintings by Picasso, Matisse and others.

12 The exhibition took place from November 20th, 1982 to January 21st, 1983 (Campidoglio, Rome) and was repeated at the Marisa de Re Gallery in New York in 1985. See the section entitled "Chronologie" in *Andy Warhol. Retrospective*, exhib. cat. (Paris: 1990), pp. 418f.

13 See the exhibition catalogue: Credito Valtellinese/Alexandre Iolas (eds.), *Warhol. Il Cenacolo* (Milan: 1987). Only 20 works are cited in the index of exhibited works, however; ibid., n.p. The number cited above was determined on the basis of press reports and confirmed by Cara Ronza of the gallery of the Credito Valtellinese.

14 See in this regard the essays by Reva Wolf ("Introduction: A Radio and a Crucifix"), Zan Schuweiler Daab ("For Heaven's Sake: Warhol's Art as Religious Allegory") and Jane Daggett Dillenberger ("Warhol and Leonardo in Milan") in the journal *Religion and the Arts*, Vol. 1, fall 1996, pp. 10–57. An important stimulus to this critical reception was the eulogy delivered by John Richardson, a friend of Warhol's, at the artist's memorial service. The address was intended, as articulated in the opening paragraph "to recall a side of his [Warhol's] character that he hid from all but his closest friends: his spiritual side". J. Richardson, "Eulogy for Andy Warhol", in: *Heaven and Hell are Just one Breath Away! Late Paintings and Related Works. 1984–1986* (New York: 1992) (also: exhib. cat. Gagosian Gallery), pp. 140–141. Also worthy of mention in this group is the essay by Robert Pincus Witten ("Pre-Entry. Margins of Error – Saint Andy's Devotions", in: *Arts Magazine*, 63, summer 1989, pp. 56–60) and the writings of Paul Giles

(*American Catholic Arts and Fictions*, Cambridge, 1992) and Mark C. Taylor (*Disfiguring: Art. Architecture. Religion*, Chicago and London, 1992).

15 Gene R. Swenson, "What is Pop Art? Answers from 8 painters. Part I: Jim Dine, Robert Indiana, Roy Lichtenstein, Andy Warhol", in: *Artnews*, Vol. 62, Nov. 1963, p. 26.

16 On the basis of the current state of research, the silkscreen prints can be subdividcd into two groups of 9 large (at least 294 x 409 cm) and about 17 small works (most of them 100 x 100 cm). Of the hand-painted pictures, 13 large and 11 small works were identified (including at least four versions of *Be a Somebody with a Body*). The works on paper include 1 pencil drawing, 14 brush drawings, 3 silkscreen prints and at least 29 pieces in which the silk-screen technique is combined with collage. The *Collaborations* with Basquiat are paintings on canvas and a set of 10 punching bags, each painted with the face of Christ and graffiti (now in the possession of the Andy Warhol Museum in Pittsburgh). Verbal communication from Tim Hunt, Andy Warhol Foundation, New York, November 24th, 1997.

17 Warhol saved working utensils, mail and objects accumulated on a day-to-day basis in a total of 610 so-called "Time Capsules", of which, due to technical reasons, only 80 have been opened. Written communication from Matt Wrbican, Archives of the Andy Warhol Museum, Pittsburgh, October 29th, 1997.

18 This statement, which is based upon accounts of contemporaries (including, among others, verbal communications from Benjamin Liu, October 30th, 1997 and January 1st, 1998 and a verbal communication from Jay Shriver, November 11th, 1997) and the remarks by Bourdon, contradicts several of Warhol's own statements and the theories posed by Szanto and Dillenberger on the origins of the works. These discrepancies are explained in the section "I just can't tell the difference" below. See Susanna Szanto, "Recovering Context and Meaning: Andy Warhol's 'Last Supper' in Milan", Master's Thesis, University of Pittsburgh, 1997 and Dillenberger, 1996 (see note 14). See also David Bourdon, *Warhol* (New York: 1989), p. 406.

19 See the following statement by the artist: "All' inizio avevo deciso di farne delle copie 'a mano' ma, poiché nessuna veniva bene come l'originale, m' è sembrato meglio ricorrere alla mia 'vecchia' tecnica: quella fotografica." ("At first I tried to make copies 'by hand', but since none of them were close enough to the original, I thought it would be better to return to my 'old' photographic technique.") Cited and translated from Alessandra Farkas: "Incontro con Andy Warhol alla Vigilia des Suo Arrivo a Milano Dove Presenta una 'Copia' di Leonardo", in *Corriere della Sera*, n.d., press folder issued by the Credito Valtellinese.

20 See Rupert Smith, in *The Andy Warhol Collection. Collectibles, Jewelry, Furniture, Decorations and Paintings*, auction catalogue. Sotheby's, New York, April 1988; remarks on article no. *927.

21 The "tragedy of the *Last Supper*", which began to fade soon after its completion, was first described by Antonio de Beatis in 1517. At about mid-century, the painter Giovanni Battista Armenini referred to the work as "half-ruined". Giorgio Vasari emphasised during a visit in May 1556 that only a number of cloudy patches were still visible. See Ludwig H. Heydenreich, *Leonardo. The Last Supper* (London: 1974), pp. 16 and 18.

22 See Pinin Brambilla Barcilon, *Il Cenacolo di Leonardo in Santa Maria delle Grazie. Storia – Condizioni – Problemi* (Ivrea: 1985).

23 Verbal communication from Pinin Brambilla Barcilon, January 30th, 1998.

24 Asked what he thought of the restoration of the *Last Supper*, Warhol responded: " Io so soltano che è un errore restaurare 'L'ultima cena': è talmente bella così com'è! Le cose vecchie sono sempre le migliori e non andrebbero mai toccate." (All I know is that it is a mistake to restore the *Last Supper*. It is incredibly beautiful the way it is! The old things are always better and shouldn't be changed.) Cited and translated from Alessandra Farkas: "Incontro con Andy Warhol alle Vigilia del Suo Arrivo a Milano Dove Presenta una 'Copia' di Leonardo", in *Corriere della Sera*, n.d., press folder issued by the Credito Valtellinese. Szanto (1997, p. 32) points out that Warhol signed a petition in protest of continued restoration of Leonardo's work just before his death on February 19th, 1987.

25 "It was one of those copies of the 19th-century version that had been redone, like you'd buy in Woolworth's." Smith, cited from auction catalogue, Sotheby's, April 1988, remarks on article *927. The photograph, currently in the possession of the Andy Warhol Museum in Pittsburgh and not acces-

sible, is based according to Szanto (1997, see note 18, p. 11) on an etching originally done in the late 17th or early 18th century. This work was used by a 19th-century copier as a model for a print that was later distributed as a photograph. See also Dillenberger, 1996 (see note 14), p. 39.

26 Depending upon the size of each picture, a different number of silkscreens was required for the reproduction of the motif or pattern. Warhol used four screens for the nearly 25-foot-long *Horizontal Double Last Supper* (ill. 24), each of which was used twice. See Dillenberger, 1996 (see note 14), p. 37.

27 John Denison Champlin, Jr. (ed.), *Cyclopedia of Painters and Paintings* (New York: 1913; first edition: 1885), Vol. 3. p. 32. The book is in the possession of the Andy Warhol Museum in Pittsburgh.

28 The print is in the possession of the Andy Warhol Museum in Pittsburgh. The effects of the heat produced by the lamp have rendered the sheet very fragile, and it is brittle and damaged in a number of places.

29 See Smith in auction catalogue, Sotheby's (see note 20), 1998, remarks on article *927. Both sculptures were sold at this auction. According to information provided by the auction house, the enamelled sculpture was made of biscuit porcelain in Capo-Di-Monte during this century. It bears a stamp and the signature "Cordest".

30 Verbal communications from John Smith and Matt Wrbican, Archives of the Andy Warhol Museum, Pittsburgh, November 4th, 1997. The domestic altar is presently on exhibit at the Andy Warhol Museum, on loan from a private collection.

31 Verbal communication from Benjamin Liu, October 30th, 1997. Of these photos, only those printed here have survived or been recovered to date. According to Jay Shriver, the artist's chief assistant for painting, hundreds of Polaroids were taken. Verbal communication from Jay Shriver, November 12th, 1997.

32 Several slides made from these drawings are in the possession of the Andy Warhol Foundation, New York.

33 Verbal communication from Benjamin Liu, October 30th, 1997.

34 Verbal communication from Benjamin Liu, October 30th, 1997. The results of this experiment appear to have dissatisfied Warhol and his assistants, although Liu also noted that they may not have worked long enough with the photographs.

35 See Smith, 1988, (see note 29), remarks on article *927, who mentioned the association between plastic and marble.

36 Verbal communication from Jay Shriver, November 12th, 1997.

37 The Arabian camel (or dromedary) has one hump; the bactrian camel has two.

38 "Mr. Peanut", a well-known figure in the U.S., was originally based upon a drawing made by a 14-year-old boy and was first used as an advertising symbol for the roasted peanuts produced by the Planters/Lifesavers Co. in 1916.

39 See the entries in Warhol's diary for May 8th and June 16th, 1986 as well as January 7th and February 5th, 1987; printed in Hackett, 1989 (see note 4). See the essay by Dillenberger in this catalogue.

40 See the illustrations on pp. 60ff. in *Collaborations. Warhol. Basquiat. Clemente*, exhib. cat. (Kassel and Munich: 1996).

41 According to Sylvia de Cuevas, Iolas' niece and assistant, the integration of the dove and the print segment was originally suggested by an art dealer, who saw one of the Mr. Peanut pictures on a visit to the studio and asked Warhol whether he wouldn't rather integrate the dove as a sign of the Holy Ghost into his pictures in place of the advertising figure. De Cuevas states that Warhol subsequently did a trial run with the company's stylised animal symbol and responded to the outcome with the exclamation "Geeeee!". Verbal communication from Sylvia de Cuevas, October 31st, 1997.

42 See Warhol's diary entry for July 9th, 1985 (in: Hackett, 1989, see note 4): "Sent Benjamin out on a simple errand and it cost me a thousand dollars! I'd given him $2,000 to go get the large-size sculpture of the Last Supper that we'd bargained the guy down from $5,000 to $2,000 on. So he went there and it wasn't there any more. The Last Supper comes in small, medium, and large. So then at this other place, I'd gotten the guy down from $2,500 to &1,000 for the medium. But Benjamin forgot we'd gotten them down, and he bought the medium one for $2,000! He *didn't remember*! It was actually the size I really wanted, anyway, but he wound up giving the second store for the medium one what he was supposed to buy the large one for. So this means

he hasn't got a head for figures – a thousand dollars is a lot to waste. I just couldn't believe it, after I'd haggled so hard". Why Warhol wanted the large sculpture could not be determined in conversations with several different contemporary witnesses.

43 Smith, cited from auction catalogue, Sotheby's, April 1988, remarks on article no. 927.

44 Verbal communication from Jay Shriver, November 12th, 1998, verbal communication from Benjamin Liu, October 30th, 1997 and January 28th, 1998. In the case of his *Last Supper* pictures, Warhol actually did make every effort to declare them as commercial works, and it is clear that he generally fostered his own image as a commercial, rather than an inspired creative artist. See his statement in *The Philosophy*: "I loved working, when I worked as commercial art and they told you what to do and how to do it and all you had to do was correct it and they'd say yes or no ... When I think about what sort of person I would most like to have on retainer, I think it would be a boss. A boss who would tell me what to do, because that makes everything easy when you're working." Andy Warhol, *The Philosophy* (New York: 1975), p. 96. The issue of "commercial artist vs. independent creative artist" is dealt with in greater detail in the section entitled "I just can't tell the difference". It is conceivable that Shriver's and Liu's views are correct. This can only be determined reliably on the basis of a catalogue raisonné, however, and no such work has yet been published.

45 Warhol in an interview with Natalia Aspesi: "Warhol a Cena con Leonardo", in *La Repubblica*, January 23rd, 1987, in the press folder issued by the Credito Valtellinese. The author's Italian translation of Warhol's remarks reads: "E li ho tutti dipinti a mano, io personalmente; ormai sono diventato un pittore della domenica, durante la Settimana devo guadagnarmi da vivere, devo trovare lo stipendio per una cinquantina di dipendenti. Perciò ho impiegato molto tempo. Ma ho lavorato con molto ardore."
Jay Shriver mentioned (verbal communication, November 12th, 1997) that his involvement in the project diminished as time passed, as he was no longer willing to work on Sundays.

46 Works from the *Last Supper* series were exhibited for the first time at the Milan exhibition. Smaller selections of pictures were shown at the Gagosian Gallery in New York (cat.), at the Dia Center in New York from September 16th, 1994 to June 25th, 1995 (supplementary exhibition leaflet) and at the exhibition room of Edition Schellmann in Cologne (cat.) from April 29th to October 30th, 1994.

47 According to Szanto, 1997, (see note 18), who regards the exhibition as the real purpose of the *Last Supper* series and thus overestimates the significance of the event.

48 See Natalia Aspesi: "Warhol a Cena con Leonardo", in: *La Repubblica*, January 23rd, 1987, in the press folder issued by the Credito Valtellinese: "Organizzare la mostra ... non è stato facile ... A un certo punto chi l'aveva ideato, il quasi novenne Iolas è scomparso, irraggiungibile nella sua casa in Grecia. Ha dovuto intervenire un altro gallerista, Philippe daverio, che è riuscito a portare termine l'operazione. E ora le cose sono complicato perchè Iolas sta in ospedale a Treviglio ..."

49 See *ibid*.: "Ma questo lugubre storia non tocca Warhol, che del resto ha già venduto le sue ventiduc opere a Iolas, si dice per mezzo milione di dollari più mezzo milione in opere d'arte antica di cui Andy è un accanito collezionista" On the issue of compensation see also *Artnews*, May 1988, p. 23.

50 John O'Connor and Benjamin Liu (*Unseen Warhol*, New York, 1996, p. 128) cite Morera with the following statement: "Andy came to Milano for the show, bringing his friend, photographer Chris Makos, with him. I was constantly on the phone with Fred Hughes before Andy arrived. They had asked me to check how the people in Milano were handling the show. So I was their inside curator and press officer more or less. The gallery people had their own curator, of course."

51 Verbal communication from Sylvia de Cuevas, October 31st, 1997. See on this matter – aside from Warhol's interest in wallpaper – the mirror effect of the aluminium-lined "Silver Factory", the New York studio (at 231 East 47th Street) occupied in 1963. The initiative for this wall, ceiling and floor covering, which Warhol is known to have regarded as "terrific", is attributable for the most part to Billy Name, a friend and assistant of Warhol's. See David Bourdon, *Warhol* (New York: 1989), p. 170.
The floor covering shown in the photo printed here was replaced during the

exhibition with another white covering. Verbal communication from Cara Ronza, Credito Valtellinese, January 30th, 1998.

According to Benjamin Liu, the artist was so excited about the idea of the semi-circular wall that he planned to have it recreated in his New York studio. Verbal communication, October 30th, 1997.

52 See Bourdon, (see note 18), p. 406: "Although he [Warhol] liked both the handpainted and the silkscreened versions, he chose only to show the latter in Milan."

53 Two of these pictures were overprinted with a camouflage pattern.

54 As Daniela Morera recalls, only a very few visitors took advantage of this opportunity.

55 At the press conference for the opening of the Milan exhibition Warhol explained that he had seen Leonardo's fresco "for the first time four years ago". See Claudio Castellani, "Ebbene, Si Leonardo Abita Ancora Qui", in Annabelle, press folder issued by the Credito Valtellinese. An uncaptioned newspaper clipping in the possession of the library of the Dia Center in New York contains the following quotation from Fred Hughes, a close friend and colleague of Warhol's: "I took Andy to see the Last Supper in Milan and the painting had a profound effect on him. He had always had a deep interest in religious iconography and his Last Supper paintings are a beautiful reflection of that interest." The opportunity for a shared visit did not arise in 1983 but in 1980, however, during a journey taken by the two to Italy, on which they also had an audience with the Pope. Several of Warhol's co-workers, including Vincent Fremont and Tim Hunt, who now work for the Andy Warhol Foundation in New York, have mentioned that the first visit may even have taken place during a trip to Europe in 1965 and 1966, or during the seventies, when Warhol made several journeys to Italy in connection with his movie productions.

The only certainty is the date on which Warhol visited the refectory of Santa Maria delle Grazie for the last time – January 22nd, 1987, in the company of Daniela Morera. Verbal communication from Daniela Morera, October 1997.

56 See the detailed analysis by Leo Steinberg, "Leonardo's Last Supper", in The Art Quarterly, Vol. 36, winter 1973, pp. 297–410.

57 The Crucifixion was done by Donato da Montorfano. Today it is generally assumed that the concept for this juxtaposition was Leonardo's idea and was supported by both the patron, Lodovico Sforza, and the monks. See Jack Wassermann, "Reflections on the Last Supper of Leonardo da Vinci", in Arte Lombarda, Vol. 66, 1983, pp. 15–34, p. 16.

The juxtaposition of the Last Supper and Crucifixion is also one of the significant innovations in the tradition of refectory paintings. Following early examples in Rome (12th century), Ravenna and Bologna (first half of the 14th century), the genre flourished in Florence around the mid-14th century, beginning with Taddeo Gaddi's Last Supper (ill. 42) at the Franciscan monastery Santa Croce. Gaddi executed his fresco of the Last Supper along with the Crucifixion (placed above it) in the refectory. In the Last Supper painted by Domenico Ghirlandaio for refectory of San Marco in Florence in 1480 (ill. 43), the Crucifixion is only a comparatively small, decorative pictorial element in the painted architecture, while the table scene is the dominant theme. This composition and the approach to the interpretation of space may be regarded as having provided a foundation for Leonardo's œuvre. The artist had succeeded in summarising and further developing the Florentine tradition by assigning both the Last Supper and the Crucifixion based upon Gaddi's work to a prominent position on the opposite wall.

58 Christ is depicted twice in each of the six Vertical Double Last Suppers, in each of the three Horizontal Double Last Suppers, a total of four times in the collaged Last Supper compositions and 12 times in the collages.

59 See in this regard the series of crosses done circa 1982 in Guns, Knives and Crosses, exhib. cat. (Madrid: Galeria Fernnando Vijande: 1982/83).

60 The relationship between figure and space developed by Leonardo was not taken up by Rubens, for example, who focused in a drawing based on the Milan Last Supper exclusively on the representation of the figures, neglecting the surroundings entirely. Rubens shows no architecture in the background, but instead incorporates a curtain that veils the total context. See on this matter Steinberg, 1973 (see note 56), P. 347 and pp. 394f., illustrations pp. 316f.

61 According to Steinberg, 1973 (see note 56), pp. 346–360, Leonardo had depicted the Last Supper as viewed from an elevated vantage point. Pinin

Brambilla Barcillon, the conservator, assumes, now that the work has been almost completely exposed and restored, that the vanishing points within the painted space correspond to a view from the opposite corners of the refectory hall. Verbal communication, January 30th, 1998.

62 During the artist's lifetime the pictures were mounted in two ways. The motifs were either "centred" as in classical oil painting, with margins folded more or less in congruence with the motifs at the edges or unprinted strips were left on the front side of the picture. See in this regard, as one of many examples, Marilyn x 100 (1962), pre-printed in: Andy Warhol. Retrospective, exhib. cat. (Paris: 1990), p. 216, ill. 205.

63 Verbal communication from Benjamin Liu, October 30th, 1997.

64 Warhol remarked to Aspesi (1987, see note 45), that he would not dare to compare himself to Leonardo but was pleased to have been able to work "with him". He added that "no artist today can be compared with this genius. The new Leonardos are Armani, Krizia and the Italian designers. (See original quote: "... mi è piaciuto lavorare con lui, con sua Cena, ma oggi nessun artista è paragonabile a quel giorno, i nuovi Leonardi sono Armani, Krizia, gli altri stilisti italiani.").

65 Warhol, cited from Alexandra Farkas, "Incontro con Andy Warhol alla Vigilia del Suo Arrivo a Milano Dove Presenta una 'Copia' di Leonardo", in Corriere della Sera, n. d., press folder issued by the Credito Valtellinese. (See original quote: "[Iolas ha] Visto che 'L'ultima cena' di Leonardo è il miglior quadro esistente e visto che nessuno può mettersi di comprarlo, Iolas mi ha chiesto di farne una copia, cosi qualcuno può finalmente portarselo a casa e appenderselo in salotto.")

66 These figures, repeatedly cited in the literature, have been confirmed by Daniela Morera, who also emphasises Warhol's great pleasure in response to the interest afforded to him, despite his poor health. She recalls that he tirelessly signed visitors' catalogues, bodies and clothes throughout the entire opening ceremony. See also John O'Connor and Benjamin Liu: Unseen Warhol (New York: 1996), p. 128, where the exhibition is described as Warhol's greatest publicity success: "We were expecting five hundred: around five thousand came. The whole street was blocked; it was the most incredible scene. I couldn't believe it was real. Andy was so exhausted; he was so much in pain. I found a little table in a corner. I asked two of the guards to push it in front of Andy, Chris Makos and me because the crowd was suffocating us and we didn't have any defense, nothing. Then Andy, after signing the posters, Interview magazines, invitations and any other piece of paper available, started to sign glasses, ties, bags, bras, scarves. Everybody was giving him something to sign. They were craving for the guru's signature. Finally I said, 'Andy, you're tired, let's go.' 'No, no, I'll finish it', he answered. He was so sweet, so sweet, really very generous with everybody till exhaustion – a real pro-star."

67 According to Bourdon, 1989, (see note 18, p. 406), the program was conceived in such a way that visitors would have viewed Leonardo's Last Supper first. But shortly after the opening of Warhol's exhibition it became impossible to view Leonardo's Last Supper. The refectory was closed so that restoration work could go on without disruption by the public.

68 Verbal communication from Benjamin Liu, October 30th, 1997.

69 Warhol, quoted from Taylor, 1987 (see note 8), p. 41. Taylor's question was: "Is there any similarity between you and the Factory and Jesus and the Last Supper?"

70 Giorgio Vasari, cited and translated from U. Gottschewski and G. Gronau (eds.), G. Vasari: Die Lebensbeschreibungen der berühmtesten Architekten, Bildhauer und Maler (Strasbourg: 1906), Vol. 4, p. 11.

71 Steinberg, 1977, (see note 56), pp. 402–406, who compiled a list of the most important copies, was unable to determine the original locations for two of the works. See also in this regard the chapter on copies based on Leonardo's Last Supper in Ludwig H. Heydenreich, Leonardo. The Last Supper (London: 1974), pp. 99–105, and G. Dehio, Zu den Kopien nach Leonardos Abendmahl (Berlin: 1896).

72 Vasari, quoted from Gottschewski and Gronau (see note 70), p. 13. Steinberg (1977, p. 403) points out that there are no clearly identifiable sources for the story, frequently cited since 1651, according to which the king asked for a copy. The painting was firmly fixed to the wall of the royal church of St. Germain in Paris – obviously as an imitation of Leonardo's fresco.

73 The piece in question is a fragment attributed to Tullio Lombardo, dis-

covered at S. Maria dei Miracoli in Venice in 1880, where it is still preserved today, firmly fixed within the wall of the sacristy. See Steinberg, 1973, p. 405. See the illustration in Carlo Pedretti, Leonardo. *Studies for the Last Supper from the Royal Library at Windsor Castle* (Cambridge University Press: 1983), ill. 33.

74 Steinberg, 1977 (see note 56), p. 406.

75 Raphael had handled the proportional relationship between the figure and the surroundings with a greater degree of realism in his paraphrase. Steinberg (ibid.) points out that in this work the apostles are positioned for the first time around the table in the manner depicted in the sculptural versions (the two apostles at the extreme left and right are moved to the front side of the table that is closest the viewer). Rembrandt (ill. 11) and Rubens appropriated only the figure groups and redesigned the surroundings in their drawings based upon the Milan *Last Supper*. In Rubens' paraphrase a curtain appears in the background, which, as is also the case in Rembrandt's drawing veils the relationship between the architecture and the figures that is evident in Leonardo's work. See a compilation of important copies in *ibid.*, illustrations pp. 316ff.

76 Johann Wolfgang von Goethe, for example, who also commented on Leonardo's *Last Supper* in his writings, wanted to have an etching made from a copy of the work he had seen in Rome. See Heydenreich, 1974, p. 100. On Goethe's written remarks see note 125.

77 Maria Giulia Minetti, "E' un autentico Andy da Vinci", in Epoca, n.d., n.p., press folder issued by the Credito Valtellinese. Asked why he had worked on the *Last Supper*, Warhol answered: "Perché il Cenacolo mi inspira religiosamente. Perché nella mia vita ho sempre cercato di mescolare vecchio e nuovo." (Because the *Last Supper* inspires me in a religious way. Because I have always tried to mix the old and the new).

78 See Warhol's statement cited in the following article: Natalia Aspesi, "Warhol a Cena con Leonardo", in *La Repubblica*, n.d., n.p., press folder issued by the Credito Valtellinese: "La Mamma ne teneva una riproduzione nel corridoio; quando ci passava davanti, si faceva il segno della croce." (My mother had a reproduction hanging in the hall. When you passed by it you made the sign of the cross).

79 Remarkably, Wackerbart did not do his photograph as a commissioned piece for the company. Instead, the company approached him after its completion. According to Wackerbart, the picture is from a series of photographs in which he – consciously working in the grey area between advertising and art – sought to find variations in the expression of religious ideas in the late 20th century. Verbal communication, February 25th, 1998.

80 The ad campaign was relaunched at a cost of about 100 million French Francs in early 1998. It shows a false Messiah recommending the newborn (!) Golf instead of bread and wine. See the *Süddeutsche Zeitung*, February 9th, 1998 ("Feuilleton").

81 Retranslated from Samuel Beckett, "Der Ausgestoßene", in: *Erzählungen und Texte um Nichts* (Frankfurt: 1990), p. 8; quoted here from Lüthy, 1995 (see note 6), p. 65.

82 Warhol, quoted from Taylor, 1987 (see note 8), p. 41.
Asked about the legality and the copyright situation as regards the use of found pictures, Warhol answered during the same interview (pp. 43f.): "I don't know. It's just like a Coca-Cola bottle – when you buy it, you always think that it's yours and you can do whatever you like with it. Now it's sort of different because you pay a deposit on the bottle. We're having the same problem now with the John Wayne pictures. I don't want to get involved, it's too much trouble. I think that you by a magazine, you pay for it, it's yours. I don't get mad when people take my things."
Contrary to Taylor's title, the *Flash-Art* interview was not the last the artist gave, since A. Farkas, at least, of the *Corriere della Sera* (see note 19) was able to speak with Warhol afterwards.

83 Warhol, quoted from Taylor, 1987 (see note 8), p. 44.

84 Warhol, quoted from "Painter Hangs own Paintings", *New York Magazine*, February 55th, 1979, p. 9.

85 See Szanto, 1997 (see note 18), who gave this possibility a great deal of thought.

86 See Bourdon, 1989 (see note 18), p. 123.

87 Warhol, in Laura de Coppet and Alan Jones, The Art Dealers (New York: 1984), p. 156; quoted here from Szanto, 1997 (see note 18), p. 21.

88 John Coplans, "Andy Warhol and Elvis Presley", in *Studio International*, February 1971, Vol. 181, No. 930, p. 49.

89 See in this regard *Earth Room and Broken Kilometer* by Walter de Maria in New York. See also the concept of the Dia Center for the Arts in New York. The very thoroughly prepared exhibitions are ordinarily shown for at least six months in order to permit the artists to adjust their installations to the physical conditions of the locations precisely.

90 The notes were not recorded by the artist himself but instead by Pat Hackett, following her daily telephone conversations with Warhol. See Hackett 1989, (see note 4).

91 Ibid., p. 710.

92 See in this regard a remark made by Joseph Beuys (translated here), whose work Warhol studied: "There is a genuine relationship to people who possess such things [multiples], such vehicles [of communication and the content to which the object refers]. It is like an antenna standing somewhere, with which one remains in contact ... I am very interested in the dissemination of physical vehicles in the form of editions, because I'm interested in the dissemination of ideas. The objects are comprehensible only within the context of my ideas." Joseph Beuys, cited and translated from *von hier aus*, exhib. cat. (Düsseldorf), p. 9.

93 Jean Baudrillard, *Amerika* (Munich: 1995), p. 173. Baudrillard relates this statement to Los Angeles.

94 Warhol, in Taylor, 1987 (see note 8), p. 42.

95 See Szanto, 1997 (see note 4), Summary, n.p. and *ibid*. p. 25.

96 Matching information received from several different contemporary witnesses, including a verbal communication from Benjamin Liu, January 28th, 1998.

97 See Bourdon, 1989 (see note 18), p. 406.

98 Farkas, 1987 (see note 19), quotes Warhol as follows: "Essere bravi nel business, per me, è la forma d'arte più affascinante."

99 The article entitled "Warhol Wrangle" (in: *Artnews*, May 1988, p. 23) mentions that the artist and the gallerist agreed that a portion of Warhol's compensation for the commission would take the form of six ancient Roman statues. Aspesi (see note 48) takes the view that Warhol sold the works exhibited in Milan for half a million dollars, plus half a million dollars worth of antique artworks.

100 See Warhol's reaction to his interviewer Paul Taylor (1987, see note 8, p. 41), who asked him about the pictures exhibited in Milan:
"PT: Did you do any preparatory drawings for them?
AW: Yeah, I tried. I did about forty paintings.
PT: They were all preparatory?
AW: Yeah."

101 Maria Giulia Minetti, "E' un autentico Andy da Vinci", in Epoca, n.d., n.p., press folder issued by the Credito Valtellinese. Asked about the artist's approach, the gallerist answered: "Ha provato di tutto. Ha incominciato con disegni in bianco e nero di quattro-cinque metri con interventi d'ogni genere, motociclette, cartelloni, pubblicitari, giochi elettrici ... alterando a volte i gesti dei personaggi. Ma infine ha buttato via tutto. Ha deciso di lavorare solo sul significato del quadro: Leonardo visto da Andy Warhol, ma Leonardo."

102 In general, it can be said with respect to Warhol that "preparatory works" mean photographs and newspaper clippings, etc. which he made or chose as models for his pictures. No groups of works that could be characterised by the term "preparatory" were identified in the documentation of Warhol's oeuvre at the Andy Warhol Foundation in New York. Benjamin Liu and Jay Shriver describe the Polaroid photos made from the sculpture as trials in the process of finding the right images.

102 See the illustration of The Last Supper (The Big C).

104 Verbal communication from Benjamin Liu, January 28th, 1998.

105 See the diary entry for January 16th, 1987 in Hackett, 1989 (see note 4), p. 793: "I still want to do the 'Worst of Warhol,' all the stuff that didn't come off. I'll *(laughs)* have to do more, though."

106 Some of the works structured according to the same scheme were not exhibited. They are autonomous but also part of the series that was represented by "exemplary" works in Milan.

107 See Bourdon, 1989 (see note 18), p. 406: "Although he liked both the handpainted and the silkscreened versions, he chose only to show the latter in Milan."

108 Szanto did not take these "left-over" pictures into account in her study. Thus there must be doubts about the correctness of her primary theory, according to which the *Last Supper* series was done exclusively for the exhibition at the Palazzo Stelline. See in this regard Szanto, 1997 (see note 18), Summary, n.p and *ibid.*, p. 25.

109 Like Szanto (1997, see note 18), Dillenberger (1996, as cited in fn 14, p. 36) has concluded on the basis of the statements quoted above that the hand-painted pictures were completed first.

110 Serial painting can, of course, be described as a process of searching for the final, finished work; it is a search, however, that in view of the objective abundance of images must be regarded as a failure.

111 Warhol made this statement in the course of a discussion about the criteria for "good" art, about the difference between "genuine" creative art and commercial art. The larger context of this portion of the interview reads as follows:
"PT: What has happened to the idea of good art?
AW: It's all good art.
PT: Is that to say it's all equal?
AW: Yeah well. I don't know. I can't . . .
PT: You are not interested in making distinctions?
AW: Well no. I just can't tell the difference."
Quoted from Taylor, 1987 (as cited in fn 8), p. 42.

112 The section heading is based upon the title of a picture done by Warhol in 1986.

113 "I think somebody should be able to do all my paintings for me ... I think it would be so great if more people took up silkscreens, so that nobody would know whether my picture was mine or somebody else's ... The reason I'm painting this way is that I want to be a machine." Andy Warhol, in: Swenson, 1963 (see note 15), p. 26.

114 Warhol referred to this type of work as a "hand job". Verbal communication from Benjamin Liu, October 30th, 1997.

115 See Bourdon, 1989 (see note 18), p. 402.

116 Letter of St. Ignatius to the Ephesians (20:2); cited from Kurt Gallig et al (eds.), *Die Religion in Geschichte und Gegenwart. Handwörterbuch für Theologie und Religionswissenschaft* (Tübingen: 1986), Vol. 1, heading "Abendmahl".

117 Warhol, in Hackett, 1989 (see note 4), p. 714, entry for February 13th, 1986.

118 Richard Pleuger, "Der Heimkehrer. Rambo erzählt, warum er jetzt Sylvester Stallone heißt, warum er seine Wiedergeburt als schüchterner Fettwanst feiert und was es für ein Gefühl ist, wenn sich keiner mehr nach ihm umdreht", in *Marie Claire*, 2, 1998, p. 51.

119 *Ibid.*

120 Rambo on Rambo, in *ibid.*

121 Rambo on Rambo, in *ibid.*

122 Stallone on his new role in Cop Land, in *ibid.*

123 *Ibid.*

124 Vasari, quoted from Gottschewski and Gronau, 1906 (see note 70), p. 12.

125 Goethe on Leonardo's *Last Supper*, quoted and translated from J. W. von Goethe, "Joseph Bossi. Über Leonardo da Vincis Abendmahl zu Mailand" in Erich Trunz (ed.), *Goethes Werke* (Munich: 1981), Hamburg edition, Vol. 12 (Schriften zur Kunst. Schriften zur Literatur. Maximen und Reflexionen), pp. 164–168, p. 166.

126 See *ibid.*, p. 166 translated here: "The stimulant through which the artist shocks the quiet, consecrated supper gathering are the words of the Master: There is one among you who shall betray me! They are spoken, and the entire party is distressed; but he bows his head, lowers his gaze; the whole attitude, the movements of the arms, the hands, everything repeats in heavenly obedience the unhappy words, which even silence affirms: Yes, it is not otherwise. There is one among you who shall betray me."

127 *Ibid.*

128 "Verily, Verily, I say unto you, that one of you shall betray me. Then the disciples looked one upon the other, doubting of whom he spake." (John 13:21–23)

129 "Therefore, when he was gone out, Jesus said, Now is the Son of man glorified, and God is glorified in him. If God is glorified in him, God shall also glorify him in himself, and shall straightway glorify him." (John 13:31–32)

130 Vasari, quoted from Gottschewski and Gronau, 1906 (see note 70), p. 12.

131 *Ibid.*

132 *Ibid.*

133 *Ibid.*, p. 13.

134 *Ibid.*

135 *Ibid.*

136 *Ibid.*

137 Bourdon, 1989 (see note 18), p. 114.

138 Verbal communication from Benjamin Liu, October 30th, 1997.

139 See Warhol's remarks in his interview with Paul Taylor (1987, see note 8, p. 41), which relate is this passage to the silk-screen prints, however.
"PT: It's odd because you normally see just one Jesus at a time.
"AW: Now there are two.
PT: Like the two Popes.
AW: The European Pope and the American Pope."

140 *Ibid.* The relevant interview passage reads:
PT: ... There [at the exhibition] you will see two Jesuses on crucifixes, one beside the other.
AW: Oh.
PT: And he [Dokoupil] explained to me something like how it was transgressive to have two Jesuses in the same picture.
AW: He took the words out of my mouth.
PT: You are trying to be transgressive?
AW: Yes."

141 See note 69 and the corresponding text passage.

142 Verbal communication from Tim Hunt, The Andy Warhol Foundation, New York, November 24th, 1997. An illustration of Basquiat's punching bags is preserved at the Andy Warhol Foundation in New York.

143 See J. D. Dillenberger, "Leonardo's Last Supper Transformed", unpublished typescript, p. 16. The text is to appear in a publication by Dillenberger devoted entirely to Warhol's *Last Supper* pictures in the summer of 1998.

144 In *Playboy. Entertainment for Men*, January 1967, ill. p. 142 (without black light) and p. 143 (with black light). *Playboy* also asked other artists, including Dali, Larry Rivers, Ellen Lanyon, Roy Schnackenberg, Ben Johnson, George Segal, Tom Wesselmann, James Rosenquist and Alfred Leslie to submit contributions, which were also printed in the same issue.

145 Warhol, in *ibid.*, p. 142.

146 See also the artist's "Rorschach" pictures, which are based on the psychological experiments carried out by the Swiss psychiatrist Hermann Rorschach, in which the meaning of the image is "determined" by the viewer.

147 See Bourdon, 1989 (see note 18, p. 403f.), who gives a more detailed account of the deaths in Warhol's circle.

148 The representations of Christ and the Playmates have a certain resemblance to drinking glasses on the bottom of which one can see a nude, when the glass is full. The nude disappears, however, as soon as the glass is emptied.

149 "I always wished I had died, and I still wish that, because I could have gotten the whole thing over with ... I never understood why when you died, you didn't just vanish ... I always thought my own tombstone to be blank. No epitaph, and no name. Well, actually, I'd like it to say 'figment'." Andy Warhol, America (New York: 1975), pp. 126–129; cited here from Trevor Fairbrother, "Skulls", in Dia Art Foundation/Gary Garrels (eds.), *The Work of Andy Warhol* (Seattle: 1989), pp. 93–114, p. 104.

150 See Richard Sennett, The Conscience of the Eye. The Design and Social Life of Cities (New York, London: 1990), p. 50. See also the last paragraph in the section of this essay entitled "I like that idea that you can say the opposite".

151 Lewis Mumford, The City in History (New York: 1961), p. 421; quoted here from Sennett, 1990 (see note 150), p. 53.

152 See in this regard the essay by Dillenberger printed in this volume.

153 See Zentralinstitut für Kunstgeschichte (ed.), *Reallexikon zur Deutschen Kunstgeschichte* (Munich: 1973), Vol. 6, pp. 42–48, heading "Eßzettel".

154 Bodhisattwas are beings who, like Buddha, are capable of enlightenment but postpone their entry into Nirvana in order to give aid and assistance to humans by virtue of their mercy or wisdom. They are regarded by believers as a kind of "healing intermediary".

155 It is possible that Warhol was familiar with comparable models, since cast

or carved groups of Buddhas or Bodhisattwas were frequently offered for sale in western shops as well. Apart from the fact that entire districts in New York City are influenced by Asian culture – the model for the silk-screens was purchased from a Korean shop for religious articles – Warhol himself visited Asia during the early eighties. Warhol's knowledge about Asian cultures may have been augmented through his contact with Francesco Clemente. Clemente, who worked with Warhol and Basquiat on the *Collaborations*, made a number of trips to Asia beginning in 1973, including an extended sojourn in India.

If one takes into account the fact that the luminous orange-yellow seen in one of the two *Reversals* (cat. 9–10) resembles the colour typically worn by Buddhist monks, one could take this aspect – in addition to the form – as an indication of Warhol's knowledge of and practical concern with elements of Asian culture.

156 The name of the building relates to the number 33 (Japanese: sanjusan). The information provided here is based on explanations found in several different travel guides, including Josef Kreiner, *Japan. Kunst- und Reiseführer mit Landeskunde* (Stuttgart: 1979), p. 215 and *Nagels Reiseführer Japan* (Geneva, Paris, Munich: 1965), pp. 625–627 (containing a floor plan of the hall).

157 In 1964 Mark Rothko was commissioned by the de Menil family to do frescoes for a chapel, which in turn had been built especially to the artist's specifications.

158 See note 3. The *Death* series mentioned by the artist also includes the *Disaster* pictures, which are based upon press photos showing the deaths of one or more people, unknown to the public, through various disasters (accident, suicide, murder). This group also includes the *Electric Chair* series, which the victims do not appear. Also worthy of mention are Warhol's portraits of Jacqueline Kennedy. These were done following the assassination of John F. Kennedy and based upon photos showing his wife before and after the attack on the American president.

159 See Richardson, 1992 (see note 14).

160 Verbal communication from Jay Shriver, November 12th, 1997.

161 Verbal communication from the photographer Christopher Makos, a friend of the artist's, who had also accompanied Warhol to the opening of the Milan exhibition, November 25th, 1997. Friends and co-workers of Warhol's generally agree that the artist mentioned such topics only in very brief, aphoristic remarks.

162 Glenn O'Brien, *interview in High Times*, August 24th, 1977, pp. 21–38. See also Wolf, 1996 (see note 14), p. 13.

163 *Ibid.*

164 Warhol's Sunday activities are described in a number of entries in his diary covering the eighties, and it is apparent that attendance at church and visits to the flea market were linked in an almost ceremonial way. See, for example, the entry for September 22nd, 1985: "Went to church. I always go for ten or five minutes. It's so empty, but sometimes there's a wedding. Then cabbed down to Sixth Avenue and 26th Street to the flea market (cab $ 6.00). It was such a pretty day. You can still get fiestaware cheap. It never went anywhere, I guess." Quoted from Hackett, 1989 (see note 4), pp. 679f.

The diary cited here in a number of places was published after the artist's death (1989). It is based upon his morning telephone conversations with Pat Hackett, to whom he regularly (but not without gaps) described his daily activities.

165 For more detail on this point see Dillenberger, in the essay printed in this volume.

166 See the wonderful sentence with which Thomas Meinecke promotes his novel, *The Church of John F. Kennedy* (Frankfurt: 1996) on the book's dust-cover (translated here): "Don't believe a single word you ever read about the South. It was probably written in New York; and you can imagine what kind of a place that is when I tell you that people live on top of each other there. Do your hear me? On top of each other."

167 According to Benjamin Liu (verbal communication October 30th, 1997), this is a typical Warhol expression, with which the artist repeatedly described his method of simply reversing a technical process or content or complementing it with its opposite. See also the technique employed in the *Reversals.*

168 "We want to be a fun experience, but people should learn something, too", says Anneli Shearer of Nike about her company. Cited from Stefan Kornelius, "Denn Design ist das Reich und die Herrlichkeit", in the *Süddeutsche Zeitung*, December 13th/14th, 1997, p. 3.

169 The "code of honour of a new generation of athletes" is propagated in Niketown. See *ibid.*

170 Asked in a 1977 interview for *Christopher Street*, a journal for gays, what his favourite building in New York was, Warhol answered: "My favorite building is that new one on 54th Street and Lexington Avenue. I looked at it this morning about 5 o'clock. It's where the church is. There's a modern church and then they built a high-rise over it. Have you seen it yet? Oh, it's great." Claire Demers, "In Interview with Andy Warhol", in *Christopher Street*, 1977, pp. 37—40, p. 38. See also Wolf, 1996 (see note 14), p. 13.

171 At that time the bank was still known as the First National Bank.

172 From a letter from the parishioners of St. Peter's (to the architect Hugh Stubbins?); cited from Judith Dupré, *Skyscrapers* (New York: 1996), p. 79.

173 "We must use the resources of big business, reinforced by moral and social ideas, to develop a new generation of office buildings planned for the community and expressive of the humanity of the individuals who use them." Hugh Stubbins in a letter to Henry J. Muller, then vice-president of the First National Bank, the contracting client. Cited from *ibid.*

174 See in this regard the *Süddeutsche Zeitung*, December 9th, 1997, p. 14 ("Streiflicht").

175 Asked what his second most favourite building was, after the Citicorp complex, Warhol said: "A church I go to on 66th Street and Lexington Avenue. I forgot what it's called." Quoted from Demers, 1977 (see note 170), p. 38.

176 Cited from Hackett, 1989 (see note 4), p. 802.

177 Oscar Wilde, *The Picture of Dorian Gray* (Ware: 1992), p.3.

THE PAINTINGS

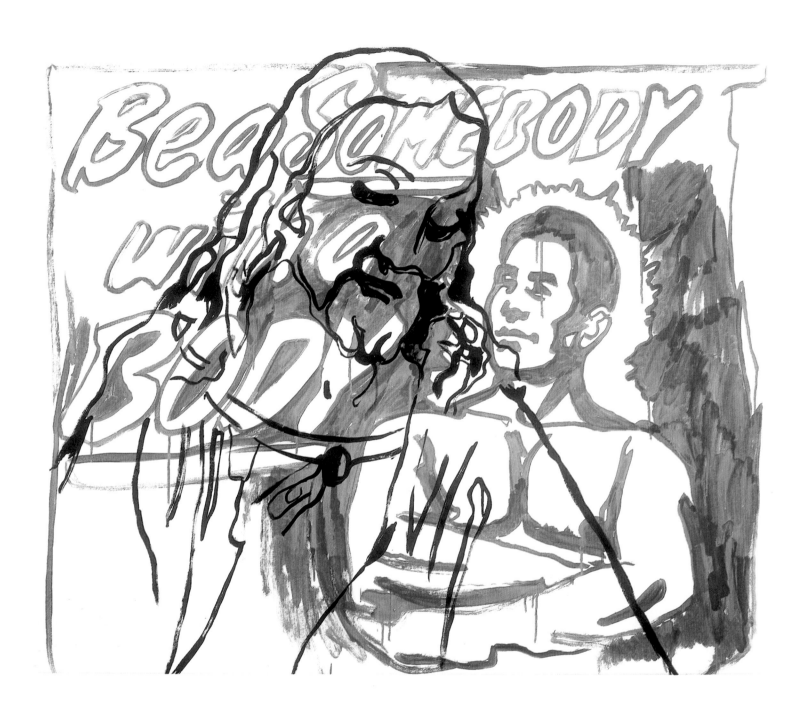

1 **The Last Supper/Be a Somebody with a Body,** 1985/86

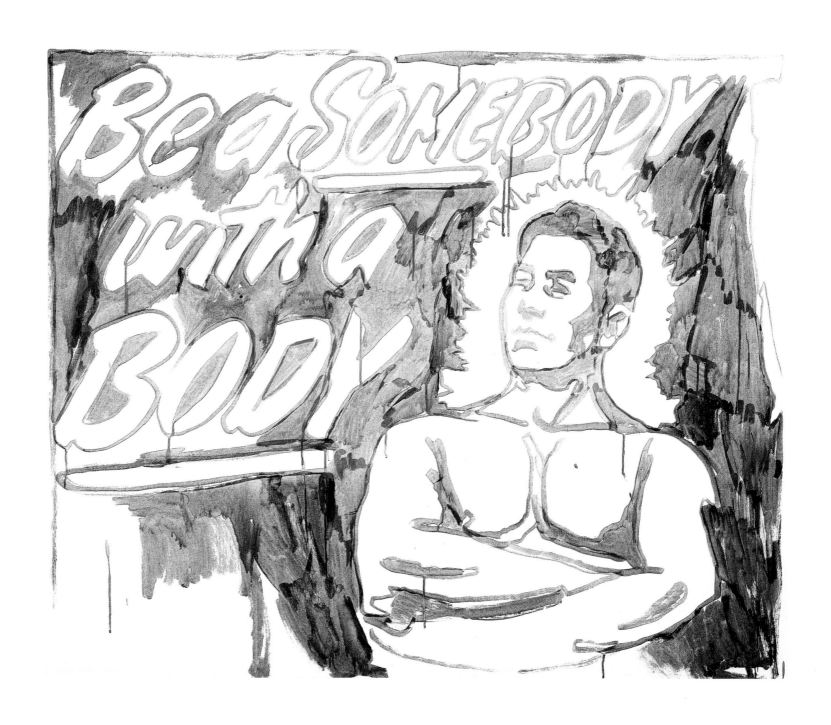

2 **Be a Somebody with a Body,** 1985/86

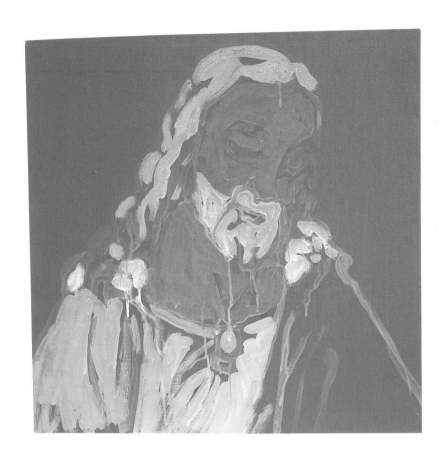 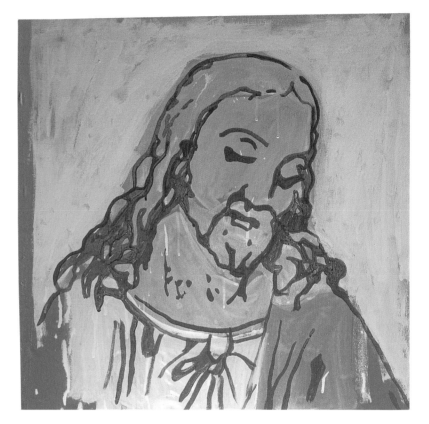

3 **Black-Light Christ,** (illuminated with black-light) 1986

4 **Black-Light Christ,** (illuminated with black-light) 1986

58

3 **Black-Light Christ,** 1986

4 **Black-Light Christ,** 1986

5 **The Last Supper,** 1986

6 **The Last Supper,** 1986

7 **The Last Supper,** 1986

8 **The Last Supper,** 1986

9 **The Last Supper (Christ 112 Times),** 1986

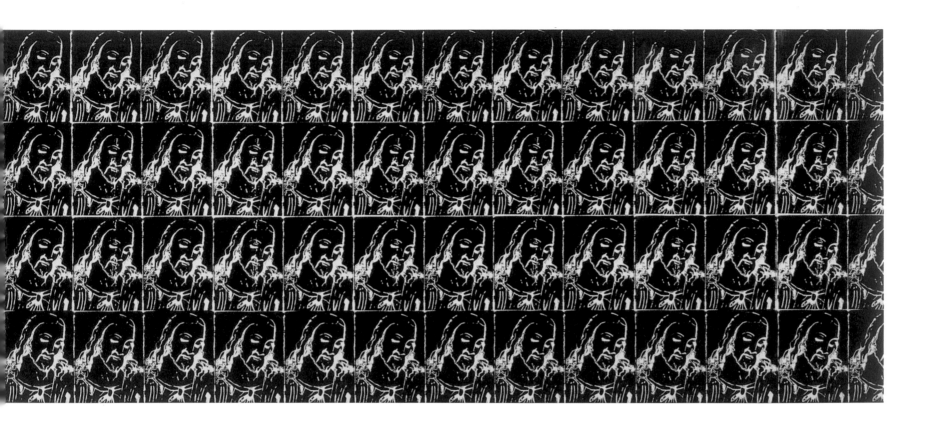

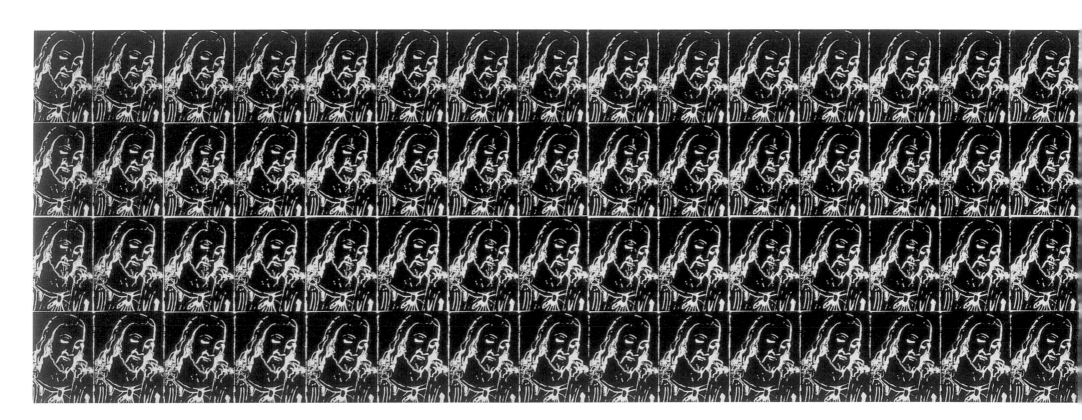

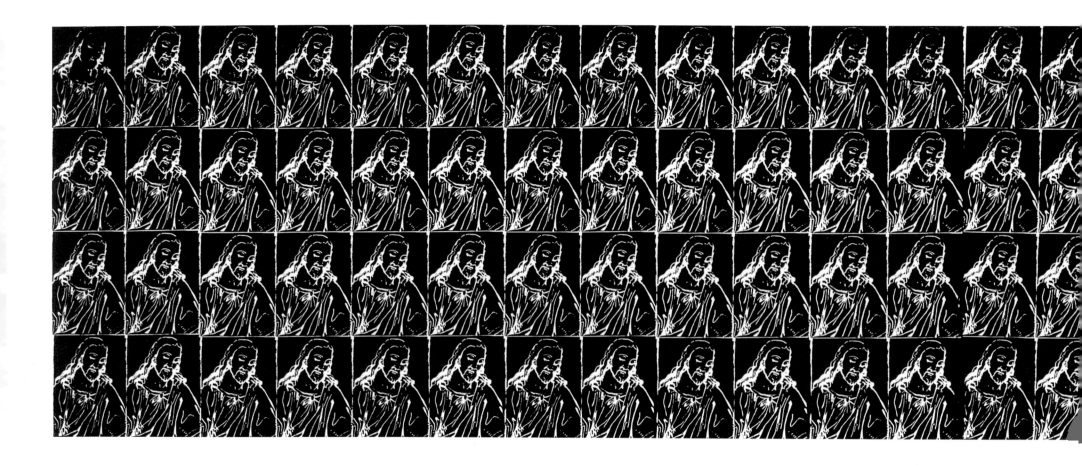

10 **The Last Supper (Christ 112 Times)**, 1986

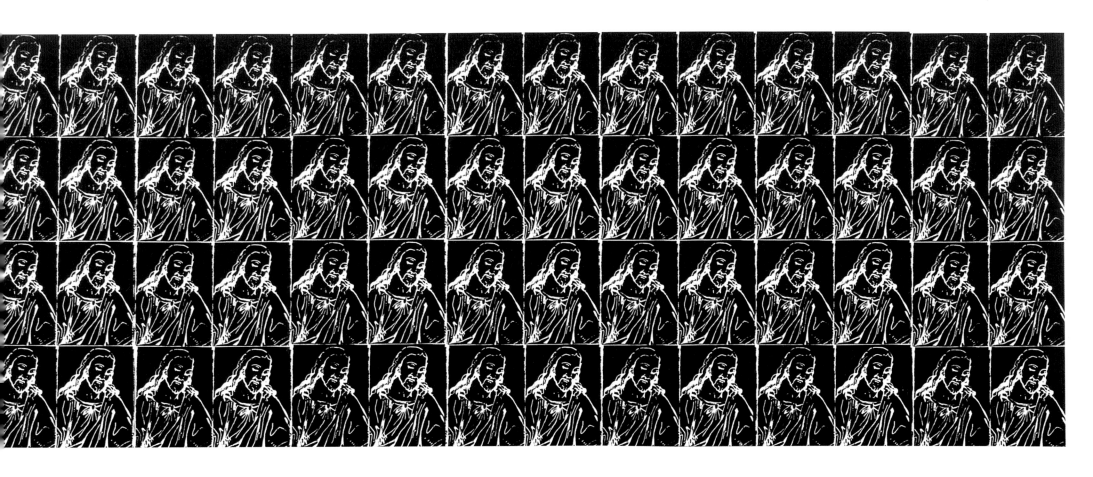

11 **The Last Supper,** 1986

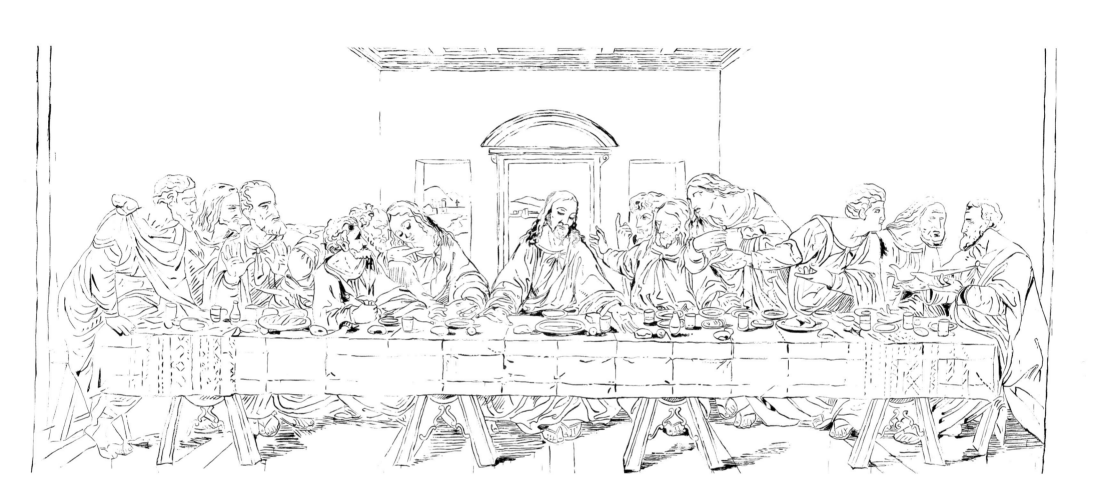

12 **The Last Supper (Camel),** 1986

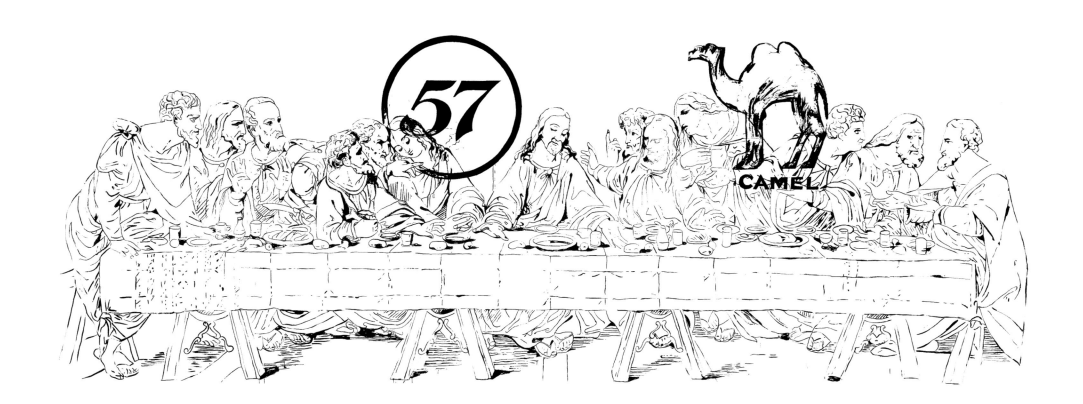

13 **The Last Supper/Be a Somebody with a Body,** 1986

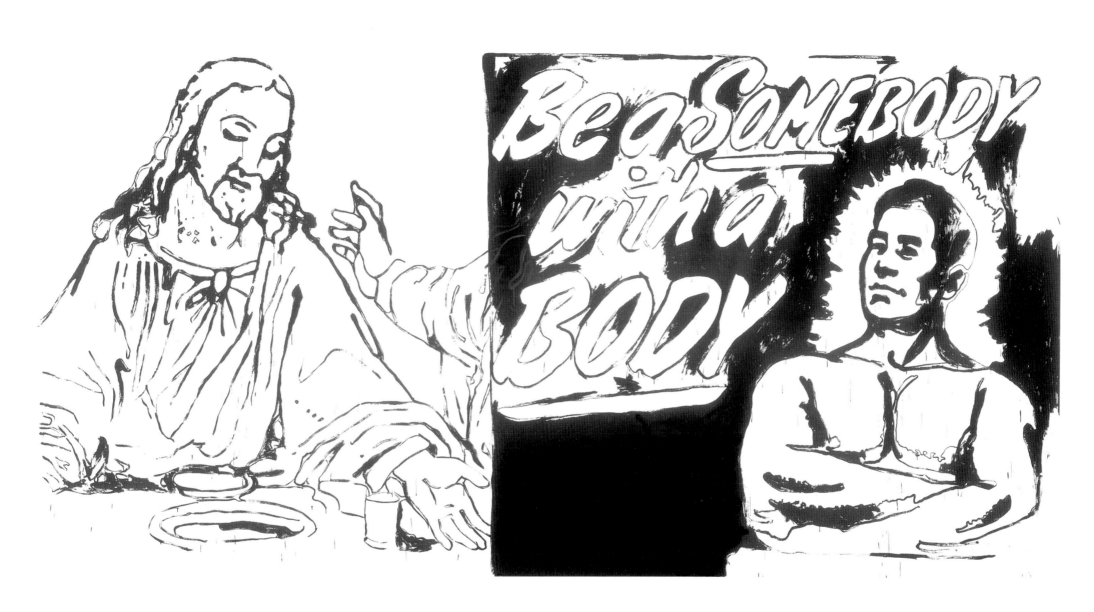

14　**The Last Supper,** 1986

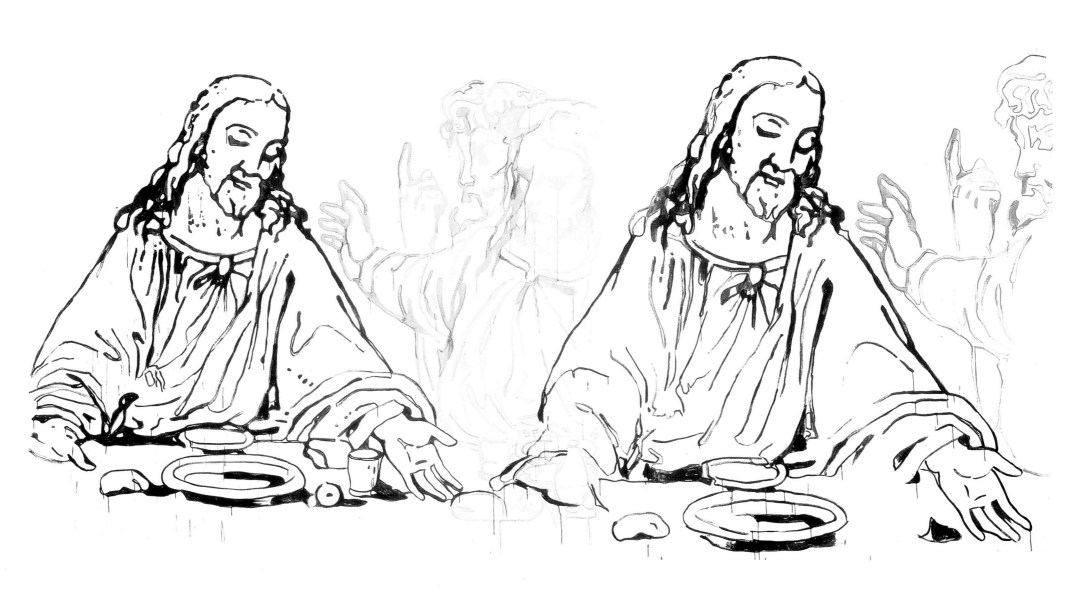

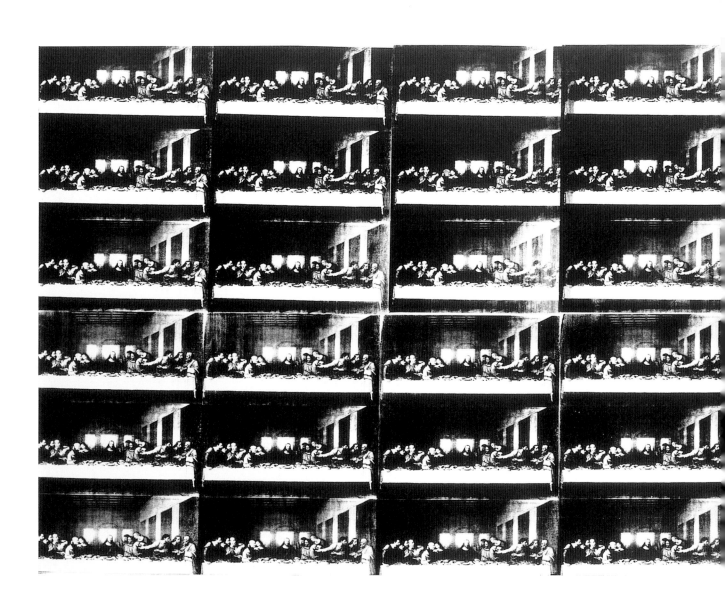

15 **Sixty Last Suppers,** 1986

74

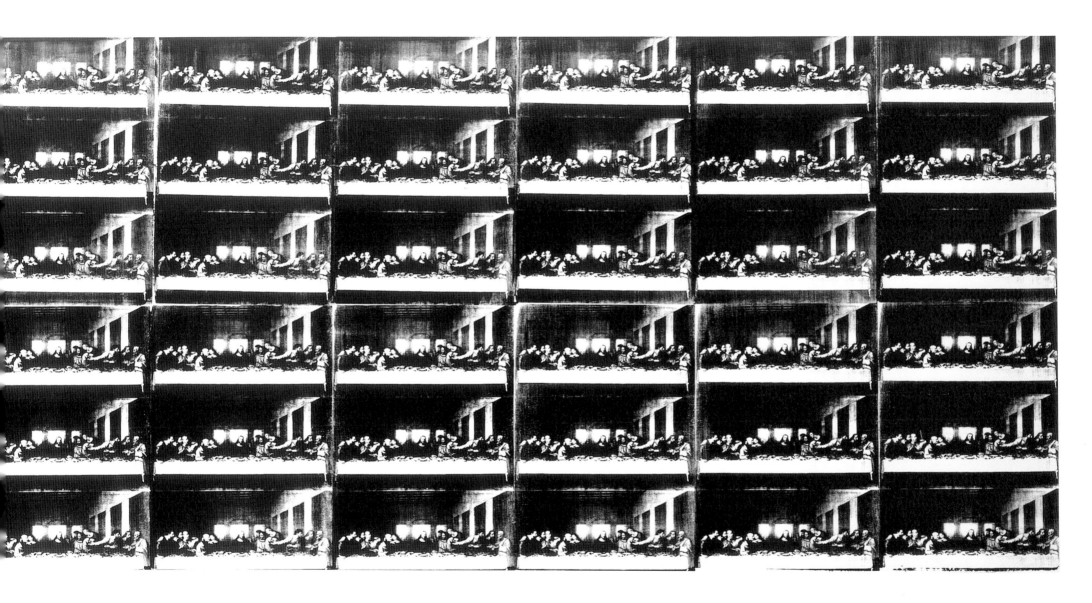

16 **The Last Supper (Wise Potato Chips),** 1986

17 **The Last Supper,** 1986

18 **The Last Supper,** 1986

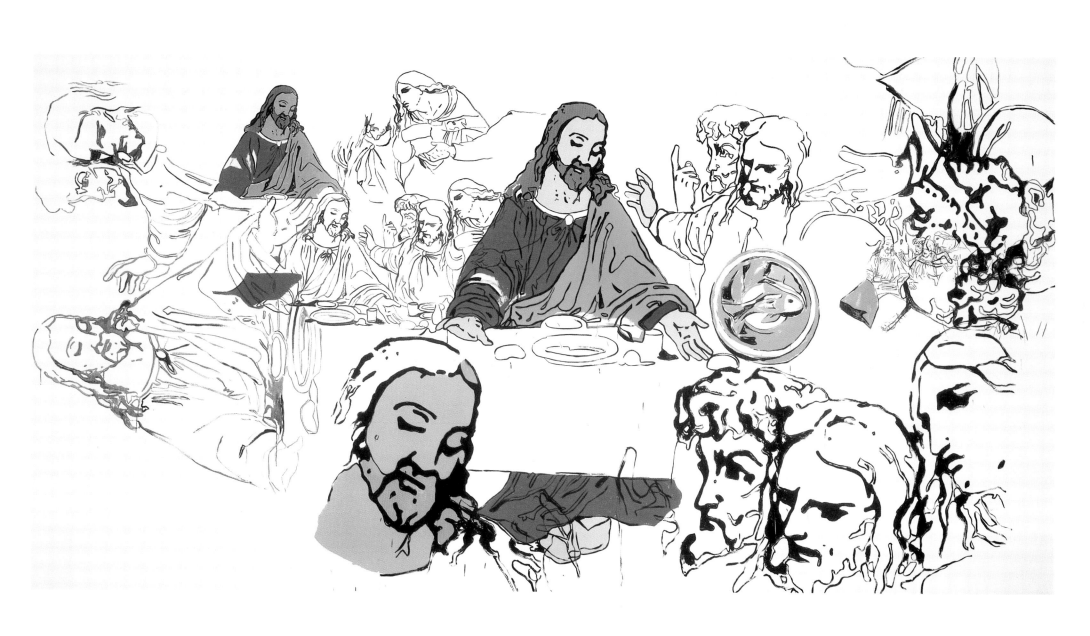

19 **Camouflage Last Supper,** 1986

20 **The Last Supper,** 1986

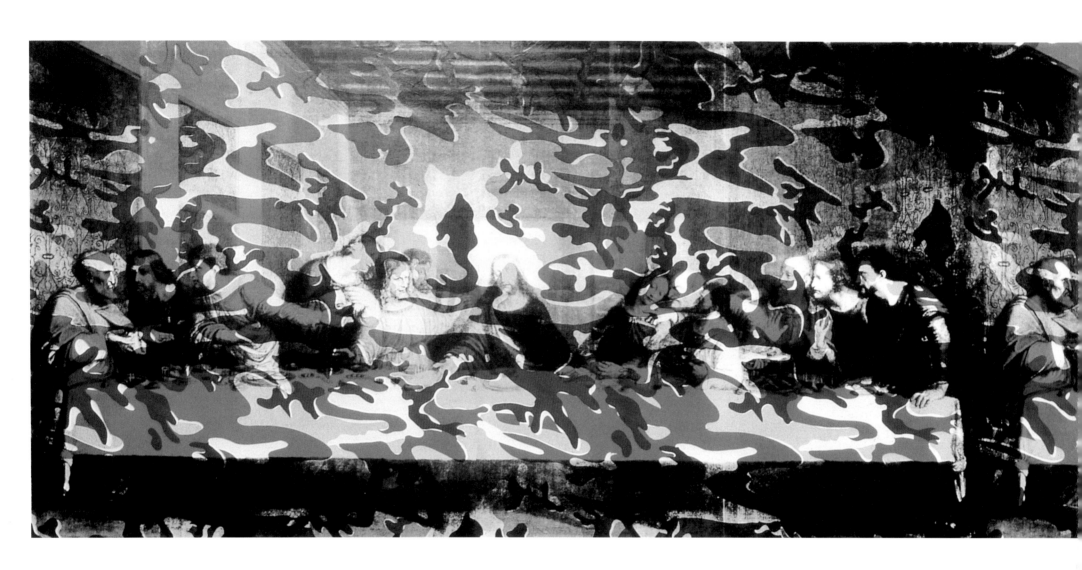

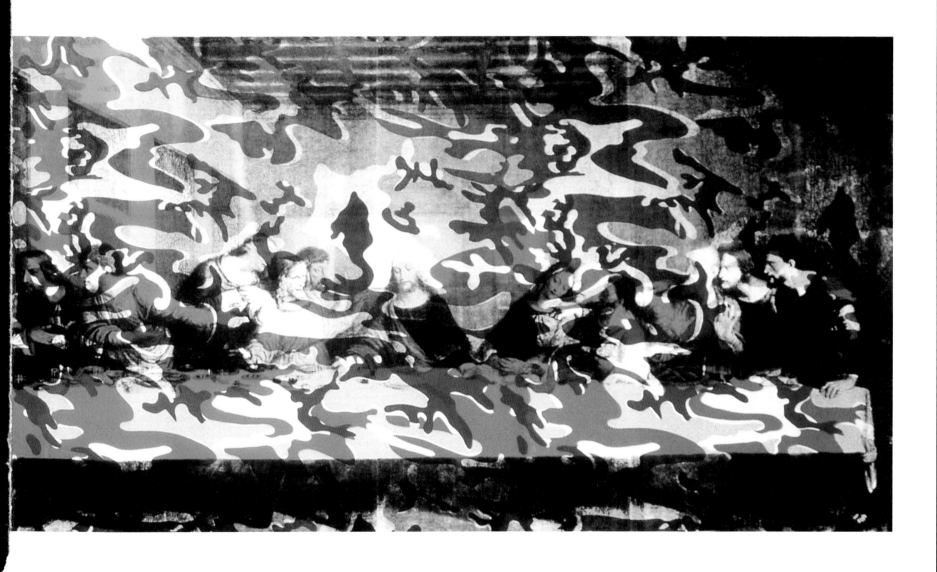

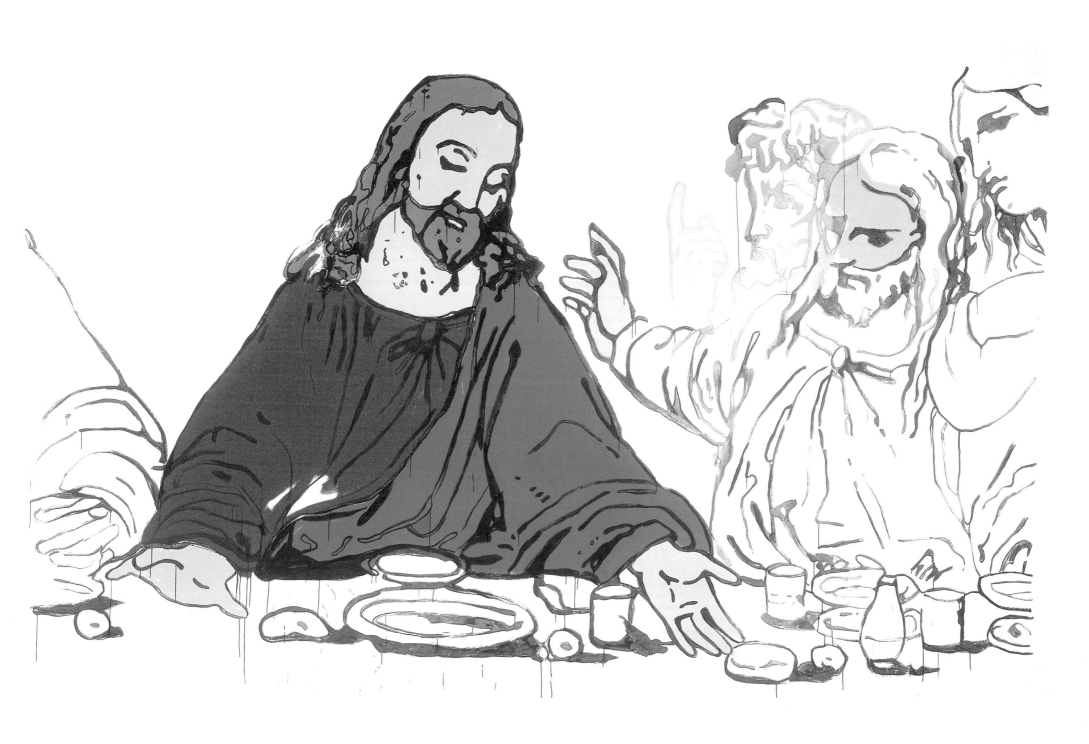

Jane Daggett Dillenberger

ANOTHER ANDY WARHOL

"Andy was born with an innocence and humility that was impregnable – his Slavic spirituality. The knowledge of his piety inevitably shades our perception of a man who fooled the world into believing that his only values were money, fame and glamour."[1]

John Richardson

On April 1st, 1987, the denizens of the art world, the rock and film worlds, the international jet set, and a throng of anonymous New Yorkers climbed the steps of St. Patrick's Cathedral to attend memorial services for Andy Warhol – 2000 people in all. It did not escape Warhol's intimates that the service was on April Fool's Day. John Richardson who gave the Eulogy likened Warhol to the holy fool of Russian literature and culture.[2] This Slavic holy fool had a sense of humor and fun. Andy Warhol would have approved the choice of April Fool's Day for his last public memorial (ill. 1).

Of all New York churches, St. Patrick's Cathedral most embodies the spirit of the city. It was the proper location for Warhol's memorial service. He had come to New York, a twenty-year old impecunious immigrant's son, but very soon became a successful commercial illustrator and then a renowned Pop artist: New York was the locus for over thirty-eight years of his very public life, and of a vast number of activities embraced by the ever-burgeoning Andy Warhol Enterprises. A life-long devout Catholic and one who loved the city, New York's flagship church was the proper locus for Warhol's last rites, but an unusual spot for a memorial service for a contemporary artist. A secular funeral parlor was the usual site for their final ceremonies.

There must have been many who attended Andy Warhol's rites who learned for the first time of his life long church attendance and his personal piety both of which he kept very, very secret. John Richardson spoke of the spiritual side of Warhol, saying that though hidden from all but his closest friends, it was the key to the artist's psyche. He described him as a youth, as "withdrawn and reclusive, devout and celibate … and thanks largely to the example of his adored mother, Julia, Andy Warhol never lost the habit of going to Mass more often than is obligatory and of dropping in on his local church, St. Vincent Ferrer, several days a week until shortly before he died."[3] Though his rags-to-riches story is in the American mold, Warhol's odd origins in an Ukrainian ghetto which was deeply rooted in Byzantine Catholic tradi-

tions is little known and yet was decisive in his life and art. It resulted in an undergirding piety and a life long habit of church going.

Two images of Andy Warhol exist in the popular press. In the 1960s he is the Warhol of his workspace, the silver-coated Factory: a passive but ruling presence in black leather and dark glasses. The partying Andy Warhol of the 1970s was a figure in black tie and fright wig at the dinner table with movie stars, international celebrities, and even with three successive American Presidents at the White House.

These images of Warhol belong to his public persona. The star-struck seeker after fame and fortune and the society of the rich and famous, the widely publicized "Pope of Pop" cannot be ignored, but it will be the background rather than the foreground of this account of Warhol's life. It is the private Andy Warhol, the spiritual side of this complex artist and his one hundred and more paintings of religious subject matter which form the focus of the succeeding chapters.

In interviews and public appearances, Warhol showed a cool detachment and gave sly monosyllabic, know-nothing responses. This was his camouflage. He wanted not to be known as Henry Geldzahler, Warhol's long-time friend, said adding: "The facts of his biography were deliberately obscured by his extreme reluctance to reveal his own system of values. An amusing paradox with Andy is that for all his love of gossip and stardom he remained coy in the face of publicity, and the private meaning of his work."[4] Geldzahler referred to Warhol as both "Mr. Mystery" and as "The Recording Angel."[5]

Facets of the enigmatic, complex and endlessly fascinating person who was Andy Warhol shine from his work. No artist of our century or of past times is as prodigiously documented. His own books and interviews, his *Diaries*, and his taped conversations (he took his Sony tape recorder, "his wife," everywhere and recorded everything) give a massive record. And yet who Andy Warhol was and is remains elusive (ill. 2).

ANDY WARHOL

A Memorial Mass

Wednesday, April 1, 1987 – St. Patrick's Cathedral

Prelude	*March of the Priest – The Magic Flute* – Mozart Piano – Christopher O'Riley
	Louange a l'Immortalite de Jesu – Oliver Messiaen Cello – Carter Brey Piano – Christopher O'Riley
Scriptures	The Book of Wisdom 3: 1 – 9 Brigid Berlin
Speakers	John Richardson • Yoko Ono • Nicholas Love
Communion	
	Amazing Grace Soloist – Latasha Spencer
Postlude	*Recessional* – Ravel Piano – Christopher O'Riley • Barbara Weintraub
Celebrant	Father Anthony Dalla Villa, St. Patrick's Cathedral
	John Grady, Director of Music, St. Patrick's Cathedral

A LESSER-KNOWN ELEMENT IN THE PORTRAIT OF ANDY WARHOL

Five hundred homeless and hungry New Yorkers will assemble on Easter Day at the Church of the Heavenly Rest, on Fifth Avenue at 90th Street. They will be served a delicious meal, and they will be treated as honored guests by some eighty volunteers. They will also be saddened by the absence of one who, with dedicated regularity, greeted them on Thanksgiving, Christmas and Easter. Andy poured coffee, served food and helped clean up. More than that he was a true friend to these friendless. He loved these nameless New Yorkers and they loved him back. We will pause to remember Andy this Easter, confident that he will be feasting with us at a Heavenly Banquet, because he had heard another Homeless Person who said: "I was hungry and you gave me food…Truly, I say to you, as you did it to one of the least of these, my brothers and sisters, you did it to me."
The Reverend C. Hugh Hildesley, *Church of the Heavenly Rest*

Flowers to be donated to Mother Teresa – Missionaries of Charity, The Department of Parks – Forestry, and children's wards at various hospitals.

Raphael I – $6.99 Andy Warhol 1985

1 The invitation to the Memorial Mass, with Andy Warhol's painting based on the *Sistine Madonna* by Raphael, and called *Raphael I – $6.99*

PITTSBURGH:
THE RUSKA DOLINA AND CARNEGIE TECH

To understand Warhol's deeply-rooted piety, it is essential to know something of the ambiance and incidents of his childhood and upbringing. Andrew Warhola was born August 6, 1928 in a two-room shanty in a ghetto of Pittsburgh[6] to Julia and Andrej Warhola who were Carpatho-Rusyn immigrants from Miková in the Slovak Republic of the former Czechoslovakia. His father was a construction worker who joined other Carpatho-Rusyn workers that had left the poverty and threatened conscription in their native Miková for jobs in Pittsburgh. These Rusyn immigrants lived in the Ruska Dolina where life revolved around the Byzantine Rite Catholic Church which preserved the language and something of the culture and history of the land of their origin. These Rusyn Byzantine Catholics observed the ancient Eastern or Byzantine Calendar, celebrating Christmas in January 7. Their dis-

tinctive church year and liturgy and their use of Old Slavonic in their churches set them apart from their Roman Catholic neighbors.

Andrej Warhola was a hard-working, thrifty, severe man who said prayers before meals and led the family on the six-mile walk to church for the Sunday liturgy. He then enforced a day of rest for all: Paul, the eldest of the Warhola sons recalled how, "you weren't even allowed to pick up a pair of scissors on Sunday – no playing, nothing. He was firm … if you didn't go to church on Sunday you didn't get out at all on that day. And we didn't have a radio or nothing. So whadya do? Mother used to tell us stories."[7]

John Warhola, the second son observed that the immigrants who came from Eastern Europe had as their first priority their religion. He said that their mother "taught you she liked going to church better than material things."[8] Julia

2 Photograph of Andy Warhol at about the age of eight, circa 1936, possibly hand-colored by the artist's brother, John Warhola

Warhola had brought with her many of the religious folk customs of her native home.

Andy, the youngest of Julia and Andrej's three boys, was baptized in St. John Chrysostom Byzantine Catholic Church (ill. 3) where the family regularly worshipped. This early attendance at the lengthy Byzantine church services before the colorful iconostasis screen with its multiple devotional images – the pomp and glitter of the processionals, and the repetition of prayers and petitions as incense rose amid the light and fragrance of many glowing candles was experienced by Andy Warhol from childhood through his college years.

Western Catholic churches have throughout the centuries surrounded the worshipper with a host of visual images, as in St. Patrick's in New York where the many paintings and sculptures of saints and biblical events invite private devotions and contribute to the environment of worship. But the Carpatho-Rusyn Church's liturgy and form of worship derived from the Byzantine tradition wherein a heightened veneration accorded the visual image, the religious icon, which engages the viewer, having a function equivalent to that of scripture, for the icon mediates between the believer and the holy person represented on the icon. Thus kissing the icon and the presence of icons are believed to be the context for contact with the divine.

In the Warhola home most rooms had icons; Andy's brother, John Warhola reported that a picture of the *Last Supper* hung in the kitchen where the family ate.[9] One of Warhol's earliest paintings of the family living room shows a crucifix on the mantle above the fireplace (ill. 4): Paul War-

4 Andy Warhol, *The Warhola Livingroom*, circa 1946–47. Watercolor and tempera on illustration board, 38 x 51 cm. Collection of Paul Warhola family

hola commented that Andy in this picture "left out Mother's holy pictures, but he put in the cross from Dad's funeral, on the fireplace where we always kept it."[10] Thus Andy Warhol's earliest experience of art was of a religious kind – it may not have been very good art, but unlike many Protestants or those outside the churches whose experience of religious art may be limited to museums, for Andy Warhol, art and religion were linked from a very early age.

"When I was little I was sick a lot," Warhol wrote in his amusing, off-beat book *The Philosophy of Andy Warhol*. He continued, in the fresh and candid style that was so characteristic of his conversation as well as his writing,

"I had three nervous breakdowns when I was a child, spaced a year apart. One when I was eight, one at nine, and one at ten. The attacks – St. Vitus Dance[11] – always started on the first day of summer vacation. I don't know what this meant. I would spend all summer listening to the radio and lying in bed with my Charlie McCarthy doll and my un-cut-out cut-out paper dolls all over the spread and under the pillow. My father was away a lot on business trips to the coal mines, so I never saw him very much. My mother would read to me in her thick Czechoslovakian accent as best she could, and I would always say "Thanks Mom," after she finished with Dick Tracy, even if I hadn't understood a word. She'd give me a Hershey Bar every time I finished a page in my coloring book."[12]

Warhol used a very simple syntax with a notable lack of adjectives, yet he often evoked a vivid picture, as he did

3 Saint John Chrysostom, the Byzantine Catholic Church where the Warhola family worshipped. Andy Warhol was baptized here and attended for 21 years. Photograph by John Warhola

here, of a young invalid amid his diversions with the attentions of a devoted mother who encouraged his art activities.

Family and friends report that Julia had a special affection for her weaker, youngest son. Having artistic talent herself, she drew cats and other animals for him, and when he was eight years old his mother got him a child's movie projector out of her own earnings from cleaning and window washing which he used to project the comics on the wall. At the age of twelve he began to collect photographs of movie stars also. Such childhood collections are not unusual, of course, but in the case of Andy Warhol the early interest flowered twenty years later into the subject matter – the iconography of Pop art by one of the originators of Pop.

Warhol's later preoccupation with death themes is certainly also related to childhood experiences. His father had tuberculosis and was ill and housebound from 1939 until his death in 1942.[13] The two older brothers were away much of the time but Warhol remained at home at his mother, Julia's side. His father's last illness was traumatic for Andy during his vulnerable early teens. Paul Warhola recalled that when his father's body was brought back from the hospital, Andy, terrified, hid under his bed, and refused to look upon the body which was laid out, as was traditional of the Rusyn Byzantine Catholics, for three days in the Warhola home.[14] The recurrent theme of death in Warhol's paintings is thus rooted in the immediacy of this indelible childhood experience.

From the fifth grade on, Andy Warhol went to the free Saturday art classes at the Carnegie Museum. His teacher, Joseph Fitzpatrick, remembered the ten-year old Andy as being a shy Slavic boy with a deft touch who was magnificently talented, personally not very attractive and socially inept. But Fitzpatrick said he was very original, and had a goal right from the start.[15] Classes at the Carnegie gave Warhol his first exposure to traditional art, for ensconced in the ponderous and elegant Carnegie building there is a collection of paintings and a splendid collection of casts of sculpture and architectural portals that spanned the ages.

He took art classes in high school, skipped the eleventh grade (he had skipped a grade in elementary school too) and was admitted to the Carnegie Institute of Technology at the age of sixteen. Despite the poverty of the Warhola's immigrant life, Warhol's father had saved money designated for Andy to go to college. He could afford to send only one of his three sons and apparently the entire family accepted that Andy's intelligence and sense of direction made him the candidate. Andy Warhol enrolled in the Department of

Painting and Design and studied with faculty artists, among them Balcomb Greene with whom he studied art history. Warhol won a number of prizes during the Carnegie Tech years, and graduated in 1949.

The destitution of Warhol's early years left him with a permanent anxiety about money. Years later when Warhol was a wealthy man, in a rare, candid moment with Bob Colacello, he said, "life isn't easy, Bob. I had to sell fruit on street corners to get through school, you know. It wasn't easy."[16]

Upon graduation Warhol moved to New York. At first he shared an apartment in the blue collar Ukrainian neighborhood[17] with his fellow student at Carnegie Tech, the artist Philip Pearlstein, then he moved several times. The move from the ethnic enclave in Pittsburgh with its family and church ties, to the freedom of the cosmopolitan city of New York might have resulted in Warhol's leaving behind his habitual church going. But even when he was sharing a basement on 103rd Street with seventeen roommates, John Richardson said, "He was forever popping into church."[18]

What Warhol did leave behind was the final "a" on his name. While he had signed his name A. Warhol on a drawing as early as 1942, in New York he adopted this form for good. "It just happened by itself," Warhol said, when he was going around with a portfolio looking for commercial design jobs. "People forgot to put it on, so, yea, it just happened." It seems to have been a matter of happenstance rather than a rejection of his ethnic origins.

In 1951 he was making enough money on commercial art projects to take a small apartment by himself and his devoted mother, Julia, moved in with him bringing her three Siamese cats, her religious pictures, and her intense piety. Warhol told how she "had shown up one night at the apartment where I was living with a few suitcases, and shopping bags, and she announced that she'd left Pennsylvania for good 'to come live with my Andy'."[19]

Before leaving home each day, Warhol knelt and said prayers with her, in Old Slavonic. He wore a cross on a chain around his neck under his shirt, and carried a pocket missal and rosary with him.[20] His mother, Julia, kept crucifixes in the bedroom and kitchen. She went to services regularly at St. Mary's Catholic Church of the Byzantine Rite. In Julia's yellowed and frayed Old Slavonic Prayer Book[21] there is a commemorative card with a cheap reproduction of Leonardo da Vinci's *Last Supper*, which her son must have often seen: this is a sentimentalized version of Leonardo's masterpiece which Warhol recreated using other copies of the original, in

5 Andy Warhol, *Portrait of Julia Warhola*, his mother, 1974

over a hundred paintings, silkscreens and works on paper in the last years of his life.

His mother lived with him for twenty years, until a few months before her death in 1972. Since Warhol had lived at home while going to Carnegie Tech, it follows that Warhol lived in the ambiance of her intense peasant piety for almost forty of his fifty-eight years. It was a close and symbiotic relationship. Few people were invited to Warhol's home, but friends who met his mother were asked quietly by him not to swear in her presence.[22] Fritzie Wood described Julia as childlike and having "a great joy to be alive and to be with Andy: he was the one quite obviously, close to her heart. She took great pride in him."[23] Julia Warhola seems to have been the central love of Warhol's life. His portrait of her which was painted posthumously, is remarkable for the affection and warmth with which he delineated her blunt features (ill. 5).

Just as Julia Warhola shared her piety with Andy so she shared her artistic abilities. She did the lettering for many of Warhol's drawings and books in these early years, as well as signing his name to many of his works. She and Warhol published two charming illustrated books together on cats, hers being entitled *Holy Cats by Andy Warhol's Mother* (ill. 6). *Holy Cats* is a whimsical, utterly enchanting work of folk art, in which angelic cats desport themselves among cherubs and angels in Julia's imagined "Pussy Heaven." She and Andy also did a full-sized folding screen which she decorated on one side while her son did the other side. Julia was Andy's first collaborator – the first of many.

In his book, *The Philosophy of Andy Warhol*, he described himself in a succession of devastatingly candid phrases: "The puckish mask, the slightly Slavic look ... the albino-chalk skin, parchment like, reptilian. Almost blue. The graying lips. The pinhead eyes. The long bony arms, so white they looked bleached ... the arresting hands ..."[24] His hands were indeed arresting: narrow, long-fingered, and capable of creating a precise and supple line, or the painted replication of a commercial product which was photographic in its detail and finish.

The two idiosyncratic characteristics of Warhol's public persona, his outrageous wigs and his monosyllabic, know-nothing remarks were both rooted in physical disabilities. Warhol began to lose his hair at an early age and started to wear hairpieces and later as he became bald, outrageous wigs. Warhol always drew attention to his weaknesses rather than trying to conceal them, making a virtue of his vulnerability.

The other hallmark of the public Andy Warhol was his legendary silence at public events and his brief, often monosyllabic replies to interviewers: "Yeah, Oh, Gee ..., I'm not sure, Really?" This was his strategy for dealing with his speech disorder.[25] Warhol described the problem in his book:

"I only know one language, and sometimes in the middle of a sentence I feel like a foreigner trying to talk it because I have word spasms where the parts of some words begin to sound peculiar to me and in the middle of saying the word I'll think: Oh, this can't be right – this sounds very peculiar, I don't know if I should try to finish up this word or try to make it into something else, because if it comes out good it'll be right, but if it comes out bad it'll sound retarded, so in the middle of words that are over one syllable, I sometimes get confused and try to graft other words on top of them ... Sometimes it is very embarrassing."[26]

It is ironic that in dealing with the uncertainty and confusion caused by his speech disorder, Warhol, who described himself as shy[27] (and many of his close friends agreed) created a public persona which appeared cool, distanced, and unflappable, sometimes even impudent.

ART FOR TIFFANY'S AND HIGH FASHION ART

Throughout the 50s and early 60s Warhol did a variety of commercial art projects – window displays for Bonwit Teller, theatre sets, shoe ads for I. Miller, and book illustrations. He had acquired a mastery of commercial techniques at Carnegie Tech which together with his great natural facility, his originality and stylishness, and his whimsical imagination led to many jobs in the 50s and 60s. Warhol became a sought-after, successful illustrator of chic fashions whose drawings often appeared in The New York Times and in fashion magazines.

For the most part the commercial artists and those who aspired to the "high" art world worked for one or the other of these worlds. Philip Pearlstein, and Jasper Johns and Robert Rauschenberg had all tried in their early years to get commercial work but the latter two did it under another name. Warhol started out in the commercial world, and worked hard and cooperatively with his art editors who were impressed by his flair, his fey humor and his extraordinary originality. His work was much in demand by many well known firms – Bonwit Teller, I. Miller Shoes, Harper's Bazaar, Glamour Magazine, as well as Tiffany & Co.

He was simultaneously, in the 50s, making and exhibiting drawings in galleries. His first solo exhibition in New York

6 *Holy Cats by Andy Warhol's Mother.* The cover for Julia Warhols fanciful book dedicated to her cat "Little Hester who left for pussy heaven"

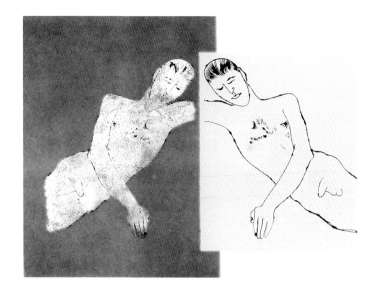

in 1952 was of drawings based on the writings of Truman Capote, and in 1954 the Bodley Gallery exhibited his *Drawings for a Boy Book*. Both exhibitions had drawings with homoerotic content. From the early 1950s Warhol produced "certain works that are as remarkable for their excellence in articulating gay sensibility as for their technical and formal achievements," (ill. 7) as Trevor Fairbrother wrote in the catalogue for a posthumous exhibition of Warhol's early art. He continued, "Warhol was no militant crusader for the gay movement, but he spent his life setting a subversive example of being what he believed in and refusing to wear a disguise. During the 50s figures prominent in the public eye rarely risked this bold stance."[28]

Warhol revealed in *POPism* how Emile de Antonio (known for his films on Nixon and McCarthy, who was in the 50s an artist's agent) answered Warhol's query as to why Jasper Johns and Robert Rauschenberg avoided him: He said it was because Warhol was "too swishy" and that though these artists were both gay, in the 50s the major painters tried to look straight. Warhol's response was "as for the swish thing, I'd always had a lot of fun with that – just watching the expression on people's faces ... I admit, I went out of my way to play up the other extreme."[29] Playfulness and the impulse to shock were both integral to Warhol's complex nature. His openly gay stance became an added facet of that carefully constructed, witty, cool, inscrutable public persona that is known through Warhol's self-promotion and through the media hype.

Andy Warhol's early drawings of religious themes come from the years when he was working in New York as a com-

mercial artist. For Tiffany & Co. he did a series of drawings for Christmas Cards. Two charming drawings of a star show Warhol's fanciful variations on the theme *The Star of Wonder*. The title comes from the refrain of a familiar Christmastide hymn: "Star of wonder, star of night, star with royal beauty bright ..." Red roses, a flower associated with the Madonna, compose the five-sided star in one drawing. The other drawing shows the star formed by the fluttering, wheeling colored birds which define its shape (ill. 8). It is this drawing that Tiffany's printed. Not only was "Designed by Andy Warhol for Tiffany & Co." printed on the back of the card, but also on the face of the card "Andy Warhol" was inscribed in the spiky penmanship of his mother, Julia, who signed many of his works in these years. Andy Warhol's renown in the world of commercial art and fashion gave his name value.

His beautiful drawing of a hand holding a Christmas crêche (ill. 9) shows both the fanciful originality of Warhol's imagination and the evidence of his knowledge of art of the past. He frequented museums and galleries and had himself a collection of clippings from art and fashion magazines and catalogues. He also used the vast clipping files found in the New York Public Library.

In this drawing of a golden hand holding the tiny crêche within its palm, the Virgin is seated on the ground with the nude Christ child lying across her knees – a type called the Virgin of Humility, which originated in Sienese fourteenth century art. The slender columns supporting a pitched roof and the wattle fence are found in paintings like Giovanni di Paolo's *Adoration of the Magi* in the Metropolitan Museum which Warhol must have seen. The drawing is encrusted with commercially confected gold–embossed decorations used for the halo of the Virgin, the cherub who flutters above, the star, and the leaves in the foreground.

The golden hand supports gently its little burden: one recognizes Warhol's narrow long-fingered hand which curves protectively about the Virgin and Child. The intimacy with which the crêche rests within the palm suggests Warhol's longtime familiarity with the theme. In his home the Christmas celebrations included folk ceremonies and customs brought by his parents from Miková in the Slovak Republic. The Christmas crêche was familiar from the holiday ceremonies of his early years.

These designs are Warhol's earliest professional work with religious imagery. They have an originality which was Warhol's – an arresting freshness of line and color and form that make them memorable, when so many Christmas cards

8 Andy Warhol, *Star of Wonder*, circa 1958. Christmas card designed for Tiffany and Company. Warhol's signature was done by Julia Warhola who signed much of his early work. Private collection

9 Andy Warhol, *Untitled*, 1957. Ink, gold leaf, and collage paper, 46 x 36 cm. The Andy Warhol Foundation of the Visual Arts. Warhol's own long-fingered hand holds a little crèche, suggesting his familiarity with the Christmas folk ceremonies brought by his parents from Miková in the Slovak Republic. Private collection

are momentary in their appeal. Warhol did other drawings of cherubs, angels and colorful traditional images of the Adoration of the Magi with embossed gold motifs. Perhaps these were intended for Tiffany's as well.[30]

WARHOL'S FIRST POP PAINTINGS

Warhol continued doing commercial work into the early 60s, but in 1960 he did his first Pop paintings, which soon afterwards catapulted him into fame. The term Pop had not been used as yet, but these paintings based on comics and advertisements heralded a new and revolutionary kind of art. The artists of the preceding generation, the Abstract Expressionists, instead of depicting traditional subject matter,[31] as Robert Rosenblum observed, explored the impalpable, paths of energy, fields of spirit, and the mysteries of creation.[32] Their intention was to evoke the Sublime, an aesthetic category which goes back to Edmund Burke.[33] They emphasized the uniqueness of each particular work of art with its exquisite impassioned brush strokes on large unframed canvases.

Warhol's *Superman*, *Dick Tracy*, and *Popeye* were dramatically antithetical to the Abstract Expressionists' work. Appropriated from the comics, these popularly known images were enlarged and copied using the flat commercial colors of the comic strip. Both the image and the technique came from popular commercial art and lacked the uniqueness and elegant brushwork valued in the so-called high art of the preceding generation of artists such as Barnett Newman and Mark Rothko, Adolph Gottlieb, and Clifford Still.

Warhol, in his book *POPism, the Warhol '60s* told of the beginnings of this movement:

"The Pop artists did images that anybody walking down Broadway could recognize in a split second – comics, picnic tables, men's trousers, celebrities, shower curtains, refrigerators, Coke bottles – all the great modern things that the Abstract Expressionists tried so hard not to notice at all.

One of the phenomenal things about the Pop painters is that they were already painting alike when they met. My friend Henry Geldzahler, curator of twentieth century art at the Metropolitan Museum before he was appointed official culture czar of New York once described the beginnings of Pop artists in different parts of the city, unknown to each other, [You were] rising up out of the muck and staggering forward with your paintings in front of you."[34]

Warhol's early Pop works were hand painted but by 1962 he had begun to use silkscreens for the printing of images on canvas. Silkscreen had been used for commercial art and for posters, but now Warhol used it for art. He described the process:

"With silkscreening you pick a photograph, blow it up, transfer it in glue onto silk and then roll the ink across it so that the ink goes through the silk and not the glue. That way you get the same image, slightly different each time. It was all so simple – quick and chancy. I was thrilled with it."[35]

So the artist's touch, his unique brushwork, the imprint of each of the artist's gestures as the paint surface was built up, all hallmarks of the Abstract Expressionist technique were eliminated in favor of mechanical replication via the screens which bore the image. Warhol himself spoke of wanting a strong assembly line effect. However there exists a large number of photographs of him working, which deny the cool mechanical image of the artist. He is seen bending over the screens working with the intensity of focus and the utter absorption of the creative artist.

When the Pop artists were first shown, their work met with incomprehension, but when the paintings began to sell – and Leo Castelli's exhibition of Warhol's *Flower paintings* in 1964 sold out completely – the critics responded by questioning, and in some cases denouncing, the quality of the art, and by querying the intentions of the artists. Hilton Kramer in 1962 saw Pop art as a juxtaposition of two clichés: a cliché of form superimposed on a cliché of images[36] – that is, mass media images rendered in the style of mass production. Another critic wrote that the works leave us thoroughly dissatisfied: most of them have nothing to say at all.[37] The Pop artists were accused of the passive acceptance of things as they are. The critics were not able to see these new paintings as Andy Warhol did, as the exuberant celebration of "all the great modern things." Pop art remained controversial for Warhol's entire career and even today can divide fairminded critics. The artists were in no sense a self-conscious group or movement, and certainly Warhol, who was shy and often inarticulate, was no leader. But he was a magnetic, enigmatic artist dubbed by the media as the "Pope of Pop."

The variety and range of Warhol's work which "anyone could recognize in a split second" presents a mirror of the popular culture of our day: widely advertised items for consumption, Coca Cola, Campbell's soup (which Warhol had daily for lunch),[38] Pepsi Cola, hamburgers, Heinz catsup, and ubiquitous images like comic book characters, movie stars, celebrities, and political leaders. Most of the images Warhol used were based on photographs, culled from newspapers

or magazines. The photographs he used are straightforward and simple, but he had an uncanny sense for those which would have the greatest resonance. Through his manipulation of the photographs – the isolation of the image, or its repetition, his sense of rhythm and of syncopation, of cropping and of the balancing of the painted image with empty space – all combined to transform the original photograph into timeless, potent signs that have become indelible in the minds of millions. These images have become icons of contemporary culture, the things which surround us in supermarkets, and on billboards and newspapers. Suddenly they assume an autonomy and significance through Warhol's imaging of them. They become totemic. As Andy Warhol said, "Pop Art is a way of liking things."[39]

Surveying his paintings of the 60s, from the perspective of a third of a century later, it becomes apparent that Warhol's subjects give more than an image bank of the times. They present serious social commentary: the paintings of suicides, car crashes, and race riots mirror the violence which permeates the culture. The portraits of politicians and celebrities so secure in their success when they face Warhol's camera, are transformed by the revealing focus his portraits brought to the very qualities which gave them their fame. Thirty years later it is the fragile and time-bound nature of their lives and fame which gives poignancy to these faces. Warhol's portrait of Katie Jones – a member of the multi-millionaire Schlumberger family, whom Warhol knew socially – stares forth with something of the mute appeal seen in the eyes of the Egyptian Fayum coffin portraits. Done for the mummy cases of the deceased the Fayum portraits were presumably painted before their death, since they express so directly a sense of individual personality. Katie Jones' eyes, like those of the Fayum portraits, are riveting, claiming the moment but focused beyond time.

The many items of food which Warhol painted with iconic directness preceded the general national concern for the hungry and the homeless. While Warhol was working on his huge series of paintings of the *Last Supper*, showing Jesus surrounded by his apostles at dinner before a table laden with bread, wine, and fish, Warhol himself was assisting anonymously at the serving of meals to the homeless at the Church of the Heavenly Rest in New York. In the *Diaries* Warhol says: "It's a different world. You see people with bad teeth and everything. And we're so used to all these beautiful perfect people ... It is such a great church, there was food for people to take home, too, and I was giving everybody a lot. If there's this many hungry people, there's really

something wrong."[40] Andy Warhol's repeated assistance at the church for these holiday dinners for the poor was gratefully received: he persuaded some of his friends to help too, and when one of them became angry at the staff, Warhol remonstrated, "Victor, we're here because we want to be here."[41] The poverty of his own early years must have come back to him, and he said that a lot of the ladies looked like his mother.

It is a typically Warholian oddity that his fame began with *Campbell's Soup* paintings and at the end of his career, it was in a soup kitchen that he found satisfaction in serving the homeless anonymously. Again the contradictions of this complex artist are apparent: Warhol's craving for fame, but also for anonymity, and his choice of seemingly common and meaningless subjects which yet connected with a genuine concern for the hungry and homeless.

In the 1960s Warhol expanded his artistic interests to other media. In 1963 he began making films while working on his Pop paintings, and in 1966 he began collaborating with the rock music group called "The Velvet Underground". The 60s were thus a period for Warhol of work in many media. In November, 1963, Warhol moved all his painting equipment into a loft on East 47th Street which would soon become the "Factory." Billy Name, (aka Billy Linich), covered the old walls with silver foil and silver paint. Filled with Warhol's art, music, and constant activity, the Factory attracted artists, college students, celebrities, New York lowlife and photographers who documented the scene.

Warhol gave a picture of the Factory in his off-beat, charming little book *The Philosophy of Andy Warhol (From A to B and Back Again)*. He remarked that in the 60s he was doing well professionally and said:

"I had my own studio and a few people working for me, and an arrangement evolved where they actually lived at my work studio. In those days everything was loose, flexible. The people in the studio were there night and day. Maria Callas was always on the phonograph and there were lots of mirrors and a lot of tinfoil ... I had a lot of work to do, a lot of canvases to stretch. I worked from ten a.m. to ten p.m. usually, going home to sleep and coming back in the morning. The same people I'd left there the night before were still there going strong, still with Maria and the mirrors ... Famous people had started to come by the studio, to peek at the on-going party, I suppose – Kerouac, Ginsberg, Fonda, Hopper, Barnett Newman, Judy Garland, the Rolling Stones."[42]

The on-going party also attracted speed freaks, acid heads, and those on the edge of insanity. Warhol himself

had, as John Richardson said, the detachment of a "recording angel" rather than the callousness of a voyeur. Richardson went on to say: "To me Andy always seemed other worldly, almost priest-like in his ability to remain untainted by the speed freaks, leather boys, and drag queens, whom he attracted … Andy was born with an innocence and humility that was impregnable – his Slavic spirituality like the Russian holy fool, the simpleton whose quasi-divine naïveté protects him against an inimical world."[43]

Warhol's fame turned to notoriety during the later sixties. It was during this period that a woman took out a gun and shot a hole through four *Marilyn* paintings which were leaning against the wall. And in 1967 a man entered the Factory with a gun and threatened Warhol and a group of Factory regulars. Fortunately his first shot did not fire, and after a wild second shot, he was apprehended.

"I SHOT ANDY WARHOL"

The dramatic climax of this period came when one of Warhol's former film stars, the deranged Valerie Solanas, walked into the Factory June 3, 1968, and fired three shots at him at close range. She had had a part in one of Warhol's movies. She was a radical feminist and lesbian who sold her *SCUM Manifesto* (Society for Cutting Up Men) on the streets, and who had written a script she had given Warhol, hoping he would film it. Warhol described the assassination attempt:

"I was putting the phone down, I heard a loud exploding noise and whirled around: I saw Valerie pointing the gun at me and realized she'd just fired it.

I said, 'No! No, Valerie! Don't do it!' and she shot at me again. I dropped down to the floor as if I'd been hit – I didn't know if I actually was or not. I tried to crawl under the desk. She moved in closer, fired again, and then I felt horrible, horrible pain, like a cherry bomb exploding inside me.

As I lay there, I watched blood come through my shirt and I heard more shooting and yelling. (Later – a long time later – they told me that two bullets from a 32-caliber gun had gone through my stomach, liver, spleen, esophagus, left lung, and right lung.)

Then suddenly Billy was leaning over me. He hadn't been there during the shooting, he'd just come in. I looked up and I thought he was laughing, and that made me start to laugh, too, I can't explain why. But it hurt so much, and I told him, 'don't laugh, oh, please don't make me laugh.' But he wasn't laughing, it turned out, he was crying.

It was almost a half-hour before the ambulance got there. I just stayed still on the floor, bleeding."[44]

Though at one point declared dead, five hours of surgery saved Warhol's life. His recovery was slow, requiring two months in the hospital and further surgery. Bob Colacello said that in the hospital Warhol "promised God to go to church every Sunday if he lived and he kept to the letter of that promise."[45]

The event changed Warhol as he said:

"It put a new perspective on my memories of all the nutty people I had spent so much time with; crazy people had always fascinated me because they were so creative – they were incapable of doing things normally … usually they would never hurt anybody, they were just disturbing themselves; but how would I ever know again which was which? The fear of getting shot again made me think that I'd never again talk to somebody whose eyes looked weird. But when I thought about that, I got confused, because it included almost everybody I really enjoyed!"[46]

The Factory, besides being a work space and a party place for interesting and odd people, had a darker side. It was the locus for drug experimentation and other deviations which led to addiction and self-destruction for some. Bob Colacello, Warhol's editor for his magazine *Interview* said Warhol himself flirted with coke but that he didn't take anywhere near as much as the rest of them.[47]

The fear of getting shot again made Warhol timid and his Factory regulars became protective. The press coverage of the assassination attempt brought an unsavory notoriety to Warhol. The open door policy of the Factory had changed when the location was moved to Union Square in 1968. The Factory was no longer a party and hang-out place. The exuberant spirit of the sixties had changed.

THE 1970s

In 1970 a large retrospective of Warhol's paintings circulated from Pasadena to Chicago, Eindhoven, Paris, London, and then opened in New York at the Whitney Museum. It was the first occasion when the full range of Warhol's large and varied body of paintings could be seen and assessed. The quintessential Pop paintings *Campbell's Soup Cans, Coca Cola, Dollar Bills*, were there as well as the macho heroes *Elvis Presley* and *Marlon Brando*. But also there was a group of *Electric Chair* paintings that invited quiet and wonder at the beauty of their close-toned colors. A large room was entirely devoted to the *Flower* paintings, riotous and jubilant

ated multi-media events. In addition he did from fifty to one hundred commissioned portraits a year. The roster included Truman Capote, Mick Jagger, Princess Caroline, Michael Jackson, the Shah of Iran, and other celebrities. Their faces can be seen not only in Warhol's striking, iconic portraits, but also in photographs that Warhol and his entourage took of the parties he hosted or attended in these years.

In 1974 Warhol moved into a handsome townhouse at 57 East 66th Street which had been located for him by Jed Johnson, one of his helpers at the Factory. Jed, a gentle, handsome and reticent young man from Sacramento, had begun sweeping floors at the Factory. During Warhol's convalescence from his surgery Jed Johnson brought the mail from the Factory and was helpful about the house. Eventually he moved in with Warhol and his mother when they were living on Lexington Avenue. Julia Warhola died November 22, 1972, and two years later Jed Johnson and Warhol occupied the 66th Street townhouse and Johnson discretely and tastefully decorated the stately rooms. It was his first decorating job. He was to become a sought after designer who worked with famous architects and clients. His Warhol connections helped bring him celebrity clients – Mick Jagger, Barbra Streisand, Richard Gere. His career was tragically cut short by his death in the crash of TWA 800 over Long Island Sound in 1996.

Warhol had become an insatiable shopper and collector of fine furniture, and art and artifacts of all kinds. The elegant and formal rooms of Warhol's townhouse looked more like the residence of an Episcopal Bishop than that of this rakishly wigged Pop artist. Warhol, perhaps alone of all his contemporaries, never hung any of his own paintings in his home. The only original work by Warhol was "one of his wigs 'prettily' mounted in a Kulicke frame ... like a cross between a large furry spider and a dahlia that has been squashed in a book."[49]

Warhol's bedroom (ill. 10), with its stately canopied bed and splendid carpets, breathed an air of unostentatious luxury. On the bedside table a Santos panel of the Crucifixion,[50] a statuette of the Risen Christ and a devotional book gave evidence of Warhol's religious practice (ill. 11). The book, *Heavenly Manna: A Practical Prayer Book of Devotions for Greek* (later editions replace "Greek" with "Byzantine") *Catholics* published in 1954, and now owned by John Warhola, shows Andy Warhol's markings of selected prayers. Warhol's piety was secret as was also his home. Only his closest friends were ever invited in for he entertained at restaurants.

10 Andy Warhol's bedroom. In 1974 Warhol moved into a handsome townhouse at 57 East 66th Street which was furnished with antiques and fine furniture, and decorated with quiet dignity by Jed Johnson.

in color. Suddenly it became apparent that Warhol was a great colorist.

It also became apparent that even before Warhol was shot, he had been preoccupied with the theme of death. The 1970 show included not only a series on the *Electric Chair* but also paintings based on newspaper and magazine photographs of suicides, fatal car crashes, and race riots. Also there were paintings of Marilyn Monroe, which Warhol did immediately upon hearing of her suicide. The death of the beautiful, vital and popular star was vividly dramatized before a shocked public by the press and media. Warhol told of painting the *Marilyns*, "I realized that everything I was doing must have been death. It was Christmas or Labor Day – a holiday – and every time you turned on the radio they said something like '4 million people are going to die' [in automobile accidents]."[48]

During the 70s Warhol painted by day and partied by night. His studio assistants say that he was a workaholic, often the first person to arrive and the last to leave, and that he worked daily including weekends. Only such a regime could account for the astonishing volume of his work in so many media. On into the 1970s Warhol made films, and cre-

11 Andy Warhol's bedroom. The table has a crucifix and a devotional book on it, and nearby is a statuette of the Risen Christ

During the 70s with its years of extraordinary productivity in film, his silkscreened works, his magazine, Interview, and the writing of his book, *The Philosophy of Andy Warhol*, he lived quietly in his home, and frequented the church of St. Vincent Ferrer for Sunday Mass and for several visits during the week. Father Matarazzo, a Dominican and the prior of St. Vincent's, revealed in an interview that although Warhol never went to confession or communion, he visited the church two or three times a week, and sat or knelt alone in the shadows at the back of the church. It was apparent that he did not want to be recognized. Father Matarazzo said that Warhol's spirituality was private even within the confines of this bustling parish church. The priest speculated that "Warhol was bonding with a God and a Christ above and beyond the Church," he remarked that Warhol's life-style was "absolutely irreconcilable" with the teachings of the Catholic Church. Many gay men, he said, were in his congregation in spite of the fact that he preached the Catholic Church's opposition to homosexual practices frequently.[51]

St. Vincent Ferrer is on 66th Street and Lexington Avenue only a few blocks from Warhol's elegant townhouse. The many altars with flickering candles, burning before the images of saints and Holy Family, its neo-gothic sense of mystery must have appealed to Warhol who in childhood had experienced worship before a golden iconostasis screen lit by many candles in St. John Chrysostom in Pittsburgh: since the Byzantine Catholic Church is in communion with the Roman Catholic Church, Warhol's attendance at St. Vincent Ferrer was natural. However, in *Diaries,* entry of April 22, 1984, Warhol noted that he did not go to church with friends, "because I would feel too peculiar in a church where they might see me praying and kneeling and crossing myself because I cross the wrong way, I cross the Orthodox way." (The Orthodox cross from right to left, rather then left to right.)

Warhol was open about his homosexuality and from the early 1950s produced drawings and illustrations which are technically fine, and which reveal a gay sensibility that ranged from the playful to the slyly suggestive to the explicit. He was unabashedly a voyeur and had occasional attachments to handsome men, some of whom lived with him for a period or traveled with him.

Some friends saw Jed Johnson's residence with Warhol as evidence of an amorous relationship, which Johnson neither denied nor admitted. Over the years Jed Johnson was not Warhol's only male companion; the question of these

male relationships was the subject of an interview with Scott Cohen in 1980 which Bob Colacello was present for:

SC: "You're still a virgin?"

AW: "Yeah, I'm still a virgin."

SC: "With all these beautiful people hanging around, don't you ever get turned on?"

AW: "Well, I think only kids who are very young should have sex, and people who aren't young should never get excited. After twenty-five you should look, but never touch."

Colacello continued with the query, "was he still a virgin? I think technically he was. Whatever little sex he may have had in his fifty-two years was probably a mixture of masturbation and voyeurism – to use his word, abstract. Andy chose his words carefully and he knew that the opposite of abstract was figurative, concrete, real."[52]

Warhol's closest associates and helpers at the Factory (and then at the Office, as it was called when Andy Warhol Enterprises moved to 860 Broadway), were Catholics, but most were drop-outs from the Catholic Church. Some of them report leaving Andy at the church, but that he went in alone. Bob Colacello told of going with him, when in Mexico, to the Shrine of the Virgin Guadalupe, the Mexican patron saint, where Andy went through what he called "all the Catholic things"[53] – holy water, genuflecting, kneeling, praying, making the Sign of the Cross after each step of the Roman ritual. It was the first time Colacello had been in church with Warhol, and he said he realized that Warhol's religion "was not an act."[54]

From 1970 until his death in 1987, the number and geographic range of solo exhibitions of Warhol's work was vast: Amsterdam, Naples, Zurich, Geneva, Cologne, London, Paris, Munich, Tokyo, Vienna, Madrid, Rome, and Malmo, Sweden as well as most sizable cities in the USA. During this period Warhol continued to do film and TV productions and his series of portraits of celebrities.

THE LAST DECADE

Significantly the decade before Warhol's death began with the creation of his *Skull paintings* of 1976 and ends with his 1986 series on the Last Supper. In this last decade he went from the theme of death and dissolution to the theme of redemption as imaged in the *Last Supper*, Jesus' last meal with his disciples at which time he instituted the sacrament of the Eucharist.

In Warhol's *Diaries*, the published version of which begins in November of 1976 and continues through

12 Andy Warhol, *Self-Portrait with Skull*, 1978. Synthetic polymer paint and silkscreen ink on canvas, 41 x 33 cm. The Menil Collection, Houston

February 17, 1987, just five days before his death, his regular Sunday church going was recorded, usually with the entry beginning, "went to Church," before he launched into accounts of parties and gossip. But on occasion he did elaborate. Upon returning from a trip to Germany and Paris, Warhol's *Diaries* record, "I went to Church, gave my thanks for the trip and getting back alive."[55] Prayer was part of his life pattern, but so was the awareness of the fragility of life itself (ill. 12).

The *Diaries* also tell of his appointments with Linda Li, a chiropractor and nutritionist, and with two "crystal doctors," both of whom were chiropractors. Warhol's diary entries about these New Age practitioners are filled with humor and show the dualism of both Warhol's skepticism and his credulity. Despite his questions he was clearly fascinated by what he called their "hokum-pokum"[56] and several times affirmed the energy he experienced after his visits to them. He bought crystals that the crystal doctors programmed for him for particular purposes.

From August 1984 until his death Warhol went to Dr. Li with some regularity and the "crystal doctors" on occasion. His own medical doctor had for some years recommended surgery for his diseased gall bladder but Warhol resisted surgery, "gripped," as Stephen Koch observed, "by a phobic belief that he would not survive it."[57] When Warhol had been shot in 1968, his heart had actually stopped beating on the operating table and, as Koch said, "In Warhol's sense of things, he had died and then been brought back, as if God had reconsidered and on second thought returned his life on loan ... He would live the rest of his life feeling a sense of metaphysical specialness and an accompanying metaphysical terror."[58] Koch's observation is reminiscent of the

medieval tales of the horrors and fears experienced by Lazarus, whom Jesus had raised from the dead: Lazarus having experienced death once, lived with the terror and fear of death's final claim.

All the while Warhol continued his regular attendance at St. Vincent Ferrer, and recorded in his diary with relief that the "crystal doctor" Reese was an Episcopalian, adding that "somehow knowing he believes in Christ I don't have to worry that crystals might be somehow against Christ."[59] This simple matter-of-fact statement shows how deeply rooted Warhol's Christian faith was. It accords with John Richardson's description of him: "Andy always struck me as a *yurodstvo* – one of those saintly simpletons who haunt Russian fiction and Slavic villages, such as Miková in Ruthenia, whence the Warhol's stemmed ... The saintly simpleton side like-wise explains Andy's ever-increasing obsession with folklore and mysticism."[60] And the power of crystal, one might add.

Warhol's involvement with the "crystal doctors" did not eclipse his religious regimen. His friend and phone pal of his last years, the photographer Christopher Makos, had traveled with Warhol to China, London, and many European cities, and was with him in Milan for the opening of the *Last Supper* exhibition. In Makos' book of photographs of his travels with Warhol, he wrote of his religious practice:

"Andy went to church every Sunday. A lot of his friends were Catholic. He may have related better to us Catholics because we all had the same background: mass, priests, nuns, Catholic school, a sense of guilt. His religion was a very private part of his life. In church he was Andrew Warhola and not the cool pop star Andy Warhol. I think it took a lot of pressure off him. It restored to him a perspective of the world that he had grown up with. In church he was the anonymous Catholic."[61]

It was in Warhol's last years that the paintings and prints with explicitly religious themes were done: the prints based on Renaissance religious paintings, the *Raphael I-6.99*, for which he used Raphael's well-known altarpiece, *The Sistine Madonna*, the *Cross* paintings, and finally the large series of paintings based on Leonardo da Vinci's *Last Supper*. With the exception of the *Cross* paintings of 1982, all of these works with religious themes were done within the last two years of Warhol's life. They constitute a kind of last will and testament and were done in a period of intense activity, when Warhol worked with fervor and was on a creative roll, as Vincent Fremont, his long-time friend and business manager confirmed.[62]

13 *Andy Warhol and Two Dominican Priests at the Exhibition Warhol: Il Cenacolo* in Milan, January 22, 1987. Photograph by Christopher Makos

In Loving Memory of

Andy Warhol

Born August 6, 1928

Died February 22, 1987

PRAYER

O God, the Creator and Redeemer of all the faithful, grant unto the souls of Thy servants departed the remission of all their sins; that, by pious supplications, they may obtain that pardon which they have always desired. Grant this, O God, Who livest and reignest for ever and ever. Amen.

Eternal rest grant unto them, O Lord, and let perpetual light shine upon them. May they rest in peace. Amen.

Sweet Heart of Mary, be my salvation! Mary, Mother of Perpetual help pray for us.

Our Father, —— Hail Mary, ——

Thomas P. Kunsak Funeral Home

OUR LADY OF KORSUN

14 The Mass Card for Andy Warhol's wake and funeral

January 22, 1987 Warhol flew to Milan to attend the star-studded opening of the *Last Supper* exhibition (ill. 13) held in a gallery right across the piazza from Santa Maria delle Grazie that houses the Leonardo da Vinci *Last Supper* which some believe has been overly – scrupulously cleaned. Photographs of Warhol taken at the opening show him smiling broadly under his wig of silver hair, but he looks gaunt and glassy-eyed. Previously he had been diagnosed as having gall bladder problems. In Milan he had bouts of abdominal pain, and left an extravagant dinner party early. Back in New York he went to the chiropractor, Linda Li. Finally as the pain continued, he went to his regular internist who advised immediate surgery for an enlarged and possibly gangrenous gall-bladder. Andy was checked into a New York hospital, and wanting to be anonymous, registered as Bob Roberts and stipulated no visitors.[63] Surgery the following day was successful, but at some point in the night his condition deteriorated suddenly, unnoticed by the private nurse, until he had become blue and had only a feeble pulse. The emergency team was called but could not revive Warhol who was pronounced dead at 6:30 a.m. on Sunday, February 22, 1987. The cause of death remains a mystery: an investigation

by the hospital ensued and the private nurse and hospital staff were criticized for neglect and incorrect procedures. The autopsy revealed no complications. The cause of death remains unknown.

Andy Warhol's older brothers, John and Paul Warhola, came from Pittsburgh and arranged to have the body transported to Pittsburgh where an open-coffin wake took place at a funeral home. Warhol was dressed in a black cashmere suit, a paisley tie and one of his favorite platinum wigs. His brothers decided he should also wear sunglasses.[64] "The sight of Andy lying in a white upholstered bronze coffin, holding a small black prayer book and a red rose, struck one viewer as 'Warhol's final discomforting work'."[65] On February 26, a Mass was said at the Holy Ghost Byzantine Catholic Church (ill. 14) with prayers in English and Old High Church Slavonic (ill. 15). Thereafter the coffin covered by a blanket of white roses was driven to the St. John the Divine Byzantine Catholic Cemetery some twenty miles away where Andy Warhol's body was buried near his parents. The simple, indeed ordinary tombstone, had in ansverse arms, and a carving below based on Dürer's *Praying Hands* (ill. 16), in reverse. Warhol had previously done a drawing after Dürer's transforming the narrow, bony ascetic looking hands of the German master into the supple, sensuous hands of a youth (ill. 17).

Warhol had remarked in his book, *America*, "I always thought I'd like my own tombstone to be blank. No epitaph and no name. Well actually, I'd like it to say 'figment'."[66] Like so many of Warhol's aphorisms this is one that is more astute than it appears. A figment, a pure invention, in some way characterizes this artist who could and did reinvent himself. The successful and sought after commercial artist of the 50s is followed by the 60s Warhol, the Pop artist; the 70s Warhol was the friend and painter of the rich and famous. Finally there is the Warhol of the 80s who partied, gossiped, and avidly collected, yet at the same time painted the late series of religious works of great beauty and gravitas.

POST MORTEM

"Andy Warhol was a great and conscious artist, and he's in heaven with Mozart and Balanchine."[67]
Henry Geldzahler

The funeral had been limited to Warhol's Pittsburgh family and a few close New York friends and associates, but the public homage to Andy Warhol took place on April 1st in St. Patrick's Cathedral in New York. Over two thousand people attended, among them many fellow artists – David Hockney, Richard Serra, Christo, Marisol, Claes Oldenberg, Roy Lichtenstein, Julian Schnabel, Francesco Clemente, Jean-Michel Basquiat, Keith Haring, Kenny Scharf, and Jamie Wyeth among others.

The invitation to the Memorial Mass at St. Patrick's reproduced Warhol's *Raphael I-6.99*, a painting based on Raphael's famous Sistine Madonna. Done in 1985, it was one of the first Warhol paintings with religious iconography. At the memorial service Andy's long-time friend, Brigid Berlin, read from scripture, and the art historian, John Richardson, gave the Eulogy and Yoko Ono also spoke. Printed on the program was a statement titled "A Lesser Known Element in the Portrait of Andy Warhol," which told of the homeless people who "will also be saddened by the absence of one who, with dedicated regularity, greeted them on Thanksgiving, Christmas, and Easter. Andy Warhol poured coffee, served food, and helped clean-up. More than that he was a true friend to these friendless. He loved these nameless New Yorkers and they loved him ..." The statement was signed by the Reverend Hugh Hildeslev, Church of the Heavenly Rest, New York.

Warhol's will left the proceeds from the sale of his belongings to the Andy Warhol Foundation for the Visual Arts. His twenty-seven room townhouse was sealed and Sotheby's auction house called to inventory the contents. Aside from his bedroom, the foyer, and the living room, every room was a store room for the vast collections of an unimaginable variety of fine art, artifacts, and "collectibles" that Andy had been buying, from Canova to cookie jars. Sotheby's pro-

15 Andy Warhol's tombstone in St. John the Divine Byzantine Catholic Cemetery. Photograph by Jane Daggett Dillenberger

16 Albrecht Dürer, *Praying Hands*, 1508. Black ink, white on blue prepared paper, 29 x 19.7 cm. The Albertina Collection, Vienna

17 Andy Warhol, *Praying Hands*, 1950s. Ink and dye on paper, 38 x 30 cm. The Andy Warhol Museum, Pittsburgh

duced a six volume catalogue of Warhol holdings. The auction spanned a ten day period and *Life* magazine called it the most extensive estate sale in history and one of the glitziest. It brought an astonishing 25.3 million dollars.

Subsequently the Warhol Foundation together with the Dia Center for the Arts which has long owned and exhibited Warhol's work, and the Carnegie Institute established the Andy Warhol Museum in Pittsburgh for the exhibition of his work in all media The museum's collection of paintings, drawings, and prints by this prolific artist gives to the art world and public, their first opportunity to see the full range of Warhol's genius. Exhibitions of Warhol's work in the United States have focused primarily on his early Pop works, and his portraits of famous people. Even the Warhol retrospective held at the Museum of Modern Art after his death had two thirds of the works from the first eight years of Warhol's twenty six-year career as an artist The paintings done by Warhol in the last years of his life are little known since they were exhibited abroad more often than in the United States. The grandeur of these late paintings can now be seen and experienced in settings designed for them in the museum in the city where Warhol was born and trained as an artist.

In these late paintings the cool and distanced artist abandoned his mask. Warhol finally created paintings in which his secret, but deeply religious nature flowed into his art. Technically he achieved a freedom and virtuosity which is analogous to the mastery seen in the late work of some Renaissance and Baroque masters. Like these earlier artists, Warhol's virtuosity served a deepened spiritual vision. In the *Last Supper* paintings, he was engaged at a level deeper than his habitual piety. Warhol made new Leonardo's mural, recreating it and making it accessible to twentieth century sensibilities, widening its meaning beyond the particularities of Christian belief to a more encompassing, universal affirmation.

This essay is from *Heaven and Hell are Just one Breath Away: The Religious Art of Andy Warhol*, New York, Continuum, 1998. Copyright © 1998 by Jane Daggett Dillenberger.

1 John Richardson, *Eulogy for Andy Warhol* given on the occasion of his memorial service at St. Patrick's Cathedral in New York City (April 1, 1987), 'Andy Warhol. Late Paintings and Related Works,' (Gagosian Gallery, New York: Rizzoli, 1992), p. 140–41.
2 Ibid., p. 141.
3 Ibid., p. 140.
4 Henry Geldzahler, *Andy Warhol: A Retrospective*, Kynaston McShine (ed.), (New York: Museum of Modern Art: 1989), p.427.
5 Henry Geldzahler, Andy Warhol: A Memorial (Dia Art Foundation, New York: 1987), p. 6.
6 Victor Bockris, *Warhol* (London: Penguin Books, 1989), p. 7.
7 Ibid., p. 8.
8 Ibid., p. 9.
9 Ibid., p. 9.
10 Paul Warhola, telephone conversation with the author, Jan. 10, 1997.
11 St. Vitus's Dance, a term for chorea, a disorder of the nervous system characterized by irregular, jerking movements caused by involuntary muscular contractions.
12 Andy Warhol, *The Philosophy of Andy Warhol* (New York: Harcourt Brace Jovanovich, 1975), p. 21.
13 Bockris, 1989 (see note 5), p. 40.
14 Ibid., p. 44.
15 Ibid, p. 51.
16 Bob Colacello, *Holy Terror: Andy Warhol Close Up* (New York: Harper Collins, 1990), p. 118.
17 David Bourdon, *Warhol* (New York: Harry Abrams, 1989), p. 28.
18 John Richardson, "The Secret Warhol: At Home with the Silver Shadow", *Vanity Fair*, July, 1987, p. 125.
19 Andy Warhol and Pat Hackett, *POPism: The Warhol '60s* (New York: Harcourt Brace Jovanovich, 1980), p. 5.
20 David Bourdon, "Warhol Starting Out" in Sotheby's catalog of *Sale of the Warhol Estate* (New York: 1988), n.p.
21 Owned now by Julia Warhola's eldest son Paul.
22 Bourdon, 1989, (see note 20), n.p.
23 Patrick S. Smith, *Warhol: Conversations about the Artist* (Ann Arbor: U.M.I. Research Press, 1988), p. 43.
24 Andy Warhol, *The Philosophy of Andy Warhol* (New York: Harcourt Brace Jovanovich, 1975), p. 10.
25 In a letter to *The New York* Times dated December 28, 1995, Warhol's friend and collaborator on films, Paul Morrisey, wrote,."... I tried to explain the extreme dyslexia [sic] Warhol struggled with throughout his life. His enormous difficulty in expressing himself verbally made him appear as somewhat limited at times."
26 Warhol, 1975, (see note 24), pp. 147–48.
27 Ibid., p 147.
28 Trevor Fairbrother, "Tomorrow's Man" in: *Success Is a Job in New York: The Early Art and Business of Andy Warhol*, exhibition catalogue (Grey Art Gallery: New York et al: 1989–90), p. 55.
29 Warhol and Hackett, 1980, (see note 19), p. 12.
30 A group of these designs are in the collection of the Andy Warhol Museum, Pittsburgh. Some are preliminary sketches and several are completed designs, two with the Three Magi and Holy Family.
31 The traditional categories were landscape, portraits, still life, genre, and history painting which included religious subjects.
32 Robert Rosenblum, "Warhol as Art History" in: *Andy Warhol: A Retrospective* (Boston: The Museum of Modern Art, Little, Brown and Co., 1989), p. 36.
33 Edmund Burke (1729–1797) author of the influential pioneer study of psychological basis of aesthetic enjoyment, *A Philosophical Inquiry into the Origin of Our Ideas of the Sublime and the Beautiful.*
34 Warhol and Hackett, 1980, (see note 19), p. 3.
35 Ibid., p. 22.
36 Hilton Kramer, statement in "Symposium on Pop Art", December 13, 1962, The Museum of Modern Art, New York; text reprinted in *Arts Magazine*, April, 1963.
37 Peter Selz, "Pop Goes the Artist" in: *Partisan Review*, Summer, 1963.
38 Bockris, 1989, (see note 6), p. 166.

39 Arthur C. Danto, "The Philosopher as Andy Warhol" in: *The Andy Warhol Museum*, Mark Francis, et al (Pittsburgh: The Andy Warhol Museum, 1994), p. 83.
40 Patt Hackett, (ed.), *The Andy Warhol Diaries* (London: Simon & Schuster, 1989), pp. 703, 777.
41 Ibid., p. 777.
42 Warhol, 1975, (see note 12), pp. 24, 25.
43 Richardson 1987, (see note 18), p. 126.
44 Warhol and Hackett 1980, (see note 19), pp. 272–73.
45 Bob Colacello, *Holy Terror: Andy Warhol Close Up* (New York: Harper Collins, 1991), p. 70.
46 Warhol and Hackett, 1980, (see note 19), p. 279.
47 Colacello, 1991, (see note 45), p. 278.
48 Neil Printz, "Painting Death in America", *Andy Warhol Death and Disasters* (Houston: The Menil Collection, 1988), p. 19.
49 Richardson, 1987, (see note 18), p. 70.
50 Steven Aronson said that "Warhol bought dozens of 18th and 19th century Spanish Colonial crucifixes and santos, three or four at a time." Sotheby, 1988 (see note 20), n. p.
51 Father Matarazzo, Interview with the author at St. Vincent's Priory , February 20, 1994.
52 Colacello, 1991, (see note 45), p. 437.
53 Ibid., p. 119.
54 Ibid.
55 Hackett, 1989, (see note 40), p. 343.
56 Ibid., p. 596.
57 Stephen Koch, *Stargazer: The Life, World, and Films of Andy Warhol* (New York: Marion Boyars, 1991), p. ii.
58 Ibid.
59 Hackett, 1989, (see note 40), p. 643.
60 Richardson, 1987, (see note 18), p. 126.
61 Christopher Makos, *Warhol: Makos: A Personal Photographic Memoir* (New York: New American Library, 1988), p. 53.
62 Vincent Fremont, interview with the author, January 7, 1998.
63 Bockris, 1989, (see note 6), p. 598.
64 Ibid., p. 604.
65 Ibid.
66 Andy Warhol, *America* (New York: Harper & Row, 1985), p. 129.
67 Geldzahler, 1987, (see note 5), p. 6.

Cornelia Syre

LEONARDO DA VINCI'S LAST SUPPER
HISTORY AND RECEPTION

"The most popular work of all Italian art, alongside Raphael's *Sistine Madonna*, is Lionardo's *Last Supper*. It is so simple, and yet so expressive that it makes a lasting impression on everyone. Christ is seated at the centre of a long table, the apostles in equal numbers on either side of him; he has just uttered the words: There is one among you who shall betray me! And this unexpected pronouncement has thrown the group into turmoil. He alone remains calm, his eyes cast downwards. And in his silence lies the repeated declaration: Yes, in truth I tell you, someone among you is about to betray me. One would think that this story had never been told in any other way, and yet everything about Lionardo's painting is new, and its very simplicity is to the benefit of great art."[1]

This brief characterisation by Heinrich Wölfflin (1898) provides an answer to the question as to what constitutes the extraordinary impact of this work of art, which up to the present day has enjoyed almost cultic veneration and undergone unparalleled dissemination in every conceivable medium[2]: the apparent simplicity and timeless validity with which it depicts a central theme of the Christian doctrine of salvation.

In the course of the centuries, the forms of recognition accorded to the *Last Supper* – which shortly after its completion was regarded as "miracoloso e famosissimo"[3] – have undergone significant changes: praised initially as an artistic miracle, it then became both the very essence of religious painting and a symbol of the transience of all that is earthly.

Leonardo da Vinci painted the *Last Supper* in the refectory of the Dominican convent Santa Maria delle Grazie in Milan on the commission of Duke Ludovico Sforza. The duke had designated Santa Maria delle Grazie as the court chapel and burial place for the members of his family. Accordingly, he had it decorated to comply with its new exalted function. Part of this project was the painting of the refectory.

The exact date of the commission and further details on the progress of the work are not known. Yet the commission must have already been given in January 1494, as Leonardo made a corresponding record of the dimensions of the wall surface at his disposal in one of his notebooks. In June 1497 Ludovico insisted on the work being finally completed, which it was probably in 1498.[4]

One eye-witness, *novelle* writer and later bishop Matteo Bandello, who spent his noviciate at the Milan convent, reports on Leonardo's method of working in the preface to his *Novella LVIII*. One revealing fact, as Bandello notes, is that art lovers from Milan would gather in the refectory to pursue the progress on the work, which Leonardo obviously did not consider to be in the least distracting: "The latter enjoyed it that anyone who saw his work should openly express their opinion of it. It was his frequent habit – I sometimes saw him doing so and watched – to climb up the scaffold early in the morning; the *Last Supper* is in fact located very high above the ground. It was his habit, as I said, not to lay down his brush from dawn to dusk; instead, he painted constantly, neglecting to either eat or drink. Then, two, three or four days could pass without his even raising a finger to work, and yet during that time he would remain there one to two hours each day and observe, examine and judge his figures for himself. I also saw him rush headlong, as the spirit moved him, to the convent delle Grazie ... from the Corte Vecchia ... climb the scaffold, apply one or two strokes of the brush to one of those figures, and leave straight afterwards."[5]

Leonardo did not carry out the mural "al fresco", meaning that he did not apply the pigment to the wet plaster so that it could unite permanently with this as it dried. Instead, he worked "al secco": the pigment, mixed with oil and tempera, was applied to the dry plaster. This technique allowed him to work more slowly and, above all, to make corrections. The great disadvantage, and one which soon became apparent, was that parts of the colour layer began to flake off from the plaster, also because of the permanent dampness of the wall. A visitor reports in 1517: "It has already begun to decay, I do not know whether due to the dampness of the wall or to some other negligence."[6]

Art scholars and educated travellers in the sixteenth and seventeenth centuries praised the *Last Supper* as "one of the most wonderful works of painting ever created" (Paolo Lomazzo, 1584) and which "reveals the genius of this divine man" (Vicente Carducho, 1633).[7] Lomazzo tells us the reason for the fame of the work: with it Leonardo had succeeded in an unparalleled way in achieving the highest goal of painting, namely, depicting emotional movements: "... and he so depicted the movements in the souls of the apostles, in their faces and their bodies, that there is no difference between reality and that depiction; ... for in those apostles one clearly perceives admiration, terror, pain, suspicion, love and other such emotions which they all were experiencing, and finally Judas with betrayal in his heart."[8] Up until the eighteenth century, all the written sources about the *Last Supper* almost exclusively acknowledge this psychological aspect. The ensuing reception of the *Last Supper*, however, was influenced by two literary witnesses who divorced the work's particular impact from the realm of art history and assigned it to another, universal human level.

For Stendhal (1817), the *Last Supper* was a stirring depiction of the betrayal of friendship: "... Among the twelve companions with whom he hid himself away from unjust persecution, whom he had gathered together on that day to partake of a meal of love, that symbol of the fraternity of hearts and of human love which he wanted to institute on earth, was a traitor ... Shattered by the repulsive wickedness of this ominous betrayal, he clearly recognises the depravity of mankind ... The noble pain that fills him oppresses our hearts. Our soul becomes immersed in the observation of one of the greatest crimes of humanity, the betrayal of friendship. We feel a need for air, and it is for this very reason that the artist depicted the door and the two windows in the background as wide open. Our eye gazes into a distant peaceful landscape, and this view is soothing."[9]

The *Last Supper* is also the subject of a detailed text by Goethe, which deals moreover with its painting technique, its state of preservation, and the numerous copies. It is quite remarkable that Goethe did not receive the decisive incentive to write this text from the original, which he went to see on May 23, 1788, but from a "reflection" of the original that had made its way to Weimar. In 1817, Grand Duke Carl August had acquired from the estate of the artist Giuseppe Bossi the latter's splendidly edited treatise *Del Cenacolo di Leonardo da Vinci* and a series of drawings – tracings of copies – which Bossi had done during his work on a large copy of the *Last Supper*. For Goethe this was a "vital impetus

to reflect on these items and call to mind the merit of one of the greatest artists that ever lived."[10] Goethe's detailed acclamation also interprets the event as a human drama; he characterises the figures on Christ's right side as follows: "Peter, farthest away and of the most impetuous character, on perceiving the words of the Lord leans over quickly behind Judas, who, gazing up in shock, is bent over the table holding the purse in his tightly closed right hand, while making an involuntary cramped movement with the left hand, as if to say: "What's that supposed to mean? – What's that supposed to suggest? Meantime, with his left hand Peter grasps the right shoulder of John, who is leaning towards him, as if to signify Christ and at the same time to encourage the beloved apostle to ask who the traitor is. With the handle of the knife in his right hand he involuntarily digs Judas in the ribs, appropriately causing him to jerk forwards in his fright and even knock over a salt cellar. This group may be regarded as the first one conceived for the painting. It is the most perfect ... Here you see expressive human reactions that range from the most gentle and seemly to the most vehement and passionate. Should all this have been painted after nature, what methodical observation, what time must have been required in order to ascertain so many details and integrate them into a whole! For this reason it is not all that improbable that he worked on this painting for sixteen years and yet could not complete either the traitor or the God-Man, as both are only concepts which cannot be grasped by the human eye."[11]

As of 1800, there was a veritable flood of engravings and copies which "reconstructed" the *Last Supper* and presented the work as if it were immaculately preserved, although in the meantime it had become difficult to decipher. Goethe, therefore, recommends that readers of his text should have recourse to the copperplate engraving by Raphael Morghen, which was made in 1800, went into numerous editions, and was regarded as the most faithful "reconstruction" of the original state of the work. As a result, Leonardo's mural was accessible for all, at everyone's disposal, omnipresent.

At the same time as these copies were suggesting the existence of a perfectly preserved work of art, an awareness of that same work's progressive decline was also growing. The veneration which the *Last Supper* enjoyed was now magnified by the mystery of its transience; it became a "glorified ruin".[12] At the end of his poem *The Last Supper* (1820), Wordsworth conjures up the work's eternal youth:

"Made to the Twelve, survives: lip, forehead, cheeks,
And hand reposing on the Board in ruth
Of what it utters, while the unguilty seek
Unquestionable meanings – still bespeak
A labour worthy of eternal youth!"[13]

Jacob Burchkardt concludes his report on a visit to Milan in 1838 to view the *Last Supper* with some gloomy considerations: "Yet how lamentable the work looks at this very moment: the undoubtedly once radiant colour has been destroyed … in parts the plaster has fallen from the wall, even sections that have been painted over have become quite drab. Of the feet visible under the table, many have as good as disappeared. I cast another disconsolate glance at the painting and was about to depart, but at the doorway I had to turn around once more and take my place in front of the painting again to take leave of it. All beauty on earth has to decay, in the world of art as in that of humans, and, by preference, death eagerly devours what is most splendid."[14]

It is quite astonishing that the *Last Supper* was only perceived as a Christian image, and only became the essence of religious painting, in the mid-nineteenth century.[15] The man who "said his morning prayers every day in front of this painting would certainly become much more grave, more noble, and freer from sin as a result. For what do I see before me in this picture? I have in front of me the most beautiful image that a highly gifted Christian made of Christ" (Alban Stoltz, 1955).[16]

A comparison between Leonard's *Last Supper* and that by Fritz von Uhde led to the following conclusion: "Leonardo's work is incomparably monumental; the Christ it portrays is majestic, and certainly one of the most outstanding depictions of the son of God, if not the most prominent … And so one cannot help but assume that the human ideal which the saviour of the world conceived comes close to this majesty, the ideal which he posited anew and which only he fulfilled entirely: benevolence, the most tormenting compassion for a world steeped in sin, self sacrifice, and therefore singular kindness and captivating beauty of the soul."[17]

The growing importance of the *Last Supper* as a popular religious motif gave rise to a regular mass production of copies of the work. Not only was it utilised as a wall decoration, but was also reproduced on drinking glasses, salt cellars, watches, writing desk sets, tablecloths etc.[18] Whereas these reproductions might still be looked upon as having a certain link, however limited or banal, with the original, that link became totally lost in the twentieth century. Richard Hüttel has devoted his attentions to the commercial "exploitation" of the *Last Supper*: The headings of the chapters in his book dealing with its "Commercialisation" and "Updating" point to the almost unimaginable possibilities for trivialisation: "The mis-en-scène of the Last Supper" (in wax, plaster or as a tableau vivant), "Political and other satires", "Eucharistic Irony", "Group portraits", "The Last Supper as a tableau vivant on film and television", and finally, "The Last Supper as a source of inspiration in contemporary art", for Larry Rivers, Robert Rauschenberg and Andy Warhol.

In his *Conversations with Goethe in the last years of his life* Johann Peter Eckermann reports the following dated 16 December 1828: "What is more – Goethe went on – the world is now so old, and over the millennia so many important people have lived and deliberated, that there is little new to be discovered or said. My Theory of Colour is also not altogether new. Plato and Leonardo da Vinci and many other notables discovered and said just about the same before me, but the fact that I too discovered it, that I said it again, and that I strove to gain truth renewed access to a confused world, that is my contribution."[19]

1 Heinrich Wölfflin, *Die klassische Kunst*, 4th edition (Munich: 1908), p. 26.
2 On the history of the work's reception up until the eighteenth century see Giuseppe Bossi, *Del cenacolo di Leonardo da Vinci* (Milan: 1810; on its reception in the nineteenth and twentieth centuries see Richard Hüttel, *Spiegelungen einer Ruine, Leonardos Abendmahl im 19. und 20. Jahrhundert* (Marburg: 1994).
3 Matteo Bandello, *Novella LVIII*, preface containing dedication to Ginevra Rangona e Gonzaga, Lucca 1554; also see Bossi (see note 2) p. 23.
4 See Ludwig Heydenreich, *Leonardo: The Last Supper* (London: 1974), pp. 14–15.
5 Bandello, 1554, (see note 3); quoted here from E. Möller, *Das Abendmahl des Lionardo da Vinci* (Baden-Baden: 1952), pp. 3–4.
6 Cardinal Luigi D'Aragona's journey through Germany, the Netherlands, France and Upper Italy, 1517–18, described by Antonio de Beatis in: L. Pastor (ed.) (Freiburg: 1905), p. 176.
7 Bossi, 1810, (see note 2), p. 35: Lomazzo; p. 48: Carducho, translated by the author.
8 Paolo Lomazzo, *Trattato dell'arte della pittura* (Milan: 1584); quoted from Bossi, 1810 (see note 2), p. 35, translated by the author.
9 Henry Beyle – de Stendhal, *Histoire de la peinture en Italie*, German edition by F. von Oppeln-Bronikowski in: *Gesammelte Werke*, vol. 10 (Berlin: 1928), pp. 131–133.
10 Johann Wolfgang von Goethe, "Joseph Bossi über Leonardo da Vincis Abendmahl zu Mailand"; afterword by W. Scheidig on the exhibition in Weimar in 1952 (Berlin: 1952), pp. 30–32.
11 Bossi 1952 (see note 10), pp. 4–5 and p. 17.
12 Hüttel, 1994 (see note 2), p. 33.
13 Quoted from Hüttel (note 2 here) p. 33.
14 Jacob Burckhardt, *Gesammelte Werke*, H. Trogt and E. Dürr (eds.), vol. 1 (Berlin and Leipzig: 1930), p. 14; see Hüttel, 1994 (see note 2), p. 33.
15 Hüttel, 1994 (see note 2), pp. 36–43.
16 Quoted from Hüttel 1994 (see note 2), p. 36.
17 D. R., "Das Abendmahl des Leonardo da Vinci und dasjenige des Fritz von Uhde" in: *Christliches Kunstblatt* 31, 1889, pp. 49–50; see also Hüttel 1994 (see note 2), p. 37.
18 Hüttel, 1994 (see note 2), pp. 54–58.
19 Johann Peter Eckermann, *Gespräche mit Goethe in den letzten Jahren seines Lebens 1823–32*, quoted from Bossi 1810, (see note 10) p. 30.

DRAWINGS AND COLLAGES

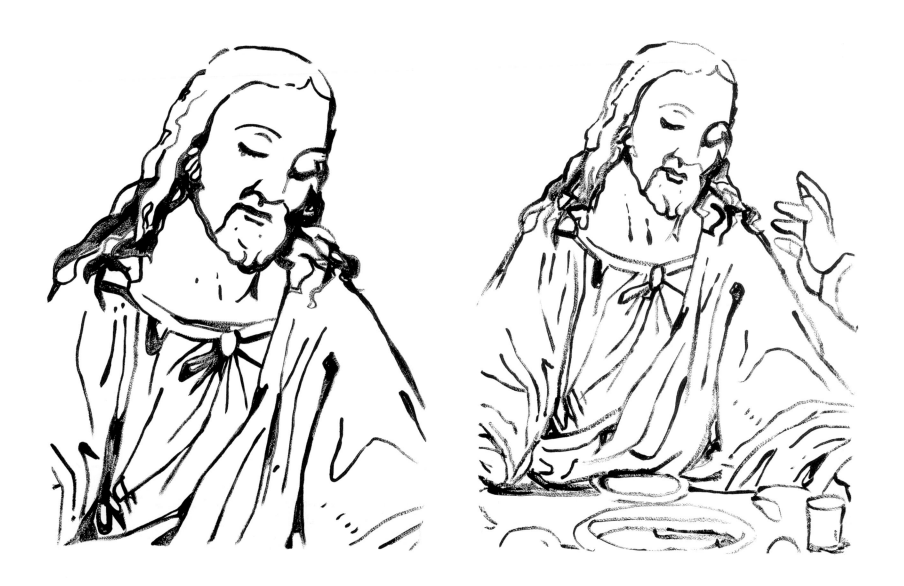

21 **The Last Supper,** 1986

22 **The Last Supper,** 1986

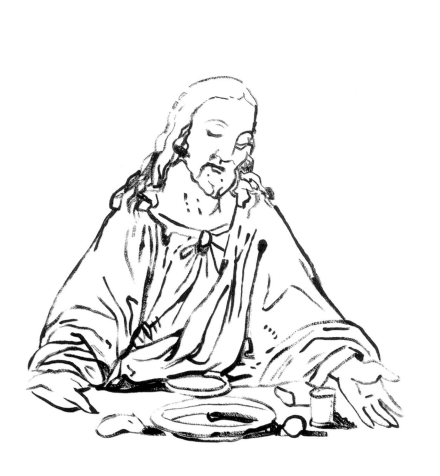

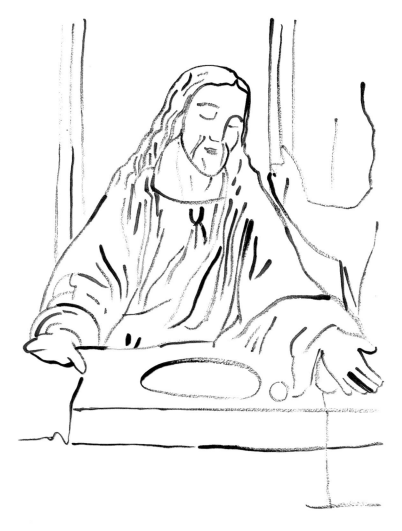

23 **The Last Supper,** 1986

24 **The Last Supper,** 1986

109

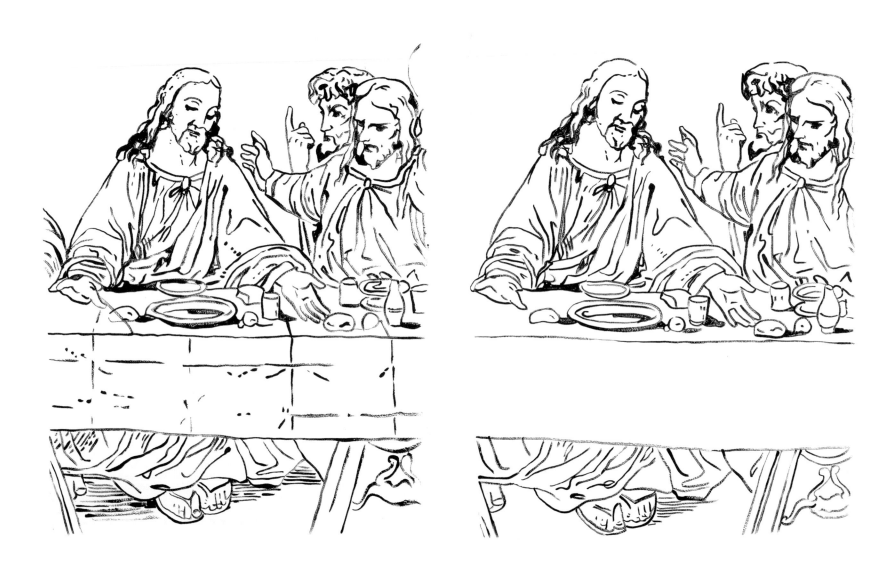

25 **The Last Supper,** 1986

26 **The Last Supper,** 1986

110

27 **The Last Supper,** 1986

28 **The Last Supper,** 1986

29 **The Last Supper,** 1986

30 **The Last Supper,** 1986

113

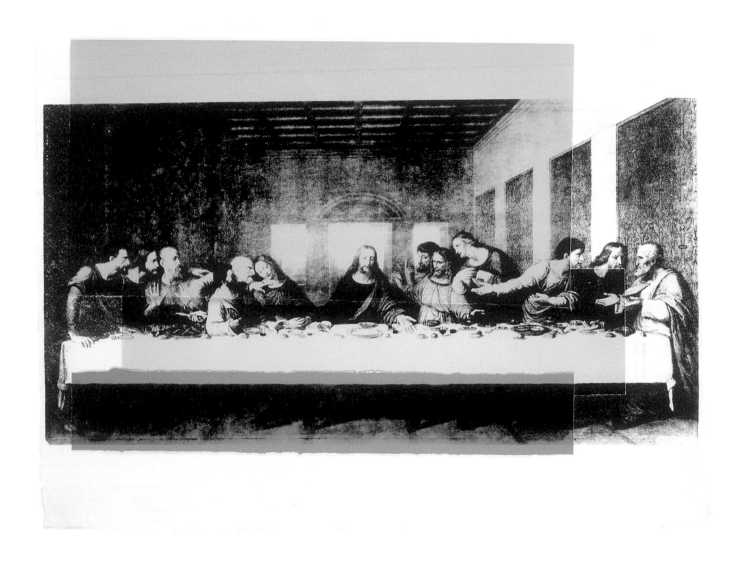

31 **The Last Supper,** 1986

114

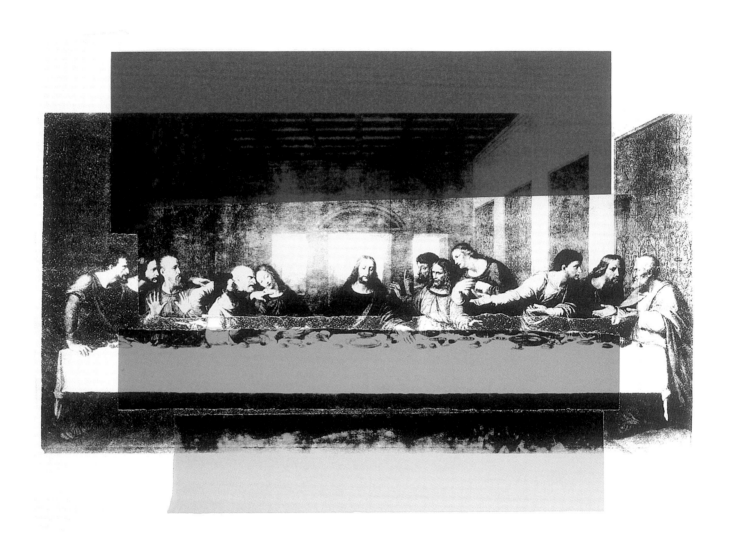

32 **The Last Supper,** 1986

33 **The Last Supper,** 1986

34 **The Last Supper,** 1986

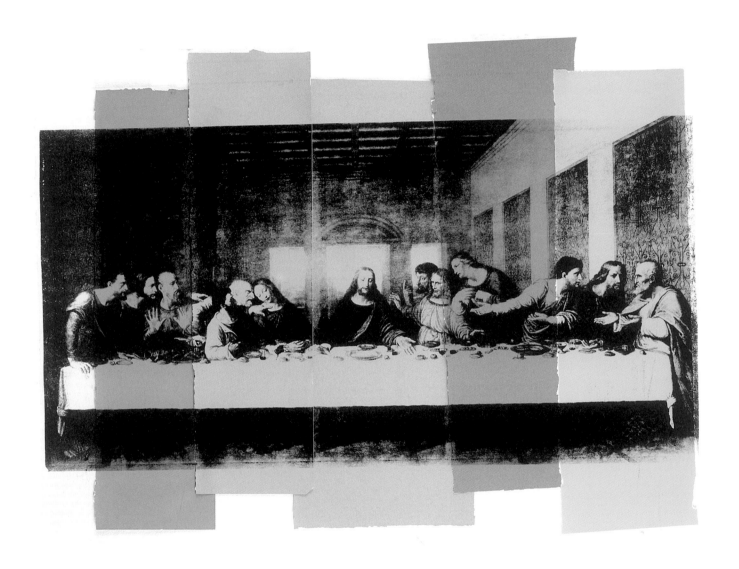

35 **The Last Supper,** 1986

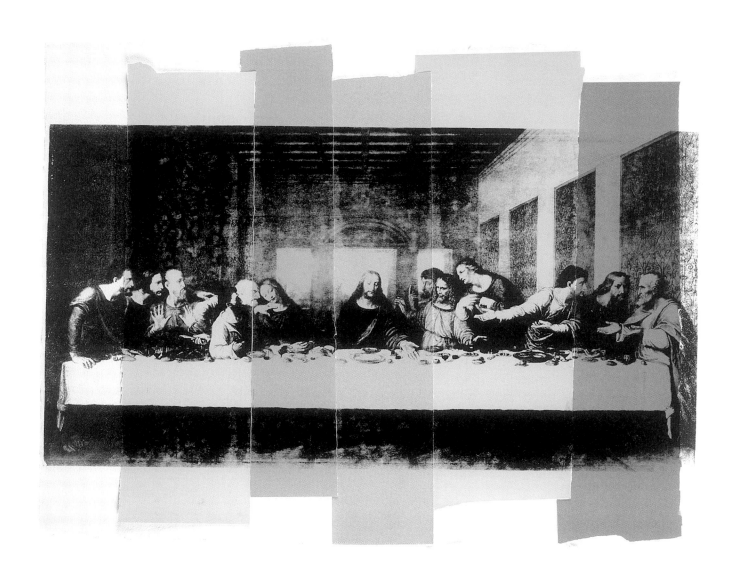

36 **The Last Supper,** 1986

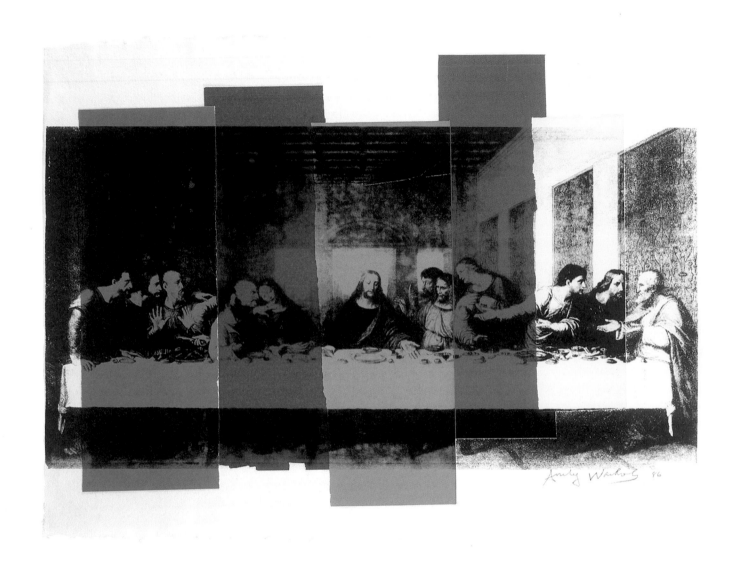

37 **The Last Supper,** 1986

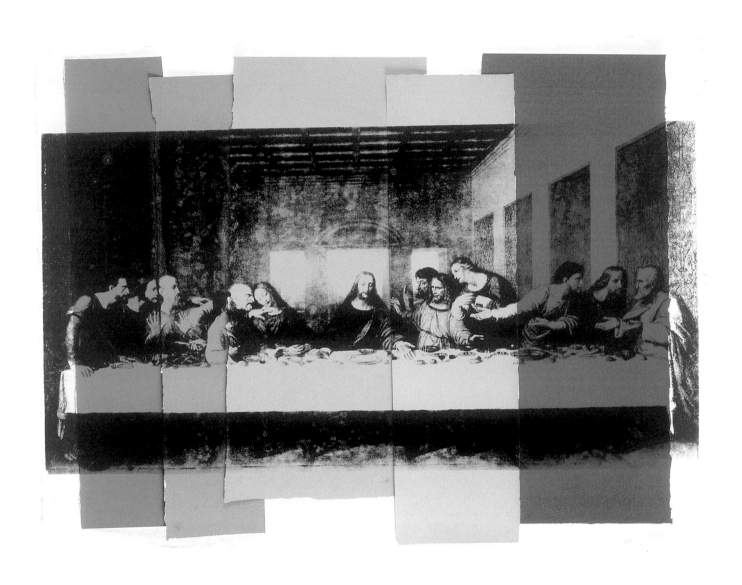

38 **The Last Supper,** 1986

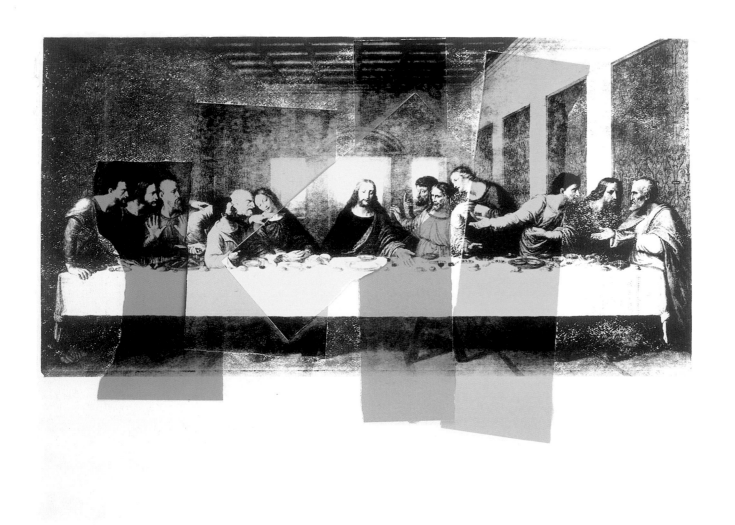

39 **The Last Supper,** 1986

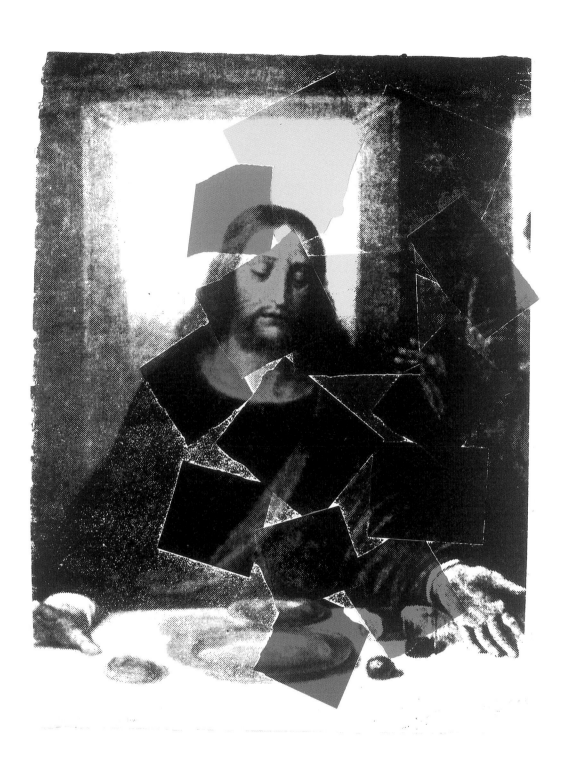

40 **The Last Supper,** 1986

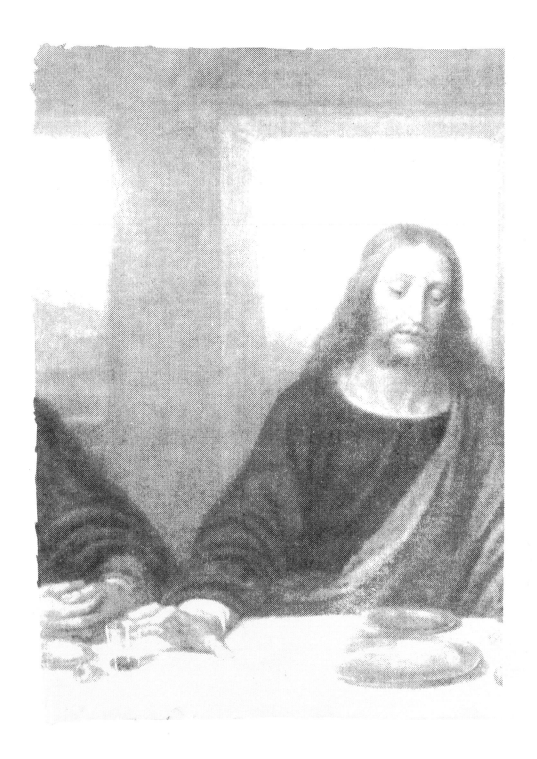

41 **The Last Supper,** 1986

42 **The Last Supper,** 1986

43 **The Last Supper,** 1986

44 **The Last Supper,** 1986

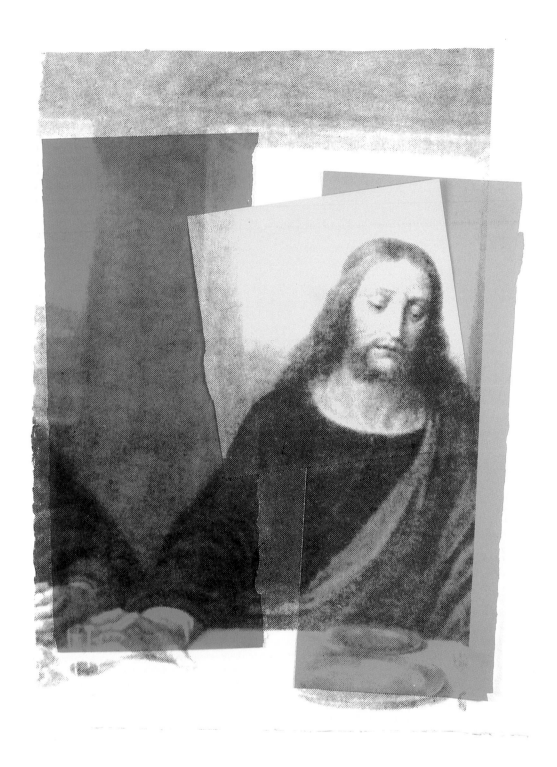

45 **The Last Supper,** 1986

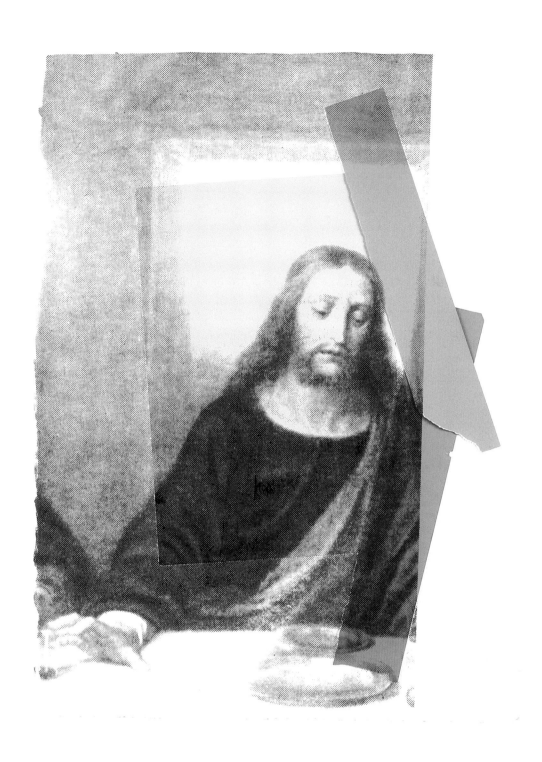

46 **The Last Supper,** 1986

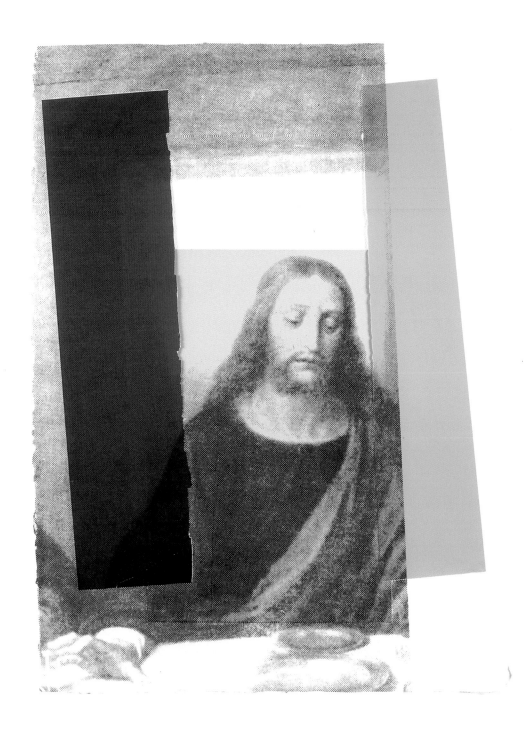

47　**The Last Supper,** 1986

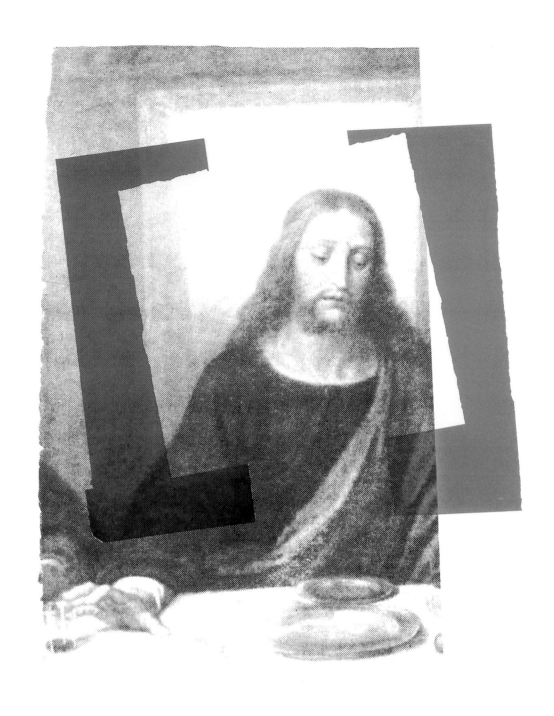

48 **The Last Supper,** 1986

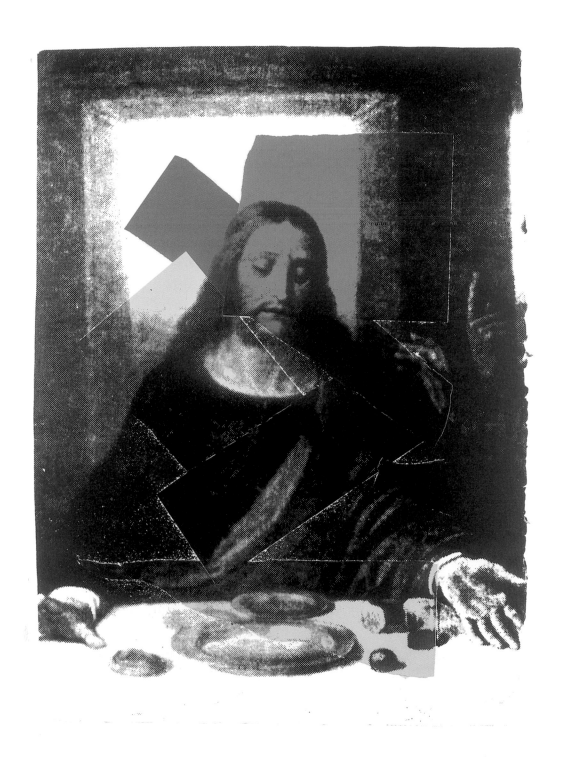

49 **The Last Supper,** 1986

132

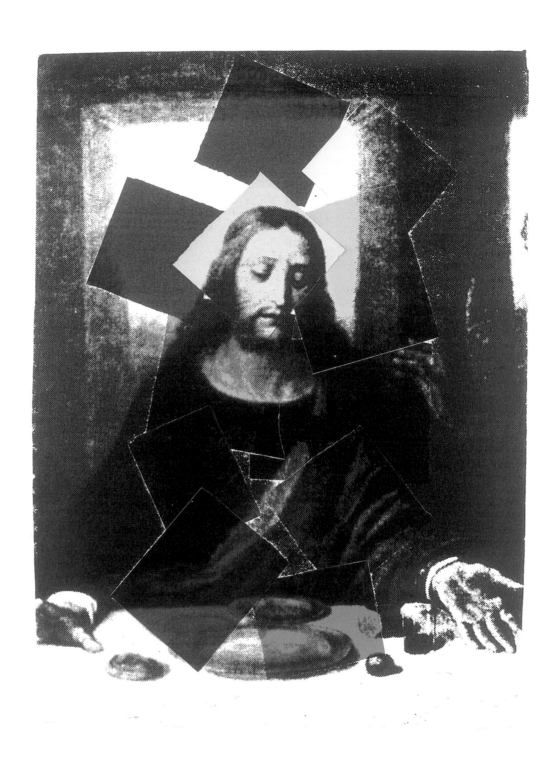

50 **The Last Supper,** 1986

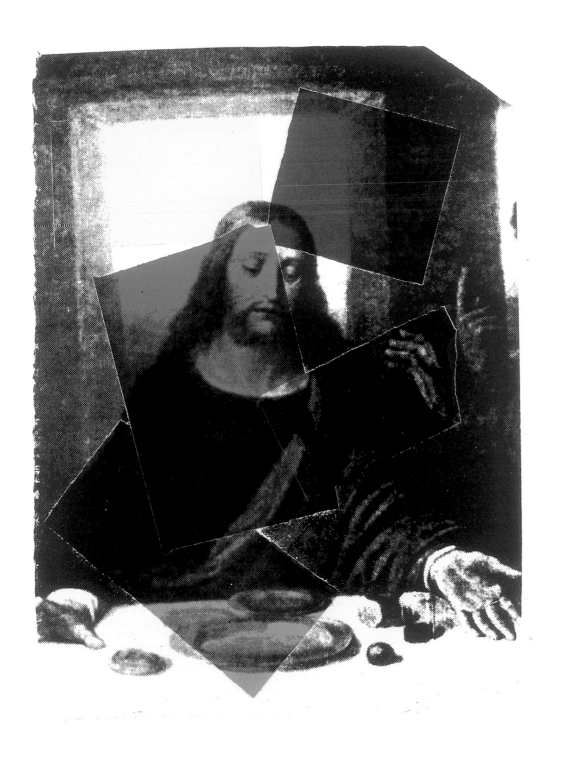

51 **The Last Supper,** 1986

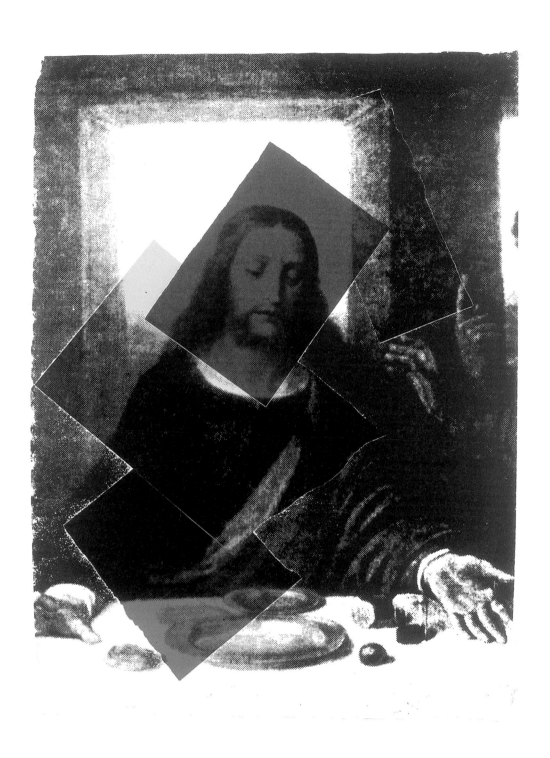

52 **The Last Supper,** 1986

135

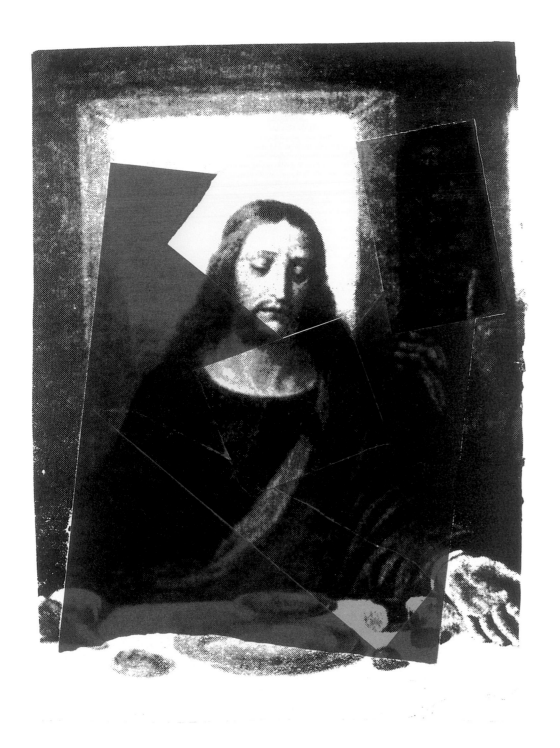

53 **The Last Supper,** 1986

136

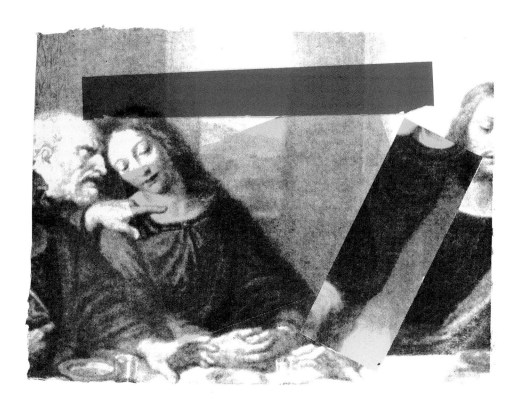

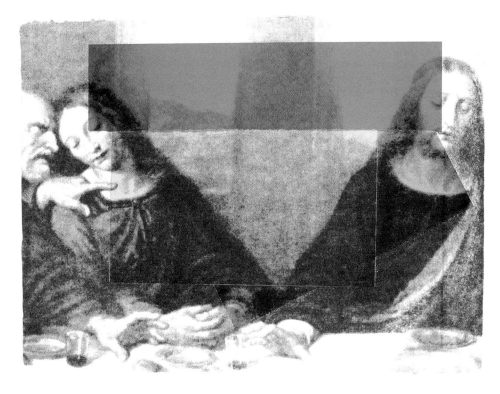

54 **The Last Supper,** 1986

55 **The Last Supper,** 1986

137

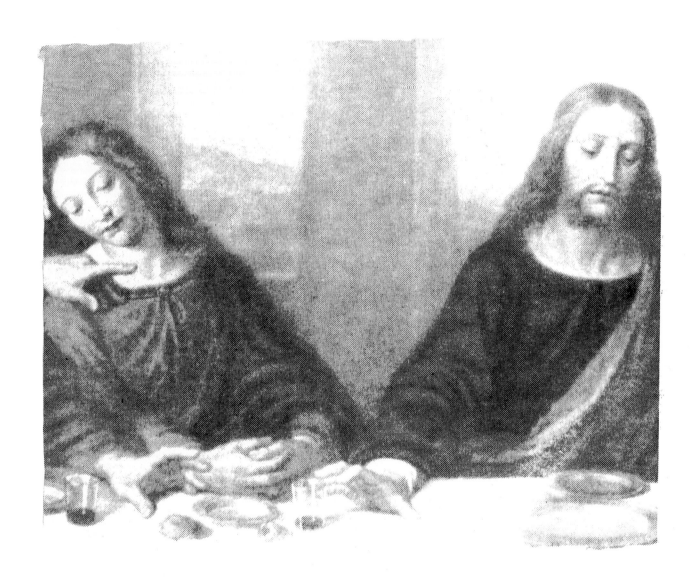

56 **The Last Supper,** 1986

ANDY WARHOL 1928–1987

1928

Andy Warhol (actually Andrew Warhola) is born on August 6th as the third son of the immigrants Andrej and Julia Warhola in Pittsburgh. Of Ruthenian descent, his parents emigrated from Miková near Medzilaborce, presently Slovakian territory near the Ukrainian border. His father, a miner and construction worker, entered the US in 1913. Besides doing cleanig work Julia Warhola supplements the modest family income with the sale of paper flowers, decorated Easter eggs and other hand-crafted items of her own making.

1934–41

The Warholas move into a small house of their own in South Oakland district of Pittsburgh. Having been plagued by frequent illness at the age of eight or nine, Andrew eventually suffers a nervous breakdown (St. Vitus' dance). He collects comics and autographs of movie stars and develops an interest in cartoons. He draws, takes photographs and works in handicrafts. His dream is to become a tap dancer.

1942

Death of Andrew's father. Andrew attends Schenley High School and takes free art courses at the Carnegie Institute of Technology. He registers as a student of Pictorial Design at the Institute in 1945 and graduates with a Bachelor of Arts in 1949.

1947

Experimentation with transfer printing processes.

1949

Warhol does a cover illustration for the Carnegie Institute campus magazine with a motif featuring faces of violin players in multiple repetition, a piece that anticipates the structural scheme of his later serial pictures. He moves to New York during the summer, where he begins a successful career as a commercial artist, contributing to periodicals such as *Vogue, Seventeen, The New Yorker* and *Harper's Bazaar*, among others. He designs shop windows, showcases, ads, articles of paper art and covers for books and records for a variety of companies, including Tiffany and Co., Bergdorf & Goodmann and Bonvit Teller. Andrew deletes the last letter from his family name and now calls himself Warhol.

1950

He finds a simple apartment on the corner of 75th Street and 3rd Avenue. It has no hot water but plenty of mice, which he tries to control with the help of his cats. His mother moves in with him (remaining until 1971).

1952

Warhol's first solo exhibition at the New York Hugo Gallery, featuring illustrations for short stories by Truman Capote. He is awarded a prize – his first – by the Art Directors' Club for his journal designs.

1953–55

Warhol moves with his mother to a larger apartment on 34th Street. He draws flowers, animals and shoes and does illustrations for children's books and a book on cats.

1956

A trip around the world from June 16th to August 12th takes him from New York to California, Japan, Indonesia, Cambodia, India, Egypt and several European countries.

1957

Dissatisfied with the shape of his nose, he has it surgically altered. Now one of the highest-paid commercial artists in New York, Warhol founds Andy Warhol Enterprises, a company with branch offices in Philadelphia and Chicago. *Women's Wear Daily* names him the "Leonardo of the Shoe Industry". A gift book entitled *A la Recherche du Shoe Perdu* appears. Warhol and his mother move into the recently purchased town house on Lexington Avenue.

1960

Warhol completes his first paintings with motifs of popular comic strip figures – *Batman, Nancy, Dick Tracy, Popeye* and *Superman.*

1961

He discovers paintings by Roy Lichtenstein at the Castelli Gallery and recognises similarities to his own works. His response is to begin searching for other motifs and techniques in his art, and he turns at this point to consumer items such as Coca-Cola and Campbell's Soup.

1962

Warhol begins working with rubber and wooden stamps and experimenting with oxidation and other random effects, such as footprints. In addition to his hand-painted pictures he completes his first silkscreen prints on canvas. Done initially by hand, these are soon produced using a photographic process. This technique would play a dominant role in all of his later work. Warhol completes his first series: *Campbell's Soup Cans*, the portraits of *Elvis Presley* and *Marilyn Monroe* and the *Disaster* pictures. The *Campbell's Soup Cans* series is exhibited at a first major solo exhibition at the Ferus Gallery in Los Angeles.

Within the context of political dialogue between the U.S. and France, Leonardo's *Mona Lisa* is sent to the U.S. as an "ambassador of goodwill" and exhibited at the National Gallery of Art in Washington. Citing the "universal character of art" in public statements, John F. Kennedy emphasises the resolve of the U.S. to "continue [our] efforts to build an independent artistic power in its own right". Warhol responds to the "visit" of the famous painting with his paraphrased *Mona Lisa* images, including *Thirty are better than one.*

1963

Warhol replaces the grey hairpiece he has worn since the fifties with a silver-sprayed wig. He purchases a 16-mm camera and shoots his first motion pictures, among them *Kiss* and *Sleep*. He occupies the studio at 231 East 47th Street, the "Factory", which would become an important gathering point and workplace for artists and celebrities alike. Billy Name covers the floors, walls and ceilings of the Factory with aluminium foil and silver paint. Warhol meets Marcel Duchamp at the Duchamp retrospective in Pasadena. After the assassination of John F. Kennedy Warhol begins work on his series of *Jackie* portraits.

1964

Warhol completes his first *Flower* pictures and a number of films (including *Empire State Building* and *13 Most Beautiful Women*). Riding the wave of success generated by his scandalous fabricated merchandise packages – corn flakes and washing powders – he becomes a prominent figure in the New York pop and underground scene. His silkscreen prints entitled *13 Most Wanted Men*, produced for the façade of Philip Johnson's pavilion for the New York World's Fair, are rejected by his clients, and Warhol covers them with silver paint.

1965

The rock group *The Velvet Underground* makes its first appearance in a Warhol movie. Warhol works closely with the filmmaker Paul Morrisey, who joins the Factory. As an artist, Andy Warhol has achieved such stunning success that he no longer accepts commissions for commercial work. Four thousand visitors present at the opening of a retrospective exhibition in Philadelphia find themselves staring at blank walls, as the organisers have temporarily removed Warhol's pictures in anticipation of unmanageable crowds of viewers.

1966

Despite his announcement that he will concentrate exclusively on movies, Warhol continues to produce extensive series of silkscreen prints, including numerous self-portraits. He covers the walls of a room at the Leo Castelli Gallery with wall-paper printed with images of cows; his helium-filled *Silver Pillows* hover in the air in another room. Films such as *The Chelsea Girls, The Velvet Underground* and *Nico* focus upon aspects of "duration" and "repetition".

1967

Warhol meets Fred Hughes at a benefit concert for the Merce Cunningham Dance Company. Hughes eventually becomes his manager and closest friend. Warhol designs a pull-off banana sticker concealing a flesh-coloured banana for the cover of *The Velvet Underground's* first album.

1968

In a departure from the unwritten law forbidding the award of prizes to artists from the West, Andy Warhol receives the Grand Prize at the Warsaw Poster Biennial. His art is obviously regarded in Poland (and in many American circles as well) as subversive and anti-American, a view Warhol consistently rejects. On June 3rd, he is shot and severely wounded by Valerie Solanas, founder and sole member of the Society for Cutting Up Men. A Warhol retrospective is held at the Moderna Museet in Stockholm.

1969

Warhol and his *Andy Warhol Enterprises* publish *Interview*, a film and society magazine that would become a forum for such now-famous photographers as Bruce Weber and Robert Mapplethorpe. The rights to this highly successful magazine, which is still published today (170,000 copies were printed in 1986) would be sold after Warhol's death to Brant Publications.

1970

Touring retrospective exhibition with stops in the U.S. and Europe.

1972

Warhol returns to portraiture, having virtually abandoned painting and silkscreen work since 1968. Producing up to one hundred portraits a year, he becomes the most prominent society painter of the latter half of the 20th century. His mother dies in Pittsburgh at the age of 80. The Walker Art Center in Minneapolis presents a retrospective of his films.

1974

Andy Warhol begins preserving his extensive collections, working documents and private possessions in *Time Capsules*, cardboard boxes of uniform size that would eventually number 610 at the time of his death. The Factory, now also occupied by the growing staff of *Interview*, is now renamed "The Office" and moved to a building on Broadway.

1975

Publication of Warhol's book, *The Philosophy of Andy Warhol*, containing the artist's thoughts on love, work, fame, death, art, time, the economy, etc.

1976

Warhol discusses the latest news in daily telephone conversations with Pat Hackett, a friend and managing editor of the European edition of *Interview*. His remarks would later be published posthumously in his *Diaries*. A retrospective exhibition of his prints is presented in Germany, Austria and Switzerland. He begins work on his *Skulls* series.

1977–80

The New York Museum of American Folk Art presents the artist's collection of folk art. Warhol begins working on his *Retrospectives*, his portraits of Joseph Beuys and the group of works entitled *Jews in the 20th Century*. Two comparatively abstract series, *Oxidations* and *Shadows*, also originate during these years.

1978

Retrospective exhibition at the Kunsthaus Zürich.

1979

Publication of *Exposures*, a book containing texts and photos by Andy Warhol.

1980

Warhol publishes *POPism: The Warhol's '60s* in co-operation with Pat Hackett.

1981–82

Warhol travels to Munich, Paris, Vienna, Zurich, East Berlin and Peking, where he visits the Square of Heavenly Peace. While in China, he also visits the Chinese Wall. Series completed during these years include *Dollar Signs, Myths, Crosses* and the *Goethe* Portraits. Warhol designs the poster for Werner Fassbinder's film *Querelle*.

1983–85

Andy Warhol works on his *Rohrschach* pictures based upon the psychological test developed by the Swiss psychiatrist Hermann Rohrschach. He also does other pieces in which he alludes to works by famous painters, focusing particularly on Renaissance masters (Leonardo, Titian and others) and classical modernists (Munch, Picasso, etc.). A joint effort with Jean-Michel Basquiat and Francesco Clemente produces the *Collaborations*. The exhibition entitled "Warhol's Animals. Species at Risk" is shown at the New York Museum of Natural History. The Galerie Bischofberger in Zurich exhibits his *Paintings for Children*. Work on the *Last Supper* series begins in the spring of 1985 and continues for nearly a full year.

1986

With his *Camouflage* pictures, works in which he covers self-portraits, portraits of Joseph Beuys, images of the Statue of Liberty and adaptations of Leonardo's *Last Supper* with a camouflage pattern, Warhol attracts the interest of a number of otherwise sceptical critics. He works on several different series – *Cars, Flowers, Cowboys & Indians* – and on new self-portraits. He hosts the show "Andy Warhol – Fifteen Minutes", in which he talks with celebrity guests, on the cable channel MTV.

1987

Andy Warhol travels to Milan for the opening of the exhibition entitled "Warhol – Il Cenacolo" on January 22nd. He is taken seriously ill while in Milan and returns to New York, where he undergoes gall-bladder surgery. He dies at New York Hospital on February 22nd and is buried in Pittsburgh.

CHECKLIST OF THE EXHIBITION

Unless stated otherwise, all works listed below were made in 1986

PAINTINGS / SILKSCREENS ON CANVAS

1

The Last Supper/Be a Somebody with a Body, 1985/86
Synthetic polymer paint on canvas, 127 x 152 cm
The Andy Warhol Foundation for the Visual Arts, Inc., New York
Inv.Nr. PA 10.300

2

Be a Somebody with a Body, 1985/86
Synthetic polymer paint on canvas, 127 x 152 cm
The Andy Warhol Foundation for the Visual Arts, Inc., New York
Inv.Nr. PA 10.301

3

Black-Light Christ
Synthetic polymer paint on canvas, 58 x 58 cm
The Andy Warhol Foundation for the Visual Arts, Inc., New York
Inv.Nr. PA 82.001
Page 58: black-light version, page 59: normal light conditions

4

Black-Light Christ
Synthetic polymer paint on canvas, 58 x 58 cm
The Andy Warhol Foundation for the Visual Arts, Inc., New York
Inv.Nr. PA 82.002
Page 58: black-light version, page 59: normal light conditions

5

The Last Supper
Synthetic polymer paint and silkscreen ink on canvas, 51 x 41 cm
The Andy Warhol Foundation for the Visual Arts, Inc., New York
Inv.Nr. PA 82.003

6

The Last Supper
Synthetic polymer paint and silkscreen ink on canvas, 51 x 41 cm
The Andy Warhol Foundation for the Visual Arts, Inc., New York
Inv.Nr. PA 82.004

7

The Last Supper
Synthetic polymer paint and silkscreen ink on canvas, 51 x 41 cm
The Andy Warhol Foundation for the Visual Arts, Inc., New York
Inv.Nr. PA 82.005

8

The Last Supper
Synthetic polymer paint and silkscreen ink on canvas, 51 x 41 cm
The Andy Warhol Foundation for the Visual Arts, Inc., New York
Inv.Nr. PA 82.006

9

The Last Supper (Christ 112 Times)
Synthetic polymer paint and silkscreen ink on canvas, 204 x 1070 cm
The Andy Warhol Foundation for the Visual Arts, Inc., New York
Inv.Nr. PA 82.019

10

The Last Supper (Christ 112 Times)
Synthetic polymer paint and silkscreen ink on canvas, 204 x 1075 cm
The Andy Warhol Foundation for the Visual Arts, Inc., New York
Inv.Nr. PA 82.009

11

The Last Supper
Synthetic polymer paint on canvas, 300 x 732 cm
Private Collection
Inv.Nr. HF 1995.2

12

The Last Supper (Camel)
Synthetic polymer paint on canvas, 300 x 884 cm
Private Collection
Inv.Nr. HF 1995.4

13

The Last Supper/Be a Somebody with a Body
Synthetic polymer paint on canvas, 300 x 587 cm
The Andy Warhol Foundation for the Visual Arts, Inc., New York
Inv.Nr. PA 82.013

14

The Last Supper
Synthetic polymer paint on canvas, 287 x 580 cm
The Andy Warhol Foundation for the Visual Arts, Inc., New York
Inv.Nr. PA 82.017

15

Sixty Last Suppers
Synthetic polymer paint and silkscreen ink on canvas, 293 x 998 cm
Private Collection
Inv.Nr. HF 1995.1

16

The Last Supper (Wise Potato Chips)
Synthetic polymer paint on canvas, 300 x 640 cm
The Andy Warhol Foundation for the Visual Arts, Inc., New York
Inv.Nr. PA 82.036

17
The Last Supper
Synthetic polymer paint on canvas, 295 x 996 cm
The Andy Warhol Foundation for the Visual Arts, Inc., New York
Inv.Nr. PA 82.014

18
The Last Supper
Synthetic polymer paint on canvas, 295 x 572 cm
Private Collection
Inv.Nr. HF 1995.3

19
Camouflage Last Supper
Synthetic polymer paint and silkscreen ink on canvas, 203 x 775 cm
Private Collection
Inv.Nr. HF 1997.1

20
The Last Supper
Synthetic polymer paint on canvas, 295 x 465 cm
The Andy Warhol Foundation for the Visual Arts, Inc., New York
Inv.Nr. PA 82.038

WORKS ON PAPER

21
The Last Supper
Synthetic polymer paint on paper, 80 x 61 cm
Private Collection
Inv.Nr. HF 1995.4.1

22
The Last Supper
Synthetic polymer paint on paper, 81 x 60 cm
Private Collection
Inv.Nr. HF 1995.4.2

23
The Last Supper
Synthetic polymer paint on paper, 81 x 61 cm
Private Collection
Inv.Nr. HF 1995.4.3

24
The Last Supper
Synthetic polymer paint on paper, 80 x 59 cm
Private Collection
Inv.Nr. HF 1995.4.4

25
The Last Supper
Synthetic polymer paint on paper, 80 x 60 cm
Private Collection
Inv.Nr. HF 1995.4.5

26
The Last Supper
Synthetic polymer paint on paper, 80 x 60 cm
Private Collection
Inv.Nr. HF 1995.4.6

27
The Last Supper
Synthetic polymer paint on paper, 80 x 61 cm
Private Collection
Inv.Nr. HF 1995.4.7

28
The Last Supper
Synthetic polymer paint on paper, 60 x 80 cm
Private Collection
Inv.Nr. HF 1995.4.10

29
The Last Supper
Synthetic polymer paint on paper, 80 x 60 cm
Private Collection
Inv.Nr. HF 1995.4.8

30
The Last Supper
Synthetic polymer paint on paper, 81 x 60 cm
Private Collection
Inv.Nr. HF 1995.4.9

31
The Last Supper
Screenprint and colored paper collage, 60 x 80 cm
Private Collection
Inv.Nr. HF 1995.4.11

32
The Last Supper
Screenprint and colored paper collage, 61 x 80 cm
Private Collection
Inv.Nr. HF 1995.4.12

33
The Last Supper
Screenprint and colored paper collage, 60 x 80 cm
Private Collection
Inv.Nr. HF 1995.4.13

34
The Last Supper
Screenprint and colored paper collage, 60 x 80 cm
Private Collection
Inv.Nr. HF 1995.4.14

35
The Last Supper
Screenprint and colored paper collage, 61 x 80 cm
Private Collection
Inv.Nr. HF 1995.4.15

36
The Last Supper
Screenprint and colored paper collage, 60 x 80 cm
Private Collection
Inv.Nr. HF 1995.4.16

37
The Last Supper
Screenprint and colored paper collage, 60 x 80 cm
Private Collection
Inv.Nr. HF 1995.4.25

38
The Last Supper
Screenprint and colored paper collage, 60 x 81 cm
Private Collection
Inv.Nr. HF 1995.4.26

39
The Last Supper
Screenprint and colored paper collage, 60 x 80 cm
Private Collection
Inv.Nr. HF 1995.4.27

40
The Last Supper
Screenprint and colored paper collage, 80 x 60 cm
Private Collection
Inv.Nr. HF 1995.4.21

41
The Last Supper
Screenprint on paper, 80 x 60 cm
Private Collection
Inv.Nr. HF 1995.4.28

42
The Last Supper
Screenprint and colored paper collage, 80 x 60 cm
Private Collection
Inv.Nr. HF 1995.4.29

43
The Last Supper
Screenprint and colored paper collage, 80 x 60 cm
Private Collection
Inv.Nr. HF 1995.4.30

44
The Last Supper
Screenprint and colored paper collage, 80 x 60 cm
Private Collection
Inv.Nr. HF 1995.4.32

45
The Last Supper
Screenprint and colored paper collage, 80 x 61 cm
Private Collection
Inv.Nr. HF 1995.4.31

46
The Last Supper
Screenprint and colored paper collage, 80 x 60 cm
Private Collection
Inv.Nr. HF 1995.4.33

47
The Last Supper
Screenprint and colored paper collage, 80 x 60 cm
Private Collection
Inv.Nr. HF 1995.4.34

48
The Last Supper
Screenprint and colored paper collage, 80 x 60 cm
Private Collection
Inv.Nr. HF 1995.4.35

49
The Last Supper
Screenprint and colored paper collage, 80 x 61 cm
Private Collection
Inv.Nr. HF 1995.4.36

50
The Last Supper
Screenprint and colored paper collage, 80 x 60 cm
Private Collection
Inv.Nr. HF 1995.4.17

51
The Last Supper
Screenprint and colored paper collage, 80 x 60 cm
Private Collection
Inv.Nr. HF 1995.4.18

52
The Last Supper
Screenprint and colored paper collage, 80 x 60 cm
Private Collection
Inv.Nr. HF 1995.4.19

53
The Last Supper
Screenprint and colored paper collage, 80 x 60 cm
Private Collection
Inv.Nr. HF 1995.4.20

54
The Last Supper
Screenprint and colored paper collage, 60 x 80 cm
Private Collection
Inv.Nr. HF 1995.4.23

55
The Last Supper
Screenprint and colored paper collage, 60 x 81 cm
Private Collection
Inv.Nr. HF 1995.4.24

56
The Last Supper
Screenprint on paper, 60 x 80 cm
Private Collection
Inv.Nr. HF 1995.4.22

COLOPHON

Catalogue published for the exhibition "Andy Warhol. The Last Supper" at the Bayerische Staatsgemäldesammlungen/Staatsgalerie moderner Kunst, Munich, from 27 May – 27 September 1998

Edited by
Carla Schulz-Hoffmann

Exhibition and catalogue concept
Carla Schulz-Hoffmann
Corinna Thierolf

Copy editing
Corinna Thierolf
Stephan Urbaschek

Coordination
Ingrid Huber, Munich
Stephan Urbaschek, Munich
Tad Wiley, New York

Exhibition secretariat
Susanne Bracht
Ingrid Huber
Birgit Rombach
Gudrun Vögele

Responsible for conservation
Amann Conservation Associates, New York
Florian Schwemer, Bayerische Staatsgemäldesammlungen, Munich

Exhibition installation
Amann Conservation Associates, New York
Scott Fergusson, The Andy Warhol Foundation for the Visual Arts, Inc., New York
Florian Schwemer, Bayerische Staatsgemäldesammlungen, Munich
Tad Wiley, New York, Nejat Baydar, Bernhard Helzel, Shila Kathami, Ingo Offermanns, Bernd Ribbeck, Stefan Schmid, Stephanie Trabusch, Klemens Walter, Munich

Press
Philip Morris, Kulturförderung
Waltraude Behring
Renate Rapelius
Stephan Urbaschek, Bayerische Staatsgemäldesammlungen, Munich

Photographs
Bayerische Staatsgemäldesammlungen (Maren Bochenek, Sibylle Forster, Bruno Hartinger, Gottfried Schneider)
The Andy Warhol Foundation for the Visual Arts, Inc.

Cover illustrations
Front: Andy Warhol, *The Last Supper/Be a Somebody With a Body*, 1986 (cat. 13)
Back: Andy Warhol, *The Last Supper*, 1986 (cat. 41)

Frontispiece
Evelyn Hofer: Andy Warhol's studio

Proof reading:
Cornelia Plaas

Translations
Pauline Cumbers, John S. Southard, Karen Margolis

Design, typesetting
Eduard Keller-Mack

©1998 Bayerische Staatsgemäldesammlungen, Munich, Cantz Verlag and the authors

©1998 for the reproduced works by Andy Warhol: The Andy Warhol Foundation for the Visual Arts, Inc., New York, VG Bild-Kunst, Bonn 1998; for the reproduced works by Jiri Georg Dokoupil, Donald Judd, Barnett Newman, Kurt Schwitters: VG Bild-Kunst, Bonn 1998

©1998 for the other illustrations: the artists, photographers, and their legal successors

ISBN 3-89322-953-1

Printed by
Dr.Cantz'sche Druckerei, Ostfildern

Published by Cantz Verlag
Senefelderstrasse 12
D-73760 Ostfildern-Ruit
Tel: 0711-4405-0
Fax: 0711-4405-220

Distribution in the US
DAP, Distributed Art Publishers, Inc.
155 Avenue of the Americas, Second Floor
USA-New York, N. Y. 10013-1507
Tel: 212-627-1999
Fax: 212-627-9484

Printed in Germany